make money
with your
digital
photography

L203,109/

make money
with your
digital
photography

erin manning

Wiley Publishing, Inc.

Make Money with Your Digital Photography

Published by
Wiley Publishing, Inc.
10475 Crosspoint Boulevard
Indianapolis, IN 46256
www.wiley.com

Copyright © 2011 by Wiley Publishing, Inc., Indianapolis, Indiana

Published simultaneously in Canada

ISBN: 978-0-470-47431-0

Manufactured in the United States of America

10 9 8 7 6 5 4 3 2 1

For general information on our other products and services or to obtain technical support, please contact our Customer Care Department within the U.S. at (877) 762-2974, outside the U.S. at (317) 572-3993 or fax (317) 572-4002.

Wiley also publishes its books in a variety of electronic formats. Some content that appears in print may not be available in electronic books.

Library of Congress Control Number: 2011924133

About the Author

Erin Manning is a professional photographer, author, educator, and media personality. Television viewers know Erin best as the digital photography expert and host of DIY Network's Telly-award-winning TV series *The Whole Picture.* Author of *Portrait and Candid Photography*, published by Wiley, and various magazine and newspaper articles, Erin specializes in lifestyle imagery for clients such as AT&T, Bank of America, and Disney, among others. While completing her degree in Studio Art/Graphic Design from Loyola Marymount University, she spent several years working as a commercial, portrait, and stock photographer, as well as working for Getty Images. Erin's clear, friendly teaching style helps people understand photography by translating technical mumbo-jumbo into everyday words.

Erin serves on the Board of Directors for the Digital Imaging Marketing Association and is a member of the American Photographic Artists, Women in Photography International, and the Los Angeles Digital Imaging Group, whose purpose is dedicated to advancing the art and science of digital imaging.

For more information on Erin and upcoming projects, visit her Web site at www.erinmanning.com.

Credits

Acquisitions Editor
Courtney Allen

Project Editor
Cricket Krengel

Technical Editor
Haje Jan Kamps

Copy Editor
Mary Louise Wiack

Editorial Director
Robyn Siesky

Editorial Manager
Rosemarie Graham

Business Manager
Amy Knies

Senior Marketing Manager
Sandy Smith

Vice President and Executive Group Publisher
Richard Swadley

Vice President and Executive Publisher
Barry Pruett

Project Coordinator
Patrick Redmond

Graphics and Production Specialists
Jennifer Henry
Andrea Hornberger

Proofreading and Indexing
Penny L. Stuart
Estalita Slivoskey

Acknowledgments

Writing a book like this requires the cooperation of many, and my gratitude goes out to everyone who helped me put it together. I would also like to thank my family and friends for supporting me on this journey.

My contributing photographers and specialists include:

Lorne Resnick www.lorneresnick.com
Lou Manna www.loumanna.com
Robert Holley www.robholley.net

Brandy Anderson www.freshsugar.com
Serge Timacheff www.fencingphotos.com
Reid Sprenkel www.reidjsphoto.com
Matt Adcock and Sol Tamargo www.delsolphotography.com
Angela Krass www.fotoprojx.com
Natalie Young www.NatalieYoung.com
Carolyn E. Wright www.photoattorney.com

A big thank you goes out to my attractive models who all kindly participated in this venture, they are: Patricia Hunt, Jack Kuller, Gianina Monroe, Michael Welch, The Nakasones, The Peternels, The Tainters, Janine Warner, Raina and Maya Serota, Susan Kaminski, Stevie Sammarco, The Rohmans & Watkins, Dylan Cavasos, Shane Wolf, The Tainters, Ciaran Killeen, Bryan Kent, and Kim Houska.

For my mother, who has inspired me and believed in me from the beginning.

table of contents

INTRODUCTION

Is this book for you? I'm guessing that you've picked up this book because you have a strong interest in photography and the title speaks to your desire to earn money doing work you love. Whether you're a beginning photographer with a new dSLR or a more advanced enthusiast with a collection of beautiful images, this book is designed to give you an overview on how to assess your opportunities. From personal stories, to practical ideas, suggestions and resources you'll learn the big picture about various genres of photography and the details about ways to make money and handle the business aspects of your business.

This book is not designed as a beginning lesson on using your camera or taking photographs. It also does not cover the details of running a day-to-day business; instead, what is provided here is an overview of opportunities for making money with your photography. Once you've completed the book you should have a good idea as to what area you need to study for deeper knowledge and more confidence in knowing what you need to do in order to create an income.

Even as a young child, the entrepreneurial spirit has always been a driving force in my life. Years ago, I started on the path toward my career in photography and have found satisfaction and fulfillment in earning my living through creating imagery. My specific path may not be yours because our individuality works to define the directions we take in life; however, I am confident that the information and guidance you find here can help you in starting out as a part-time photographer.

In the spirit of collaboration and sharing the love, I have enlisted the knowledge and experience of other photographers and contributors who have been successful in their work. As you read these chapters, you will find a palette of opportunities opening to you and specific information about the types of photography businesses you might engage in — everything from travel to food and product photography, wedding and portrait to sports photography. These professionals share with you some of the things they have learned along the way as they developed their business and refined their craft. It is my hope that you find what you need here to start your journey.

1

personal discovery

Everyone is the child of his past.
— Edna G. Rostow

There is something in all of us that was there from the very beginning — a desire, an interest, a passion that makes us happy. Whether a vocation or avocation, to do what you love every day seems a luxury, yet it is possible. Through evaluating your current situation, interests, skills, and experience, you may begin to see a pattern emerge that helps guide you in your journey. Making money is fundamental for survival, but so is recognizing and clarifying your inspiration — this is what fuels our energy and success in any endeavor.

MY JOURNEY

I cannot imagine anything more gratifying than dreaming up an idea, bringing it to life, and figuring out how to share it. As much as I enjoy expression and creativity in my photography, I am also thrilled whenever I can make money by marketing and selling my work. This passion for art and commerce has driven much of my life, but it was not fully realized until I synthesized my experience, interests, skills, and desire.

IN THE BEGINNING

As far back as I can remember, I have always been an artistic, enterprising sort of person — from making potholders on a loom and selling them door-to-door when I was five, to dragging a refrigerator box home at ten so I could turn it into a lemonade stand. I made love beads in the '70s (which I'm modeling in Figure 1.1) and sold them to my classmates, and created wooden rings in eighth-grade woodshop that I marketed as the hippest jewelry in homeroom. I was always trying to figure out what I could create, share, and sell, partly from a desire to express myself and partly because I wanted to make money.

I was also interested in photographs and photography. My parents had a book that was popular at the time entitled *The Family of Man*. Looking through the images of people from all over the world touched me and inspired me to take notice of people's faces, their emotions and expressions. I also discovered an old family photo box at the top of the hall closet. I pored over every old black-and-white image of my relatives, mesmerized by the stories and faces. I yearned to connect with these long-lost souls from my family

Me in the seventh grade, wearing the love beads I made and sold to all my friends at school **1.1**

history and invite them into my life. My grandmother heard about my interests and gave me an Instamatic camera for Christmas that year. I recall being delighted with the power and creativity to document life as I experienced it, from setting up imaginary scenarios to capturing authentic moments in my everyday life. I developed the film with money from my lemonade stands.

PROGRESS

My foray into an adult education and career was full of experiments, jumps, and jolts. After a brief stint at a college in northern Wisconsin, I decided to make the jump and move to California, the land of fun in the sun and what I saw as opportunity. I arrived here without much money, or a job, or a car,

or even any friends, but I did have a place to stay for a few weeks and despite family opinions, projections, and objections, I found work, made a life, and ended up staying. Over the course of the next ten years, I attended a few different colleges and had many different sales careers. Most sales jobs fed my desire to be independent, to connect with people, and to make some money, but none were ever creatively fulfilling. At a crossroads in my 30s, I took a battery of tests at a career counseling office in hopes of discovering what I was meant to do in my life. After much ado, I was informed that I was an AE, which stands for Artistic Enterprising. This validated what I knew from the very beginning and inspired me to begin the journey toward honoring my creativity in the world of work.

The journey was not a straight road that led immediately to my destination, but a process of self-evaluation, education (both formal and practical), testing business models, and working at different kinds of photography, while gradually refining my career path to take advantage of my talents and to discover the kinds of work I enjoyed doing most. Along the way, I made mistakes, experimented, took leaps of faith, and had some "luck" that never would have occurred had I not prepared the ground for it and responded with immediacy and enthusiasm. Here, I want to share elements of my process and the resulting lessons learned in order to help you take steps toward reaching your goals. It helps to have some lessons before you go out and ride the trails, so to speak, as in Figure 1.2.

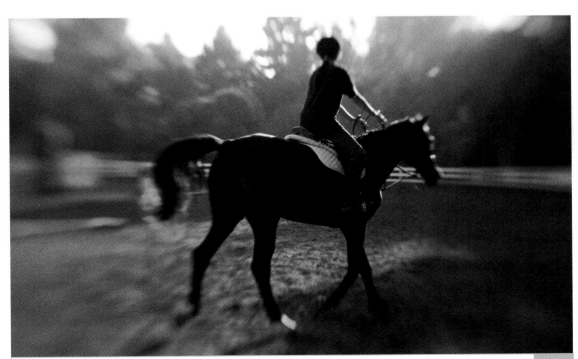

This image is a metaphor for beginning your journey as you forge a path to find your creative point of view.
© Erin Manning

1.2

SELF-EVALUATION

What motivates you to take a photograph? Is it a desire to create and express? To document? To control? To hide? To perform? To explore? To love? Maybe all of the above, or none of the above? It may seem a little unclear or even unnecessary, yet questioning ourselves and gaining an understanding of what makes us tick is an important process — it's a step toward the evolution of self- and life-purpose. If you discover one new thing about yourself in this chapter and apply it toward your photography, you are that much closer to the self-knowledge that can lead to achieving your goals.

ASSESSING INTERESTS, SKILLS, AND EXPERIENCE

We all share a common interest in making money with our photography, but every one of us comes from a different situation. In the spirit of kindling ideas and providing inspiration, I'm going to share my story. I hope that my experience resonates with you and sends a motivating message: It is possible to find your passion and make money too.

When I decided to begin my photography business, I was in no position to drop everything else in my life and dive in head first. I was working in business development for a large corporation and was on the ten-year plan to finish a long-awaited college degree at night. I needed to survive, I had financial commitments, and I wasn't willing to live like a pauper in my adulthood. I had been photographing people, events, and landscapes for years as an amateur, but felt I needed more technical knowledge about lighting and the general photography business to be truly serious. I enrolled in weekend photography classes at the local university, attended workshops, joined photo associations, networked with other photographers, read every book I could find about photography, and practiced on anyone I could convince to be my model. I knew if I improved my photographic skills by learning and doing everything possible in the world of photography, things would work out. As I learned and gained more confidence, I opened up shop as a weekend family portrait photographer by printing up a business card and taking out an ad in the local newspaper. I had one camera and shot on location, the beach. It was fun photographing families and kids with my own journalistic style. People liked my images and referred me to other families. In a short period of time, I built up a portfolio that helped me land my first commercial photography job. It was exciting, but I felt I could do more and I needed to make more money in order to quit my day job. I just wasn't sure how to do it. I was frustrated.

As time went on, I thought my business development skills could be an asset at a stock imagery company in Los Angeles, so I continued to work in business development, but at a place that brought me closer to my passion. I learned a lot about the stock photography industry and was able to keep all my endeavors in balance until I was laid off a year later and my world came tumbling down. I was stunned, but viewed this as my opportunity to make major changes in my life, to slow down and evaluate my interests, skills, and experience, to ensure that I was investing my time and energy in the areas I truly felt passionate about, and to make money. Sometimes when things go wrong, it's not all bad. It's an opportunity for growth and change that would not have happened otherwise.

Give yourself an honest assessment to start. As you go through an examination of your personality, your inspiration, your likes and dislikes, your strengths and weaknesses, and your skills and experience, listen to what comes up and don't reject anything. Just make a list. Everything evolves, and so will your photography business. You are going to be learning new things and changing within the context of your environment. Once you choose a path, it's not set in stone, but a place to begin.

What's your personality? Do you consider yourself an extrovert or introvert? Are you comfortable in large groups of people, or do you prefer to work alone? If you are very shy and feel awful about the thought of directing a large group of people in a photograph, you may want to either work through your shyness with directing techniques and be prepared to feel uncomfortable while you practice, or think about directing your efforts in areas that don't require an outgoing personality. I have a photographer friend who likes being around people, but prefers to design creative scenes with jewelry and food on her own time and in her own way. She's more comfortable photographing alone and feels that she produces her best work that way. I, on the other hand, prefer a mix of working with people and also working alone. Figure 1.3 is an image I created on a solitary Sunday afternoon, experimenting with objects around the house. I placed three pears on a black backdrop near window light and played around with positioning them. Once I chose my favorite shot, I created a Polaroid transfer on watercolor paper, added a unique effect with colored pencils, and turned this "art piece" into limited edition prints, selling them to local art galleries.

NOTE — A Polaroid transfer is a photographic image-transfer process, or printmaking technique, which uses Polaroid film. It enables you to place an image on textiles, cups, glass, and many other surfaces.

What is your experience? What skills have you built upon over the years? What do you do in your spare time? Is there something that you think you could only dream of doing? What do you like to do? What makes you happy? Write it down in a journal — it's going to come in handy. If your thoughts aren't flowing freely, try this exercise: For a week or more, list all the desirable qualities of the tasks, jobs, or processes of work you enjoy. Try to remember experiences where you felt the happiest and found the most reward. For example, prior to my photography career, I worked in sales where I designed sales strategies, built relationships, and gave presentations. In repositioning myself as a photographer, I drew upon my skills and experience in these areas and used them to my advantage in designing my own sales strategies, forming relationships, and giving successful presentations to my clients.

You may feel that your vocation is very different from your avocation, your hobby or passion, but there may be more overlap than you think. Take the time to think about and list your skills, interests, and desires and you may see a pattern or recurring theme reveal itself. If you don't work, or you are not in the job market at this time, think about all the things you do that require your skill and talent, from volunteer work to church groups to community involvement to raising children. You have experience at something, and you can use your natural talents and abilities as a way to express yourself and

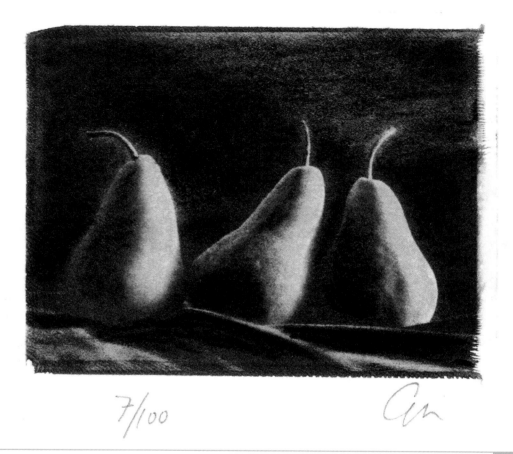

7/100

| I took an original image of three pears and made it into a Polaroid transfer on watercolor paper, and then sketched it with colored pencil. © Erin Manning | 1.3 |

support yourself economically and emotion-ally. You can make money doing what you like to do, if you are determined to try. I love to travel and make it a point to bring a camera with me everywhere, from the corner grocery store to faraway places, such as the Eiffel Tower (shown in Figure 1.4).

When I started out in photography, I had a roommate and no private space to set up my growing collection of photography equip-ment. Fortunately, I lived in a location with a temperate climate and access to the ocean, so I was able to shoot on location at the beach or the park most of the year, although if it rained, I was out of luck. I was able to expand my space once I began meeting more photog-raphers in my classes and sharing my goal of finding a space to shoot. I had taken a class at UCLA Extension and, through contacts there, was able to rent space in a co-op environment in downtown Los Angeles. This space gave me room to conduct professional photo shoots,

and I had access to additional equipment at a very affordable price — from backdrops to tripods and lights. The drawback was the one-hour drive time to get there, but it gave me time to think about what I was going to create before I arrived at the studio.

If you're busy with a family, school, and work, it can be overwhelming to consider making space in your life, let alone your home, for a photography business, but anything is possible if you really want it. Be creative in your problem solving and let go of any "coulda-shoulda-wouldas" in your

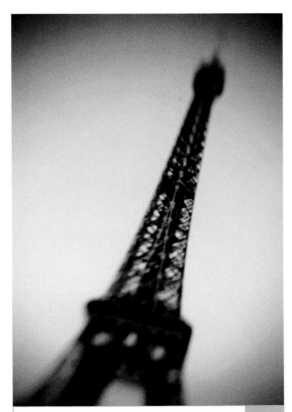

In this image, taken on a gray, stormy day in Paris, I decided to place the tower at an angle and use a selective focus lens to create an effect that elicits a sensation of movement. © Erin Manning 1.4

vocabulary. Think about carving a solid hour or more out of a night or weekend every week to learn more about your craft, plan your studio and equipment purchases or usage (this includes borrowing and renting), and create and implement your marketing strategy. The hours quickly add up like sand in an hourglass, and suddenly you are ready for the next level, making money at what you like to do.

In a perfect world, it would be great to have the money and space needed to set up a professional photo studio. If you do, that's fantastic, but for those of you that require a more creative approach, I have a few ideas. First, it's not necessary to have top-of-the-line equipment and a huge space to get started. You can build up your equipment cache and evolve over time. Depending upon which photographic genre you choose, you may need to set up a temporary or permanent studio space to shoot. For example, if you decide to create a portrait business, you may want to allot a space in your garage or backyard for your photo shoots. If this space isn't an option, consider setting up temporarily in any room in your home. If you plan on using natural light, do what the great artists have done over centuries, and use window light. Johannes Vermeer was a Dutch Baroque painter who is known for his beautifully illuminated subjects. Most of them are standing near a north-facing window with soft, directional light. Pay attention to the quality of light in different areas of your home during the day, and take advantage of this attractive and natural-looking light source. I often take portraits of people sitting in my living room. I have a large, sliding-glass door that faces northwest and a large sofa opposite the window. If the background seems cluttered,

I can easily shoot against a backdrop and achieve a professional-looking portrait with very little setup time involved, as shown in Figure 1.5.

CURRENT PHOTOGRAPHY WORK

I love looking at other photographers' work, especially the masters — Henri Cartier-Bresson, André Kertész, Dorothea Lange, and Ansel Adams. Contemporary photographers are also a source of inspiration — Annie Leibovitz, Peggy Sirota, and Peter Lindbergh produce images that I find compelling. I'm also amazed by some of the images from beginners and enthusiasts that I see on Web sites such as Flickr and Photo.net. It's easier

than ever before to search online and immediately find an abundance of photographic images and photography information. Take advantage of the many books and photography trade magazines that are available. Go to museums and art galleries. Think about what attracts you to certain photographs and why.

Review the images you've taken to date, the images you are most proud of, the images your friends and family comment on. Is there a particular subject or topic that you find recurring in your photos? Is there anything in particular that inspires you and fills you with energy? Is there something that touches your heart, or makes you well up with feeling, as in Figure 1.6? Something that makes you laugh? These are all areas to pay attention

I shot this photo in my living room in front of a blue paper backdrop, using natural window light. © Erin Manning 1.5

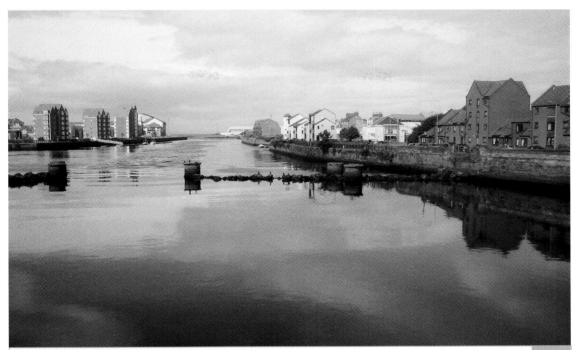

The early morning light in Scotland created a beautiful reflection on the water that connected earth and sky in this composition. © Erin Manning

1.6

to and reflect upon when determining where you want to spend your time and energy. It's an ongoing process to feed and develop your talent. In learning and working toward your goal, new ideas and information will be revealed, and people who assist you in your endeavors will show up in your life. I enjoy taking landscape photographs when I travel and have discovered my personal style is somewhat serene and reflective, as shown in Figure 1.6.

LEARNING CURVE

Knowledge is a lifelong process and depending on your current photographic and computer experience, you may need to learn new skills to take advantage of the benefits of digital photography and enhance your

moneymaking opportunities. From art to technology to the ever-changing marketplace, there is always something new to learn about the photography world.

We all have our own particular way of learning, and it's important to develop an awareness of how you work the best. I discovered that I can concentrate better late at night when I have few distractions. Friends of mine find early morning to be the optimum time for productive study. Whatever the time slot or mode of operation you choose, it helps to have an inspiring project in mind to foster your imagination — this could be documenting family history, retouching a senior portrait, or taking better pictures at your child's soccer game. Any project that you find exciting will work.

DEVELOP YOUR CREATIVE EYE

You may already have mountains of images from over the years that you need to assess. Learning how to determine why an image is or is not good can be an intuitive, subjective process. It helps if you can learn to look at images and articulate the composition, the quality of light, the focal point, and the concept or message in the image. If this is an area you feel you need more help with, approach photography instructors, professional photographers, and other people involved in the world of imagery to discuss what is or is not compelling about a selection of photographs.

Using a visual reference guide is a helpful creative tool. A good example is what professionals use when they formulate ideas and need to express them to others on their creative team. Sometimes referred to as *tear sheets*, *scrap*, or *comps*, these visual references can be pages from a magazine or newspaper, or anything that inspires you and helps communicate your idea. Find another photographer's work that resonates with you and study his images. Look through magazines, cut out images you are drawn to, and create a visual reference folder with them. I like to keep my visual inspiration in a three-ring notebook, placing my tear sheets in clear sheet protectors. This visual reference guide reminds me of what I want to do, and I use it as a resource when brainstorming about ideas for photo shoots, which is how I chose the composition for the image in Figure 1.7.

TAKE CLASSES

Once you evaluate your strengths and weaknesses, it's time to take a class. Photography classes, whether they are group classes, workshops, online learning, or one-on-one instruction, can all help you progress at any level of photography. For hands-on learning, find a professional photographer in your area and offer to assist on some of his photo shoots. Good places to look for classes are local colleges and photo workshops, such as Santa Fe Workshops (www.sfworkshop.com), or Maine Media Workshops (www.theworkshops.com). Online sources can provide both quick tutorials and long-term learning. I like lynda.com (www.lynda.com). One thing to keep in mind as you continue your art and commerce education is that learning is an ongoing process, an evolution of self. As in Figure 1.8, there is a lot to learn, but it's not necessary or possible to know everything at once.

I took photography classes from various photographers over the years, and each class seemed to be a life-changing experience. I was around other like-minded people with the same passion for learning and growing, which opened up my world in many ways. It also felt good to know I was working towards exploring my creativity. Be aware that class quality and teacher personalities can vary, so it helps to keep an open mind. If you ever feel intimidated, just remember that everyone else is also there to learn, and there is no such thing as a dumb question.

You should also consider business classes. You can contact the U.S. Small Business Administration (www.sba.gov), which offers free or low-cost advice, seminars, and workshops. At a local community college, you may also find short-term evening and weekend courses on topics such as creating a business plan or finding financial assistance.

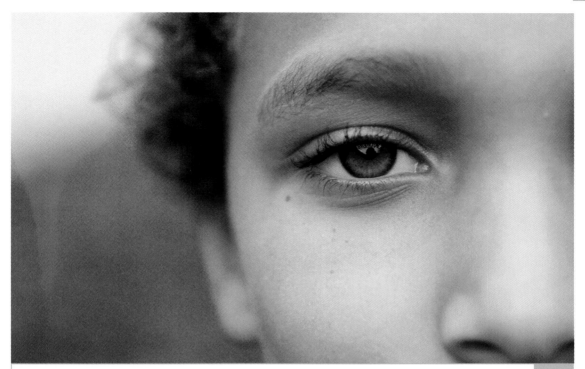

I created this shot based on an idea from an image I had in my visual inspiration notebook. © Erin Manning / Getty Images

1.7

JOIN PHOTO GROUPS

Photography can be a solitary pursuit. Whether you live alone, with roommates, or a lot of family members, you are going to need some solitude to create, think, and work. However, it does help to reach out and connect with other like-minded people. By joining a group, you will have access to professional information about best practices and standards, and other information that will motivate, educate, and inspire you. I've found that the energy in these groups can be very positive and productive. Forming relationships and alliances with my peers has created a supportive network that has proven to be extremely valuable in my photography endeavors.

Whether an amateur or professional photographer, you can share and nurture your passion for photography and entrepreneurialism. There are myriad of photography groups and associations available all over the world, and many of them host seminars and events that facilitate meeting and interacting with other members. These groups consist of people who are passionate about learning and doing anything related to photography. Photographers I've met through these associations and groups have been an invaluable source of information and assistance. The excitement about doing something that inspires you is contagious!

Like the group of girls in Figure 1.9, who are very interested in photography and have

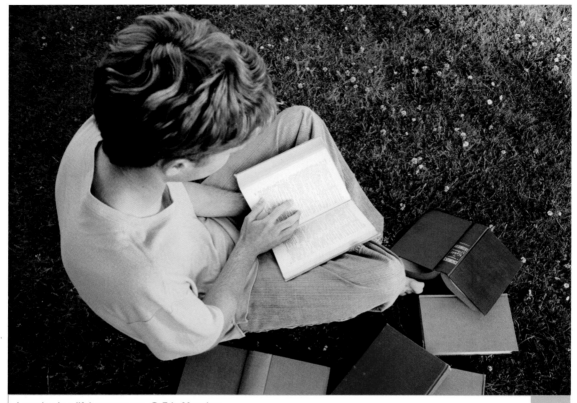

Learning is a lifelong process. © Erin Manning 1.8

formed their own photography-learning group, I have been part of several groups because they fit my particular interests:

- **APA.** American Photographic Artists (www.apanational.com)

- **PPA.** Professional Photographers of America (www.ppa.com)

- **NAPP.** National Association of Photoshop Professionals (www.photo shopuser.com)

RESEARCH THE MARKET

Once you choose a specific area of photography to pursue, you need to understand the context of your market. Talk to your connections for referrals, check out your local newspaper, and check with your local chamber of commerce to discover other photographers. Shop your local competition and look at their Web sites. What do they charge? How do they work? What's unique about them? What do they do well? What do they do poorly? Who is doing the most business? For national competitors, conduct an online search and evaluate what they offer to help fine-tune your idea.

NOTE I discuss market information in more detail in each specific photography genre chapter and in Chapter 9.

BUILD A NETWORK

By taking classes, networking with your peers, and reaching out to other like-minded photography enthusiasts, you will begin to build a network of information, inspiration, and support. I have met many talented, interesting, and generous people along the way, and we have contributed to each other's growth and progress in the world of photography. Some people may find you through your advertising, online presence, and word of mouth, or you may proactively pursue other photographers you find interesting. It makes sense to connect with others of like mind and spirit — you never know when you may need a helping hand or when you might be of service to someone else.

I have also drawn upon my connections and friendships with people who were not photographers, but could contribute a service or help me in reaching a specific photographic goal. For example, one of my first commercial clients was a hospital that required that I shoot numerous, large groups of people who needed a lot of spirited direction. I employed a make-up artist friend with a very loud voice and directive personality who could help me in communicating with these large groups. We all worked very hard and expended a lot of energy on the day of the shoot. As a result, the pictures turned out great, the client was happy, and we had a lot of fun.

Think of all the people you know who could help you with your photography, from a neighbor that can hold a reflector, to business and marketing friends, technology types, people with beautiful spaces where you can shoot, make-up artists, hairstylists, printers, and the list goes on. Be creative in thinking about whom you know right now, and be open to meeting new people in your area of interest, photography.

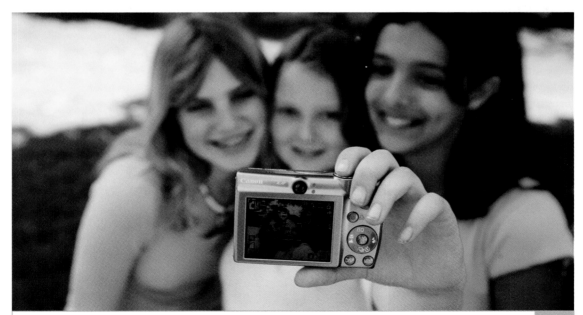

You are never too young or too old to begin learning about something you love. © Erin Manning
1.9

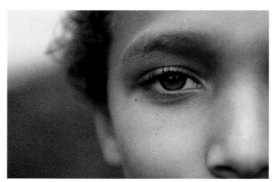

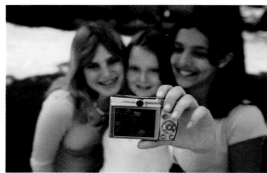

CHAPTER REVIEW

A Think about what sparks your creativity and inspires you so you can better assess your interests, skills, and experience.

B Consider your current photography work and spend time reviewing it to see where your strengths and weaknesses are.

C Never stop working to develop your creative eye and sense of style.

D Spend time researching the market, what is already out there, and what is popular, and network however and whenever you can.

2

equipment essentials

The quality of a photograph depends more on the vision and creativity of the photographer than on the equipment used to capture it. Still, you need some basic gear from the outset, and you should plan for additional equipment purchases over time. This chapter helps you identify what equipment you need, from inexpensive household items to pricey professional equipment and everything in between.

DSLR CAMERAS

Although it goes without saying, I'm going to say it anyway: You need a digital camera — preferably a dSLR (digital single lens reflex) camera. A dSLR camera possesses a higher-quality sensor that allows for faster image capture and better-quality images; in addition, it enables you to use different lenses. Figure 2.1 shows a Canon EOS 550D dSLR camera.

What dSLR is right for you? That depends. Although budget is always a consideration when determining which camera to choose, you should also determine what features you are going to need. For example, if you are interested in photographing people, having a camera with a spot meter is important. This helps you create the proper exposure in backlit or high-contrast lighting situations. If you're interested in sports photography, then consider a camera that can shoot more frames per second to ensure you don't miss your shot. And of course, one of the best ways to evaluate a camera is to hold it in your hand to make sure it's easy to handle. The basic features to consider are image quality, performance, ergonomics, features, and price. There is no such thing as a technically perfect camera; only you can decide what is good enough for your interests. The following is a checklist with overall key features to look for in a digital camera:

You can purchase a new camera, do some research online for a good used camera, or borrow one from a friend or family member. Photo courtesy of Canon USA, Inc.

2.1

■ **Interchangeable-lens, full system digital SLR.** This camera allows you to remove one lens and replace it with another. A starter lens is often included with the dSLR body. The benefits of this lens are that it's light and inexpensive, and it can produce quality images. The downside is that it lacks the speed necessary to capture images in low-light situations. You should invest in the best lenses you can afford, but the kit lens is a good place to begin.

■ **More megapixels don't necessarily mean higher image quality.** The image quality has to do with the size of the sensor. Most entry-level dSLR cameras have an APS-C sensor that produces excellent images. If you purchase a more expensive dSLR camera with a full-frame sensor, your images will be of the highest quality. It comes down to price.

NOTE
Larger sensors are why 12 megapixels from a digital SLR create higher quality images than 12 megapixels from a compact camera. To spread the same number of pixels over a larger sensor area, the pixels must be bigger. These bigger pixels gather more light, so they produce less-noisy images, capture greater dynamic range, and perform much better at high ISO settings.

■ **High ISO range.** This varies between cameras, but generally dSLRs offer an array of ISO settings that allow you flexibility shooting in various conditions.

■ **Easy-to-use controls.** A dSLR is designed in a way that assumes you want to use the manual settings. Visit a camera store, pick up the camera and see how it feels. Are the controls easy to adjust? Can you find them?

■ **Burst mode.** Also known as frames per second (fps), this is the camera's ability to capture a lot of images in quick succession, just by holding down the shutter button. This is great for action and sports photography. Most dSLRS can shoot from 3 fps to 11 fps.

■ **Flash.** Most professional grade dSLR cameras don't have a built-in flash option; instead there is a hot-shoe located on top of the camera for an external flash. Many entry-level dSLRS have an on-camera flash (and they offer a hot-shoe as well).

■ **LCD size.** It's nice to have the largest viewing area possible when reviewing your images.

■ **Maximum shutter speed.** Most dSLR cameras have a wide range of speeds available. If speed is important, such as action or sports photography, consider this feature.

TIP
A good independent source for unbiased, detailed camera reviews is the Digital Photography Review Web site (www.dpreview. com).

IMAGE STORAGE

When you use your digital camera to capture images, they are stored on a memory card until you transfer them to your computer or to another medium or device for backup. From your memory card to storage and backup, you should consider a few options when planning your digital workflow.

MEMORY CARDS

Various types of memory cards are available depending on the type of camera you select. For example, CompactFlash cards (CF) are used by most professional level dSLR cameras, Secure Digital cards (SD) are probably the most popular and are used in many compact cameras and some entry-level dSLR camera models, and Memory Stick cards (MS) are proprietary to Sony still and video cameras. The camera box and camera manual will reference which memory card a camera accepts.

Figure 2.2 shows a *CompactFlash* (CF) memory card. Figure 2.3 shows a *Secure Digital* (SD) memory card.

A Secure Digital (SD) memory card. Photo courtesy of SanDisk. 2.3

A CompactFlash (CF) memory card. Photo courtesy of SanDisk. 2.2

TIP

Memory cards are small and very sensitive electronic devices that you should handle with care. Do not place them near strong magnetic sources, drop them, or mangle them — you could lose all your images. Make sure you label your card with your name and contact information, just in case you misplace it.

Higher megapixel cameras equal larger files and need more image storage space. Your digital camera probably came with a small capacity memory card that holds a few images to get you started, but it's always a good idea to purchase a memory card with enough capacity to hold a lot of photos and video, plus additional cards. When shooting an important event, it's a good idea to spread your images over multiple memory cards due to possible memory card failure. Memory cards can become corrupted, and although there is software you can use to try and retrieve your images if this terrible incident occurs, it's always better to be safe than sorry.

Memory cards are available in gigabyte (GB) capacities, and they hold from hundreds to thousands of images, depending on the image quality setting you choose on your camera. Some digital camera LCD viewfinders even display the approximate number of

images you can shoot once you insert the memory card and set the image quality. I often use a 16GB card in my dSLR.

Unlike conventional film, high-speed memory cards are not more sensitive to light; they just record or write and transfer data faster. However, that's an advantage only if your camera reads and writes data quickly. Without getting into the all the differences in speeds and classes, keep in mind that digital SLRs work faster with high-speed cards such as 150x or class 6–10, while compact camera models will accept lower speed cards. Here are a few important tips for working with your memory cards:

- DO have a fully charged battery before transferring images to another location.

- DON'T remove the memory card while files are still being transferred.

- DO format your memory card in-camera and not in-computer.

- DON'T use a memory card from another camera without formatting it first.

Even if you are using a high-capacity memory card, having multiple cards on hand is always a good idea. There's nothing worse than running out of space on your memory card in the middle of a shoot!

TIP

Some memory cards have Wi-Fi capabilities, enabling you to transfer images from the card to your computer via a wireless network. Figure 2.4 shows a wireless SD Eye-Fi memory card; with it, you specify where you want your photos sent, select a Wi-Fi network, and then turn on your camera to make the transfer.

A wireless memory card enables you to transfer photos from your camera to your computer via a Wi-Fi connection. Photo courtesy of Eye-Fi

2.4

EXTERNAL HARD DRIVES

Your digital-photography workflow includes transferring photos from your camera's memory card to your computer. In addition to storing photos on your computer, you

Format Your Memory Card

Before you begin taking pictures, it's a good idea to format your memory card. This prepares and optimizes the card for use with your specific camera. Formatting is also the best way to clear images from your card after transferring them to a hard drive or portable storage device or burning them onto a CD or DVD. Formatting your memory card after safely saving your images elsewhere ensures that your card is clean, restructured, and ready to go. Check your camera's manual for details.

should also store them on an external hard drive. That way, if disaster strikes and your computer is lost, stolen, broken, or your hard drive fails, your precious images are not all lost. I use full-sized G-Technology hard drives in my studio (see Figure 2.5) and small, travel-sized G-Technology and LaCie hard drives when traveling.

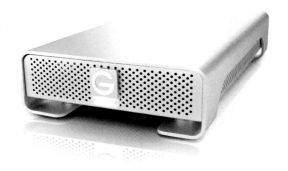

In addition to storing your images on your computer's hard drive, you should keep copies on an external hard drive. Photo courtesy of G-Technology by Hitachi

2.5

> TIP
> Never format a card before you've transferred and backed up your images somewhere else, because formatting also erases all your images on the card. And, although it's okay to do every once in a while, deleting images with the trash can icon on your camera is not the optimum choice. Most camera and memory card manufacturers recommend formatting your memory card when it's in your camera.

LENSES

One reason a dSLR camera is a great choice is that it enables you to use different lenses. Lenses for dSLRs come in many varieties,

each with their own advantages and disadvantages. Understanding the benefits and limitations of the various types of lenses is key to controlling the outcome of a shoot.

> TIP
> Be sure to examine your computer to determine which types of connections it supports. For example, you don't want to purchase an external hard drive that uses a FireWire connection if your computer doesn't have a FireWire port.

FOCAL LENGTH

A key characteristic of any lens is its *focal length*. Speaking technically, the focal length of a lens is generally measured in millimeters, and is the distance from its front lens element to the imaging sensor, when the lens is focused at infinity. Think of focal length as the amount of magnification a lens has — the longer the focal length, the more the lens magnifies the scene.

> TIP
> Buy the best lenses you can afford. They do make a difference!

There are many lenses to choose from, so it can become a little confusing. If you've only used one lens on your dSLR, you're missing out on the creative possibilities different lenses provide. It's important to cover all the bases regarding focal length, from close-up, mid-range, telephoto, wide-angle, and the normal or standard perspective. Keep in mind that purchasing lenses is an evolving process. Get what you need to begin and build your lens collection over time. The following are some lens suggestions:

Store Your Images Online

As broadband connection speeds increase and digital image libraries expand in size, many people have discovered that uploading images to an online storage service in addition to backing them up on an external hard drive improves their workflow — and their peace of mind. For example, I subscribe to an online storage service called Mozy (www.mozy.com), which enables me to perform automatic backups of my images for a small monthly fee. I can then access my images from any computer.

■ **Normal lens.** A normal (also known as a "standard") lens approximates the perspective of the human eye (see Figure 2.6). With a normal lens, the spatial relationships of objects in your image closely mirror the way you see them in the real world. In general, normal lenses are lighter, cheaper, and faster than their wide-angle and telephoto counterparts. (You learn about what makes a lens "fast" in the upcoming section on lens

speed.) Figure 2.8 shows an image captured using a 50mm normal lens.

■ **Wide angle.** A wide-angle lens has a shorter focal length than a normal lens and yields a significantly wider angle of view — hence its name (see Figure 2.7). (*Angle of view* simply refers to how much of a scene a lens can capture.) A wide-angle lens exaggerates the spatial relationship of objects in your image, making it ideal for capturing the interior of a room or for expansive environmental portraits. In addition to allowing for a wider angle of view, wide-angle lenses can render a greater depth of field, making them a favorite among landscape photographers who seek to capture detail in their images from the foreground to the background. The image in Figure 2.9 was captured using a 16–35mm wide-angle lens.

■ **Telephoto.** A telephoto lens, which is longer than a normal lens, provides a narrower angle of view, capturing

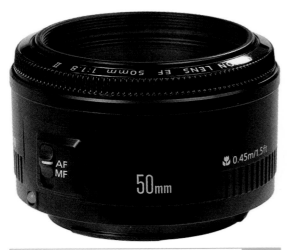

A 50mm "normal" lens. Photo courtesy of Canon USA, Inc. **2.6**

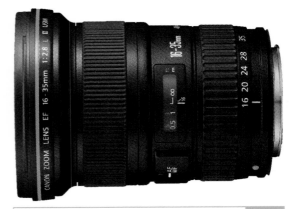

A wide-angle zoom lens. Photo courtesy of Canon USA, Inc. **2.7**

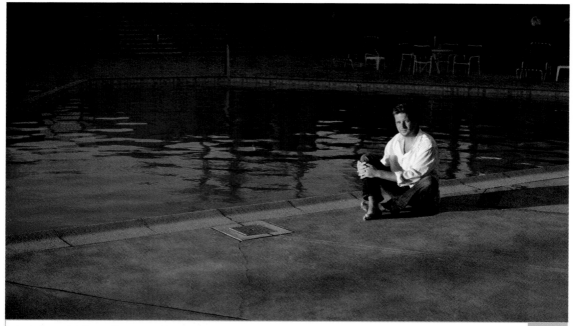

A photograph taken with a normal lens approximates the perspective of the human eye. © Erin Manning

2.8

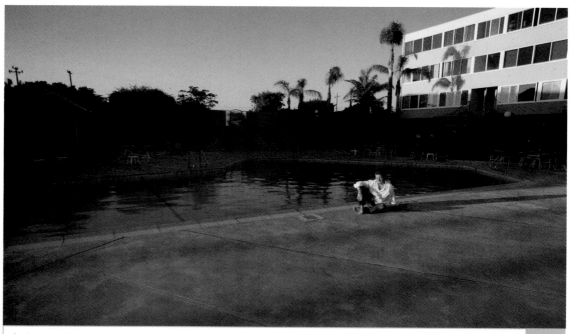

A photograph taken with a wide-angle lens expands space and widens the perspective. © Erin Manning

2.9

less of the surrounding area and magnifying the objects in the scene (see Figures 2.10 and 2.11). In addition, using a telephoto lens helps create a shallow depth of field. Doing this blurs the background and isolates your subject from the surrounding distractions. To achieve this effect, you must move your subject more than a few feet away from the background. I like to use a telephoto lens for portraits because it provides a flattering perspective. The lens flattens the scene somewhat, meaning that noses don't look larger than normal. If you plan to shoot wildlife or sporting events, a telephoto lens is a must, as it enables you to zero in on your subject even from a distance. The image in Figure 2.12 was captured using a 70–200mm telephoto lens.

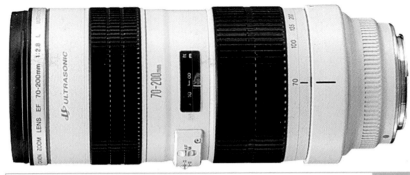

A 70–200mm telephoto zoom lens. Photo courtesy of Canon USA, Inc. **2.10**

TIP

Be aware that any subject that you photograph up close with a wide-angle lens appears larger than life — generally not flattering for portrait photography. Vignetting (that is, a reduction of the image's brightness in the periphery) and barrel distortion (in which lines near the borders of the image appear to bend outward) can also occur with a wide-angle lens. Nonetheless, you can create some very interesting effects by shooting with a wide-angle lens in close proximity to your subject.

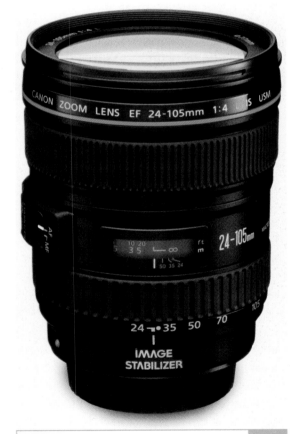

A 24–105mm mid-range zoom lens. Photo courtesy of Canon USA, Inc. **2.11**

A photograph taken with a telephoto lens helps create a shallow depth of field, isolating your subject from the background. © Erin Manning

2.12

Depth of Field

Depth of Field (DOF) refers to the zone of sharpness in your image. Your DOF is deep if most of your scene is in focus; it is shallow if a small area is in focus. The human eye is drawn to the part of an image that is sharp and in focus. You can creatively use DOF to direct the viewer's eye to the important elements in your photograph.

■ **Macro.** A macro lens enables you to focus at a very close range in order to capture tiny objects so that they appear quite large, filling the frame

(see Figure 2.13). Macro lenses are ideal for photographing flowers as in Figure 2.14, insects, and other small objects.

TIP

Telephoto lenses are heavy. If you plan to use a shutter speed slower than 1/250 second, you may need to use a tripod to prevent camera shake (unless your camera boasts image-stabilization technology, in which case you may have more leeway).

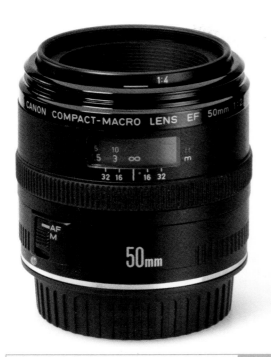

A 50mm macro lens. Photo courtesy of Canon USA, Inc. `2.13`

LENS SPEED

Another factor when it comes to choosing lenses is speed. A lens with a wide maximum aperture (for example, f/2.8) is considered a fast lens because more light passes through the lens, enabling you to use a faster shutter speed. A lens with a smaller maximum aperture (for example, f/5.6) is slow because less light passes through the lens and therefore a slower shutter speed is required. Figure 2.15 shows a moving subject captured using a fast shutter speed; this is where a faster lens can really make a difference.

Keep Your Lenses Clean

Regardless of what types of lenses you choose to buy, it's imperative that you keep them clean. Otherwise, your images will suffer. For starters, always use a lens cap when your lens is not in use. That way, you don't get dust, fingerprints, or smudges on your lenses when handling them. If dust or other particles do find their way onto your lens, use a bulb blower and brush to remove them. Remove fingerprints by breathing onto the lens and wiping it with a clean microfiber cloth. For smudges that are harder to remove, use a lens cleaner that is designed for camera optics with a special lens-cleaning tissue. A word of warning: Don't over-clean! Cleaning occasionally as needed is the best way to go.

Fixed Lenses versus Zoom Lenses

Some lenses are fixed — that is, their focal length does not change. In contrast, zoom lenses offer a range of focal lengths, such as 24–70mm. With zoom lenses, you can switch from one focal length to another, including more or less of the scene in your shot, simply by moving the lens barrel. While using a zoom lens enables you to lug fewer lenses around, zoom lenses do have their disadvantages: They tend to be more expensive, and they are generally less sharp than lenses with a fixed focal length, which can be a problem if the image will be printed in a larger format.

Use a macro lens for extreme close-ups. © Erin Manning 2.14

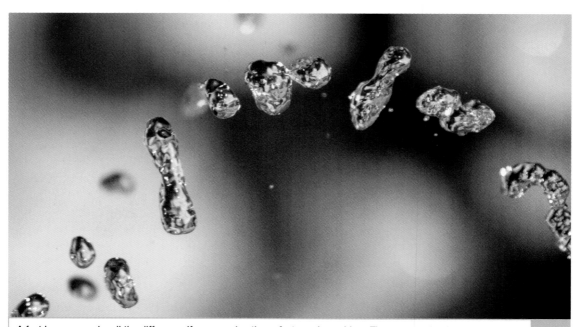

A fast lens can make all the difference if you are shooting a fast-moving subject. These water droplets were captured 2.15 in midair with a fast shutter speed of 1/4000 second. © Erin Manning

LIGHTING

Sometimes, natural light is not enough, and so you need to illuminate your scene with artificial light. In photography, artificial light can be divided into two categories:

- **Flashes and strobes.** These emit a burst of light for a fraction of a second.

- **Continuous lights.** These create a consistent and continuous light in your scene.

FLASHES AND STROBES

Although most digital cameras have a built-in flash to cover basic lighting needs, the light they emit can result in images that look flat and lack subtle gradations of tone. A better option is an external flash, like the one shown in Figure 2.16. You connect an external flash to your camera via a *hot-shoe*, a mounting bracket located on the top of your camera. If the flash is designed to work with your camera, you can use the camera's TTL (through the lens) metering features to light your scene.

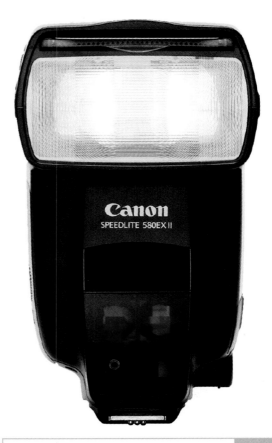

Use an external flash rather than your camera's built-in flash. Photo courtesy of Canon USA, Inc. 2.16

Using Slave Flashes and Transmitters

A *slave flash* is an external flash unit that you can use to provide extra lighting. When your camera's flash fires, it triggers the slave flash to fire as well, often within milliseconds. You might use a slave flash to fill in the shadows created by another light source or to even out the light in your scene. Another option is to use a *transmitter,* which attaches to your camera's hot-shoe and sends an infrared signal to dedicated flash units in the vicinity, causing them to flash.

A strobe light is simply a bigger, more powerful version of an external flash. Like external flashes, strobe lights are triggered by the camera and emit a brief flash of light to illuminate your scene. The difference? Instead of being mounted on your camera, a strobe light can be self-contained, meaning it has its own power source, and mounted on a light stand. This is referred to as a *monolight* (see Figure 2.17). It can also be powered by a central power pack (see Figure 2.18).

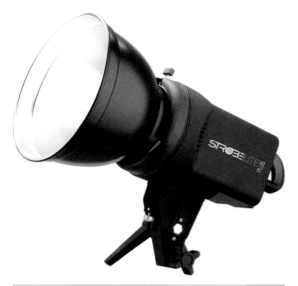

Each monolight strobe head has its own power pack. Monolights are easy to transport and tend to be less expensive than a power pack strobe system. Photo courtesy of F.J. Westcott Company **2.17**

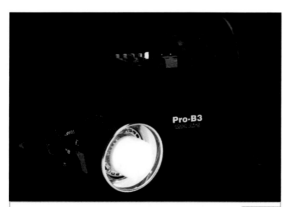

In this type of strobe lighting, all the strobe heads (lights) are wired to a central power pack. Photo courtesy of ProPhoto **2.18**

Variable Aperture Versus Fixed Aperture

The lens that came with your camera is most likely a variable-aperture lens, meaning that the lens speed and aperture change as you focus closer in or farther away with the wide or telephoto capability of your lens. Variable-aperture lenses are less expensive than their fixed-aperture counterparts and are capable of producing excellent images, but they do have limitations. For example, you can only capture action in bright light or by using a flash. Also, variable-aperture lenses cannot render a very shallow depth of field. In general, fixed-aperture lenses yield better results.

CONTINUOUS LIGHTS

A continuous light source is one that comes on — and stays on. This makes it easy to see the light falling upon your subject (see Figure 2.19). The disadvantage is that some continuous light sources can generate a lot of heat, making your subjects hot and uncomfortable. Fortunately, there are different types of continuous light sources available:

■ **Fluorescent lights.** Fluorescent photo lights are very popular because they operate at cooler temperatures, are energy efficient, and are easy to use.

■ **Photo floods.**
Photo floods offer a few advantages: They're inexpensive, they can be purchased at your local hardware store, and they produce a generous amount of light. There are, however, some drawbacks to using photo floods: Not only do the bulbs have a fairly short life span, but they also emit a lot of heat.

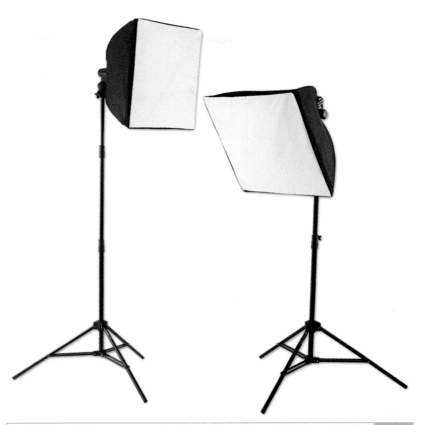

These soft boxes, which are explained in the next section, contain continuous, florescent, cool-to-the-touch lights. Photo courtesy of F.J. Westcott Company

2.19

TIP

When working with hot lights, exercise caution. If you are photographing people, avoid pointing the light directly at them. Instead, bounce it off a white wall or white board. Not only does this protect your subject from the heat, but it also casts a softer light on your scene. Also, never place anything flammable over a hot light.

MANIPULATING LIGHT

If you are unable to enhance or subdue the available light, whether it is natural or artificial, your photographs may not turn out as well as you want. By using reflectors, light blockers, and diffusers, you can exert more control over your creative vision (see Figure 2.20).

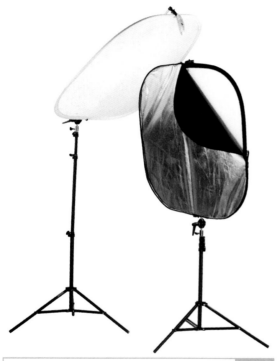

You can use reflectors, light blockers, and diffusers to manipulate light. I never go on a photo shoot without them. Photo courtesy of F.J. Westcott Company

2.20

- **Reflector.** A *reflector* can be anything that reflects light into your scene. A mirror, a white tablecloth, a cookie sheet covered in tinfoil, or even a car dashboard reflector or white wall can meet your needs. Professional-quality reflectors come in various shapes and sizes and are essential for bouncing light back into areas of unwanted shadow to reduce contrast. They're available in white, silver, and gold. You can also create your own reflector out of a piece of white foam core or even a car sunshade.

- **Light blocker.** A *light blocker* can be anything dark or black that obstructs light or subtracts it from your scene. This is helpful when you want to create shadows or block light in a certain area of your image. Light blockers are also known as *flags* or *gobos* because they "flag off" the light or "go between" the light source and your subject. I use the Westcott black flags that come in a kit called Fast Flags; this kit also includes metal frames and a carrying case. Alternatively, you can use large, black pieces of poster board or foam core.

- **Diffuser.** A *diffuser* is translucent material that, when placed between your light source and your subject, can soften and diffuse harsh light falling upon your subject. Everyday household items such as a white shower curtain, sheer white fabric, or a white umbrella can help diffuse light. Tracing paper from an art supply store also works well. Alternatively, you can use a

soft box (see Figure 2.21), which is the light-softening choice for most professional photographers. Yet another option is to use a *flash diffuser* — a white, translucent plastic cover that slips over the head of your flash unit so it emits a softer, more flattering light — to soften your scene.

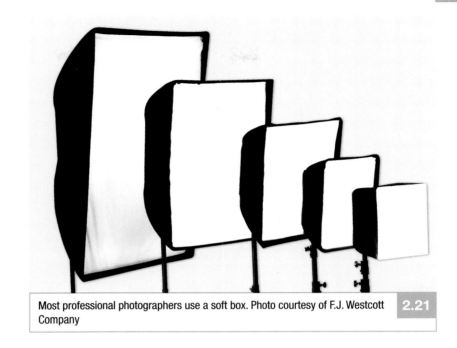

Most professional photographers use a soft box. Photo courtesy of F.J. Westcott Company | 2.21

NOTE Umbrellas are a great tool for spreading and softening light. For example, you might place a white, translucent umbrella on a stand between your light source and your subject to soften the light, or point your light toward the inside of an umbrella with a reflective surface to redirect it.

TRIPODS AND MONOPODS

If you aren't concerned with split-second mobility and traveling light, then using a tripod is an excellent way to improve the sharpness of your images (see Figure 2.22). A tripod's purpose is to steady the camera during longer exposures — for example, when low-light conditions require the use of a slow shutter speed — during which your camera is sensitive to the slightest movement caused by wind, unsteady hands, or even pressing the shutter button.

TIP When using your tripod, position the third leg away from you and not between your legs. That way, you won't trip and accidentally knock over the tripod and your camera.

A tripod consists of three collapsible legs and a center shaft that you can use to raise or lower the camera. At the top of this center shaft is a flat platform with a threaded screw where you mount a tripod head. Although less-expensive tripods generally include a basic tripod head that either

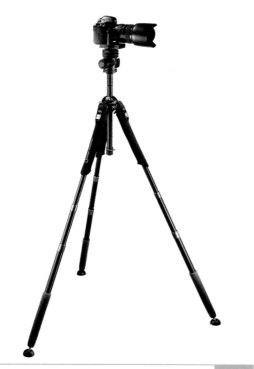

Using a tripod can improve the sharpness of your images. Photo courtesy of Bogen Imaging **2.22**

TIP — A quick release, which enables you to quickly release the camera from a tripod, is a must-have for photographers who often use a tripod. Without a quick release, you need to unscrew your camera from the tripod head, which can be cumbersome and impractical.

swivels on a small ball or is controlled by a series of knobs, professional-quality tripods do not, meaning you need to buy a tripod

head separately. A ball-style tripod head is easiest to use, enabling you to quickly position your camera at any angle (see Figure 2.23).

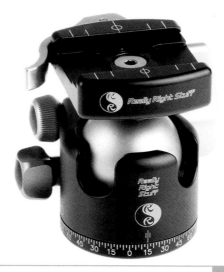

With a ball-style tripod head, you can easily position your camera at any angle. Photo courtesy of Really Right Stuff **2.23**

To ensure a sharp shot, confirm that your tripod is stable enough to hold the weight of the camera and lens mounted on top of it. A dSLR camera and a long lens can be heavy, so a heavier tripod may be necessary to balance the weight and provide a secure platform. A lighter tripod may work well for a smaller, lightweight camera-and-lens combination. A third option is a mini-tripod, which is a much smaller version of a standard tripod (see Figure 2.24).

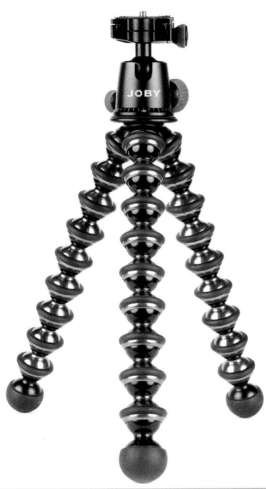

This Joby Gorillapod mini-tripod can stabilize a dSLR camera, even with a large telephoto lens. Photo courtesy of Joby **2.24**

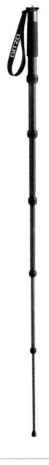

Monopods are a good option if maneuverability is a requirement. Photo courtesy of Bogen Imaging **2.25**

MISCELLANEOUS CAMERA EQUIPMENT

If portability is a requirement, a monopod might be a better option. As shown in Figure 2.25, a monopod consists of only one leg and requires you to hold it upright. Monopods are generally used by sports photographers who need to move around quickly and efficiently, yet need to stabilize their camera.

In addition to the items already discussed, there are a few more pieces of camera equipment that you might want to consider:

- **Remote shutter release.** A remote shutter release (see Figure 2.26) enables you to engage the shutter without having to press the shutter release button

on the camera, which is handy for minimizing vibrations that could cause image blur. It's a must when photographing in low light or at night.

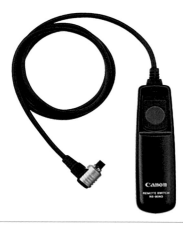

A remote shutter release is handy for minimizing vibrations that could cause image blur. Photo courtesy of Canon USA, Inc. **2.26**

- **Backdrops.** Inside or outside, a solid-colored backdrop can provide a clutter-free background, which serves to emphasize the subject in the photo. A classic backdrop is seamless paper (sold in rolls and available in a variety of colors) or a simple cloth draped behind the subject. You can purchase a professional backdrop setup or you can make your own by hanging a wooden pole from the ceiling.

- **Light stands.** Light stands are a necessity for holding softboxes and umbrellas, and they also come in handy for holding your flash units. Almost any light stand will safely support a shoe-mount strobe. Look for one that is reasonably priced, can stand some abuse, and is light and easy to transport.

- **Dioptric adjustment lens.** To ensure that images and focusing points in your viewfinder are adjusted for your vision, you can adjust your camera's diopter dial, located to the right of the optical viewfinder on a dSLR camera. If you require stronger correction, consider purchasing a dioptric adjustment lens, which fits over the camera's optical viewfinder.

- **Camera bag.** You need a place to safely store and transport your camera and accessories. Camera bags come in all shapes and sizes, so look for one that can accommodate your gear and fits your lifestyle. For example, a bag on rollers is great for carrying gear to a shoot. When you visit the local camera store, bring your camera and a few lenses and try out the camera bags. Choose a bag that is comfortable to carry and makes your equipment easily accessible (see Figure 2.27).

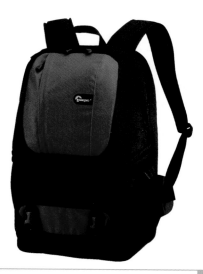

A camera bag is an essential piece of equipment. Photo courtesy of Lowepro **2.27**

COMPUTER EQUIPMENT

You're not just any photographer; you're a *digital* photographer. That means there's some baseline computer equipment you need on hand. Earlier in this chapter, I mentioned the importance of having an external hard drive. In addition to that, you need the following:

■ **A computer.** Every digital photographer needs access to a computer for transferring, editing, enhancing, organizing, and archiving images. You'll have an easier time working with your images if your computer processor is less then a few years old, and your operating system and software are up-to-date. Whether it's Mac or PC, most software programs now work on both platforms. Desktop computers are often less expensive than laptops but laptop computers afford you the most mobility. As with most things you purchase for your photographic ventures, you have to weigh out your priorities.

■ **A printer.** There are so many economical, easy, and high-quality ways to print your images. Many online printers offer free or subscription-based services for everything from viewing to retouching to print sales. The film processing labs of yesterday are the digital printing powerhouses of today. I like to use White House Custom Colour (www.whcc.com) as my direct print provider and Pictage (www.pictage.com) for viewing, printing, and delivering orders to my clients. If you intend on printing photographs from home, it would be wise to invest in a dedicated photo printer and photo-quality paper. Historically, home-based photo printers produced prints that quickly faded over a short period of time. Things have improved however. Now consumer photo-quality printers can produce amazing, high-quality prints that retain their color and detail. Most printer manufacturers claim that even their dye-based ink prints will not fade in over 100 years provided that you use the same manufacturer's printer, paper, and ink. Pigment-based ink printers are more expensive and are more stable over time, meaning the colors won't shift and the subtle gradation of tone remains intact. This is especially important if you are producing your own fine-art prints from home.

NOTE When printing your images, be sure to use photo paper and inks that are manufactured by the same company as your printer. Otherwise, the quality of the print may suffer, especially over time.

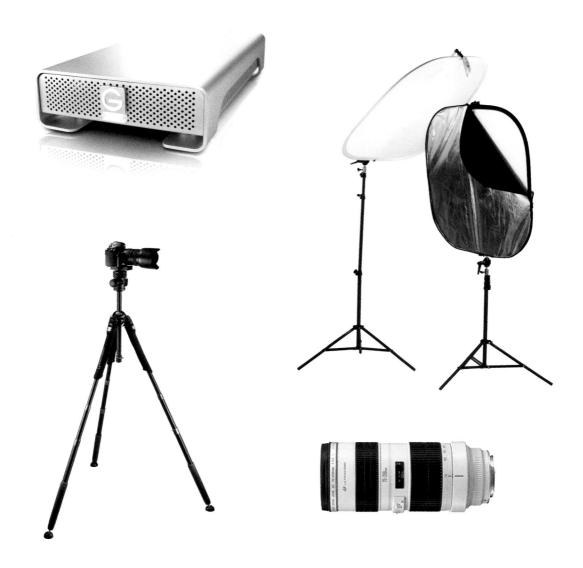

CHAPTER REVIEW

A

Back up your images in at least two locations — for example, on an external hard drive and an online storage site.

B

By understanding the benefits and limitations of the various types of lenses, you have more control over the final result.

C

You can exert more control over the light in your scenes by using reflectors, light blockers, and diffusers.

D

If you aren't concerned with split-second mobility and traveling light, then using a tripod is an excellent way to improve the sharpness of your images when using a slow shutter speed.

3

portrait photography

Portrait photography involves more than simply capturing an image of a person. A successful portrait of an individual reveals something significant and identifiable about that person's character and personality, while a group portrait might be more memorable if people are interacting in the photograph. Babies, children, and couples are also part of the mix. You also need to consider location, lighting, wardrobe, makeup, and props. Sound overwhelming? Don't worry; this chapter covers the basics you need to know in order to get your portrait-taking business off the ground. In this chapter, you discover ways to work with your subject, how to find and create a flattering environment, special gear to consider, and an interview with a successful family and portrait photographer who shares her secrets for success.

© Erin Manning

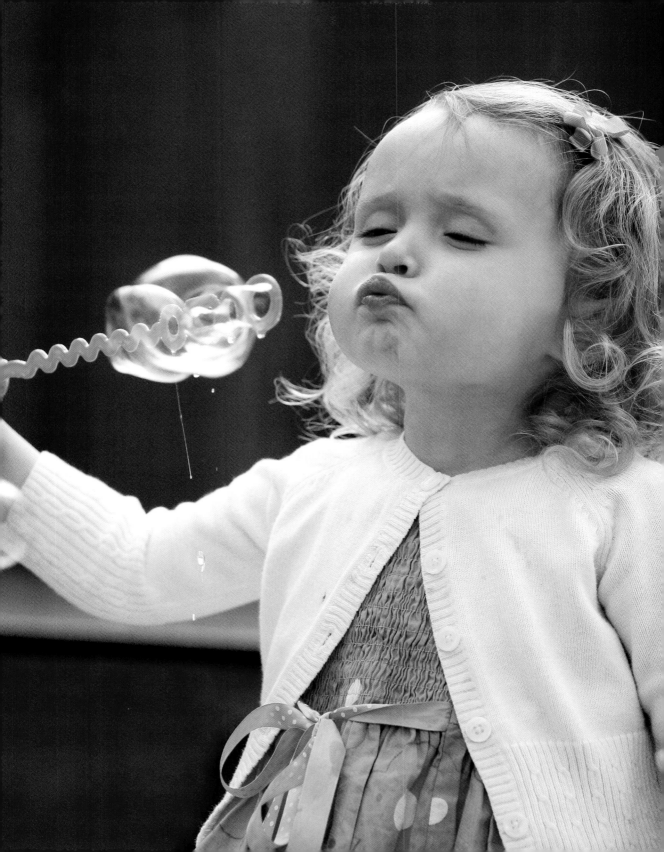

Q&A WITH A WORKING PRO

Brandy Anderson is an international award-winning photographer, claiming the coveted first place in Wedding & Portrait Photographer International's 2009 children's portrait category. In addition to other accolades, including being named WPPI's first-ever "Fresh Face," Anderson became the only photographer to win two first-place prizes in the National Association of Professional Child Photographers' 2010 image competition.

Anderson's work has been featured on the covers of various magazines and on *Redbook* magazine's Web site. Clients include members of the National Hockey League, Little Soles footwear, the Epilepsy Association of Calgary, the Alberta Children's Hospital, Girl Gotch, and a national campaign for the March of Dimes.

She currently owns Fresh Sugar Photography in Calgary, AB, Canada, where she resides with her husband Dave, her daughters Emma and Charlotte, and her dog Ollie.

1. Can you tell me about your background — your personal, professional, and educational history? How about your continuing self-education?

I started out in television, working at Country Music Television in Canada. When I had my first daughter, I discovered scrapbooking, and it led me to try to develop my photographic skills. The more I learned about photography, the greater passion for it I had, and soon I was building my portfolio so that I could start advertising and taking on portrait clients.

I was self-taught for the most part, and digital cameras allow the beginner much more freedom to learn through trial and error. I also joined several online photography forums. One in particular, www.ilovephotography.com, is such a great resource for children's photographers. Another amazing Web site is www.napcp.com, an organization dedicated to the support of the child photographer.

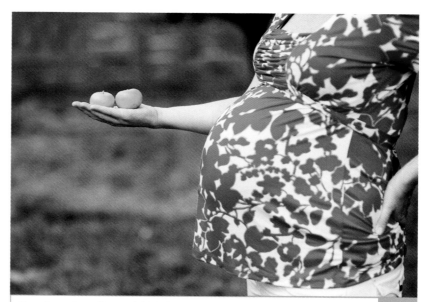

Have fun, get creative, and think about concepts you can incorporate into your images. The woman holding these apples might be implying that she's about to give birth to twins. © Brandy Anderson

3.1

I still constantly try to learn new techniques, and I recently took a workshop where I printed my first image in a darkroom. Until that point, I had only used a lab to print my images. It was terrifying and thrilling to see the print develop on the paper! Another thing I have done to continue my education is I've started delving into the world of photography competitions. You can learn an amazing amount from watching judging and getting feedback on your photographs.

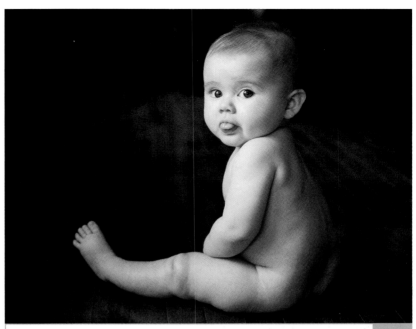

Always be ready to capture a baby's expression, and get down on the baby's level to compose your shot. © Brandy Anderson **3.2**

2. What attracted you to portrait photography?

I have two daughters and they are my most oft-used models. Every time I have a concept I want to try with a client, I test it out on them first, poor kids! I prefer portraits to weddings because as a stay-at-home mom, I need a flexible schedule. I get to spend much more time with my family because my sessions last a couple of hours instead of a whole day.

3. How did you start your business? How did it evolve? Did you have a studio or did you shoot on location?

After portfolio-building for about six months at VERY reduced prices, I felt ready to take on full-paying clients. One thing that I've been very happy that I did was figure out where I wanted my prices to be right away. Then, while portfolio-building, I was able to discount those prices, showing clients the value they were getting, and also not creating sticker shock when it came time to charge my full rates.

4. What was the toughest thing about getting started? What was your worst experience when you began? What did you learn from it that helped you in the future?

The hardest thing about getting my portrait business started was definitely confidence. Being self-taught meant that I had really no proof that I was any good. There's no degree or diploma, and you have to go by your own

judgment and what friends and family tell you. Of course, no one would actually say that you stink, so there's a huge risk that you are just fooling yourself!

My worst experience starting out was being pushed around by a client because I didn't have the confidence to say "no." I ended up doing several sessions for free just because I wanted to please the client, and I was exhausted and overwhelmed. If I hadn't been so new, I wouldn't have agreed to work for free, and the client would have respected me a lot more than she actually did.

Now I have no problem setting boundaries and giving clients very clear guidelines as to what to expect during a session. I always say that I will bend over backward for a client, just not forward! Seriously, though, there will always be people who will try to take advantage of a small-business owner, especially a woman business owner. I've learned to respect myself and my time, which leads to clients respecting me so much more.

5. What tactics and strategies were most useful in developing your photo business? Was there anything that marked a turning point in your business — a contact, a realization, an idea?

The biggest realization for me throughout this process has been that owning a photography business is actually very little about photographing people. Marketing has been the key point of my success in this field — not only marketing my business, but myself. I am my brand, and it's important that my clients get a clear idea of who I am before they decide to hire me. Because my brand is

so fresh, modern, and fun, I get clients who fit that perfectly. People can read my blog or my Twitter feed to get an idea of who I am, and they get the feeling that they know me before they even meet me. Being real and honest in my way of speaking has helped me tremendously.

I spent a lot of money on marketing the first two years of my business. I tried several different methods — blogging, displays in baby stores, baby fairs, magazine ads, client loyalty programs. I wanted to cement my name and brand in the minds of parents in my city so that I was an automatic thought when it came to child portraiture. It turned out to be one of my best moves because it's given me credibility in an oversaturated marketplace.

To have a successful portrait photography business, you need more than just talent. You need to be able to run the business side of things too, or at least hire people who can.

6. Do you have any tips for creating better portrait photographs?

Always, always, always move around your subject. You can get all sorts of interesting angles and views just from moving. Don't be afraid to get down, especially with kids. When you are on a child's level, it can go from a picture of a kid to an emotional portrait that resonates.

■ **A zoom lens is great with kids.** They are quick and you need every advantage you have. A high-quality zoom lens (I use a Nikkor 24–70mm f/2.8) allows you to zoom in quickly when there's an expression just begging to be a close-up.

■ **When taking family shots, ask Mom and Dad to continue to look at you, instead of trying to get their kids to smile.** So often, parents ruin a fantastic shot because they are trying to make sure their kids are looking at the camera. Go figure!

■ **Never use the on-camera flash.** Never. Even the darkest house has a window somewhere, so I always try to find it.

■ **Photoshop is a great tool, but not a save-all.** I actually really like the way my images come out of my camera. I do a little tweaking to the color (saturation) and the brightness (levels) and sometimes touch up any booboos the child may have. But I don't rely on Photoshop to cure under- or over-exposed images, and I rarely clone out backgrounds or do head swaps. I always try to get as much right in-camera as possible.

■ **Pay attention to your backgrounds.** If there are any distracting elements in the frame, move your subject. Use composition to draw the viewer's eye straight to what you want her to see.

■ **Take your time.** A rushed photographer is usually not a very good one. Breathe, keep calm, and use the extra time to make sure you are connecting with your subject. Don't hide behind the camera.

7. Can you name some of your favorite equipment (cameras, lights, computer, software, printer, and any photo-related gadgets)?

I use a Nikon D3. It has amazing, low-light/high-ISO capabilities, which is such a necessity for me when shooting indoors during the long Canadian winter months. My go-to lenses are the 24–70mm f/2.8 and the 85mm

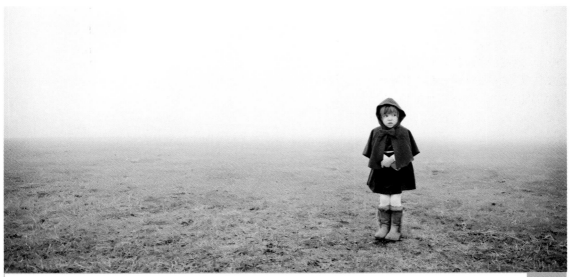

The outfit and the expression help tell a story in this image. © Brandy Anderson 3.3

f/1.4. I use a Crumpler bag for my camera, and I couldn't live without my Shootsac to carry my lenses and cards. I have two Apple iMacs for editing, and a MacBook Pro for business travel. I also use an iPad to show clients my portfolio on the go. My Web site is designed by BigFolio, the best Web site company around for photographers. I edit using a Wacom tablet and Adobe Photoshop CS5. I shoot in RAW and use Adobe Bridge to narrow down my images and do basic edits before bringing them into Photoshop. I use a lab to print my images, but I use a Canon Pixma printer to make customized DVDs for clients who purchase digital files.

8. What feeds your creativity? Where do you find your inspiration — for example, other photographers' work, art, or any particular travel experiences?

I absolutely love Flickr for looking at other photographers' work. I like to look outside of my own genre for inspiration, so I love to look at fashion magazines and clothing catalogs, and to read wedding photography blogs. Even architecture has a big influence on me, as I really love to incorporate a lot of background into my portraits.

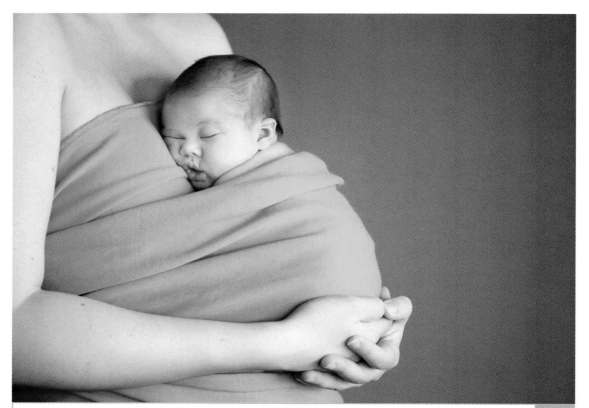

Photographs of a mother and child are timeless. This image uses a lot of negative space for a contemporary feel. © Brandy Anderson

3.4

I've recently been really interested in art history, particularly the Renaissance period. I've been studying posing from old paintings and learning how light can transform something seemingly ordinary into something magical. I'm traveling to Italy soon and am beside myself with excitement to see some amazing works of art in person.

9. How do you market your work (newspaper, referrals, Web site, online marketing, social networking, printed collateral)?

At the beginning, I tried everything — some methods with more success than others. I found that the best way to market myself is through personal connections. Social networking is such an incredible way to create a sense of trust with clients before they even meet me. It's also a great way to connect with other local businesses who may be able to help connect me to clients. My Web site is where most clients go first to get a sense of the type of photography I do, and then they go to my blog and are able to learn more about my personality and who I am. I have run Facebook promotions and done Google ads, but still my greatest success is with being real and open with people. You can go far for very little cost by using the current social-networking tools available. I have over 2,000 Facebook fans on my Fresh Sugar Photography page, and over 1,500 Twitter followers. Social media is a give-and-take, though — you can't just continue to spam followers with your message. I make sure I follow people who follow me and try to comment to them as often as time allows. I tag clients (asking permission first) on Facebook and that lets them share my photography with all their friends, in turn promoting my business for free.

Also, I always give clients extra business cards after their session, so that they can give my card to any friends or family that may need my services. One other thing I do is send a small gift and an awesome holiday card to every client each year. Last year I made donations in each client's name and sent each client a card to let them know. It was a big success. Not only did it make everyone feel great, but it kept me in their minds as well.

10. Are there multiple ways that you make money with your portrait photography? Which area of distribution have you found to be the most profitable?

I sell images of my daughters as stock photography through Getty Images. It's been a nice way of bringing in some extra income; most months see about a $200 check. I don't sell client images because I want to maintain that level of trust with them, and I think selling their images to an outside company would violate that. I use the extra money made from Getty to support a child we sponsor from Guinea.

I do various commercial works now and again, but I don't like to take too many of those kinds of projects on just because they are so big and involve more time and effort. I do like doing the kids' fashions shoots, though, because I love getting free clothes and shoes! I also mentor other photographers when I have free time. I tried to do it for free at first, but because of the time commitment involved, I had to start charging.

My portrait photography business remains my biggest source of income. My average sale per client is around $2,000, which allows me to take limited sessions and be able to spend more time with my family.

ESSENTIAL GEAR

As a portrait photographer, your job is to make people look their best. To achieve that, you need a few key pieces of gear:

- **Lights.** Depending on the hour, natural (ambient) light can be extremely flattering. But dragging people outside for a photo shoot isn't always an ideal scenario. For one thing, there are weather considerations. For another, an outdoor setting might not be what your subject has in mind. In that case, you need some artificial lights on hand, such as strobes or continuous lights, or both. However, avoid using hot lights, also called photo floods, when shooting portraits, especially when photographing babies.

- **Reflectors and diffusers.** When shooting portraits, it's particularly critical to control the light falling on your subject. Reflectors and diffusers enable you to do just that. By manipulating light, you can make it appear more beautiful. Figures 3.5 and 3.6 show the effect of

Notice the hard shadows on my subject's face caused by the direct, late afternoon light. © Erin Manning 3.5

Using a reflector to bounce light back onto the subject's face also fills in the shadows. © Erin Manning **3.6**

using a reflector to fill in shadows on a subject's face, while Figures 3.7 and 3.8 show the effect of using a diffuser to soften the light falling on a subject.

For more information about the gear discussed in this section, refer to Chapter 2.

NOTE

Try mixing artificial lights, such as daylight-balanced fluorescents, with natural light from a window.

TIP

■ **Lenses.** People always look better when you photograph them using a longer lens. Opt for a lens with a focal length of at least 80mm.

■ **Backdrops.** Although a natural environment is often ideal for shooting portraits, backdrops can be a great

Try shooting portraits with a shallow depth of field. That way, the background blurs, enabling you to really isolate and emphasize your subject. Note that in order to achieve this effect, you must position your subject several feet in front of the background. Also, a lens with a longer focal length — 80mm or longer — helps enhance the shallow depth of field (the blurred-out background).

NOTE

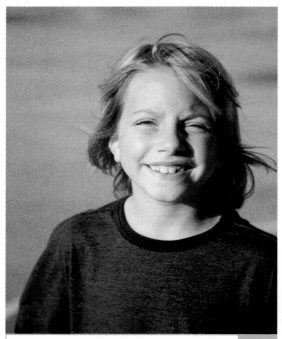

Harsh light from the overhead sun creates shadows on this young boy's face.
© Erin Manning
3.7

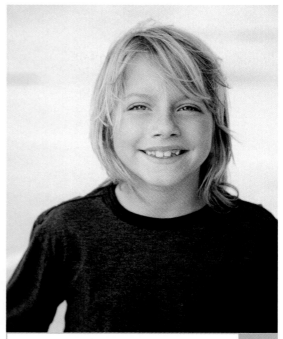

Placing a diffuser between the harsh light and my subject helps to soften and even out the light.
© Erin Manning
3.8

way to achieve a classic look (see Figure 3.9) or to eliminate distractions behind the subject.

TIP If you zoom in close to your subject, a smaller backdrop made of household items like scarves, blankets, or even swatches of fabric can work beautifully.

BEFORE THE SHOOT

Although being resourceful and creative is critical for any photographer, attempting to do so on the fly during the middle of a photo session can be extremely stressful, especially when you are also thinking about the technical requirements and conversing with your subject. For a successful shoot — one during which both you and your subjects remain relaxed — a bit of planning is essential. Planning a photo shoot in advance also helps you head off problems *before* they start.

Here are a few points to keep in mind:

■ **Who is the subject?** In addition to determining whether you will be photographing a single individual or a group, you want to find out about the individuals involved. How old are they? What are their interests or

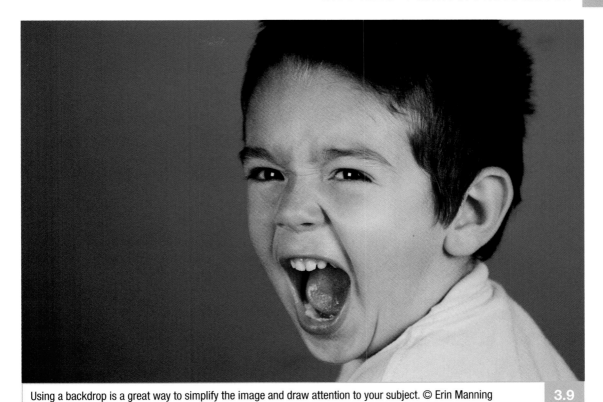

Using a backdrop is a great way to simplify the image and draw attention to your subject. © Erin Manning **3.9**

hobbies? If you are shooting a group, how are the members related? This can help you establish where the shoot should take place, what (if any) props you might require, and so on.

■ **Does your client have a specific idea for her photos, or does she expect you to do the creative legwork?** Some clients will have very specific, set ideas for their images; others will come to you because they saw something you did for someone else and they want you to do something similar for them.

■ **What will the images be used for?** Are they for a business brochure? A dating Web site? A holiday card? A photo album for a relative? Is it a head shot for an actor, real-estate agent, or what have you? This can help you determine whether to shoot a casual portrait or to arrange a more formal sitting, which in turn enables you to plan for location, lighting, and positioning.

What Is a Head Shot?

A head shot is a type of portrait that emphasizes the head and shoulders. Head shots are generally used for marketing purposes in various industries. For example, actors and models need head shots to market themselves in the entertainment field, and other professionals, such as real-estate agents, often incorporate head shots into their promotional materials.

When shooting head shots, especially for actors, it's important that you have a sense of the prevailing style in your client's industry and location. That is, you need to have your finger on the stylistic pulse. To achieve this, a bit of market research may be in order. Check out online casting sites, such as www.lacasting.com, to get an idea of what works and what doesn't. (Note that many of these sites also enable you to post images for advertising purposes.)

TIP

During these planning stages, ask your clients to share visual references with you to help convey what they want to achieve with their own photos. These might be pages from a magazine, printouts of pictures they've found online, images in books, and so on. At the same time, consider showing them some of the work you've done for other clients to inspire their creativity.

In addition to planning, you want to have everything you need on hand to ensure a successful shoot. This includes your camera, lenses, fresh batteries, multiple media cards, and may also include an external flash or continuous lights, reflectors and diffusers, and so on.

One more thing: If you're shooting outdoors, be aware that the weather can wreak havoc on your session. Even a slight wind can create a hair-tastrophe. If you don't have a professional make-up artist or hair stylist handy, the next best thing is to ask your subjects to bring at least one change of shirt or outfit, and request that women bring some of their makeup to the shoot. I also keep a few shades of face powder on hand, along with some hair product, a comb, moisturizer, lip balm, and a mirror. It doesn't have to be a big investment. Drug stores often have travel-size products that are perfect for packing up and bringing to a shoot.

SCOUTING LOCATIONS

It may be that your client simply wants to shoot at your studio or at his home or place of business. But it could be that the client wants the shoot to occur elsewhere. If the client has a location in mind, take time beforehand to scout it out. Look for simple backgrounds and evaluate the available light. (Be sure to visit the location around the same time of day as the shoot.) This scouting expedition enables you to plan for positioning, lighting, props, and wardrobe.

If the client has left it to you to select a location, consider whether the portrait should be environmental in nature — that is, shot such that the location is a key part of the photograph and serves to reflect the subject's life or personality in some way (see Figure 3.10). For example, if your subject is a bank executive, you might photograph her inside the office or on the steps outside the bank. If your subject is a teacher, you might photograph him in the classroom. If your subjects are rock-climbers, you could photograph them outside, near the mountains, and so on.

to add interest and purpose to your portraits. They also help keep your subjects relaxed by giving them something to do with their hands.

If you decide to use a prop in a shoot, make sure it's relevant to the message you want to convey. For example, if your subject likes to knit, give her knitting needles and some beautiful yarn that contrasts nicely with her shirt. Or if he likes to read, place him in a library and have him hold a book. Figure 3.11 shows two sisters proudly displaying their homemade pizza for a pizza party invitation.

WORKING WITH WARDROBE AND MAKEUP

Although different types of portraits may require different types of clothing in general — for example, if you are photographing a doctor at work, then a lab coat might be the best wardrobe choice — your best bet is to keep things simple. Instruct your subject to wear solid colors that complement her hair, skin tone, and eyes (see Figure 3.14), and that do not detract from her face. Avoid busy patterns, logos, and colors that are so bright they overpower your subject. Typically, jewelry and watches should be avoided unless they are understated or have special significance in the context of the photograph.

Makeup is great for enhancing a person's best features, evening out skin tone, and controlling oily shine. If a professional make-up artist is not in the budget (more often than

This real estate agent and builder was photographed inside her home as if she were conducting business. © Erin Manning

3.10

TIP

If the subject of your shoot doesn't have a lot of experience in front of a camera, scout out locations that are quiet and away from any crowds. That way, your subject won't feel self-conscious.

SELECTING PROPS

In portrait imagery, fewer distractions generally result in a more compelling image. That being said, props can be a great way

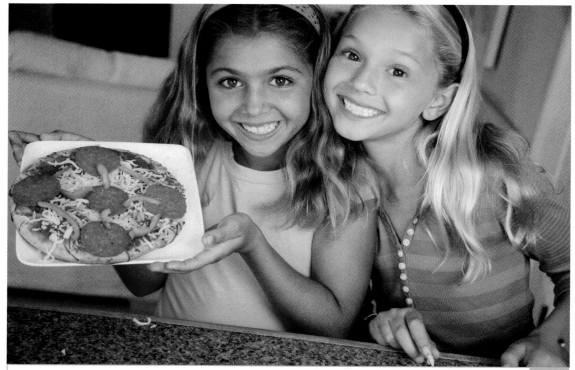

Props can be anything that helps tell a story, or reveals something about your subject. This image was used for a pizza party invitation. © Erin Manning

3.11

not, it won't be), ask your client to keep the make-up tones neutral, with a soft and pretty finish (see Figure 3.13). Note that even men could do with a little bit of makeup; in fact, I find that powder is a necessity for everyone.

TIP

Keep a few neutral tones of loose powder and a brush in your camera bag. It comes in extremely handy when someone needs a touchup!

Expect the Unexpected

Imagine you have planned every aspect of a photo session. You have the perfect location, the light is just right, and everyone you need is in position, happy, and ready to go — and something goes wrong. Maybe your camera is malfunctioning, maybe the media card is damaged, maybe you drop the lens, maybe the battery dies, and the list goes on.

The success of any photo session depends on how you handle these unexpected situations. Professional photographers always have a backup plan. They bring an extra camera, extra batteries, extra media cards, extra lenses, and additional lights, and they have them ready and available. On every shoot, you should hope for the best but plan for the absolute worst!

This jeans jacket helped create a casual feel to the photograph while it also complemented her hair, skin tone, and eyes. © Erin Manning

3.12

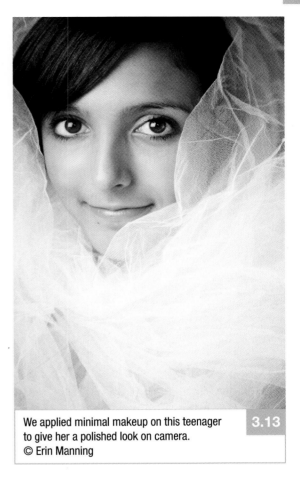

We applied minimal makeup on this teenager to give her a polished look on camera. © Erin Manning

3.13

AT THE SHOOT

You've talked with your client to determine what kind of image he or she wants; you've scouted the location; you've assembled your gear and any props you need. You are, in a word, ready. This section helps you master the ins and outs of conducting your portrait photo session.

TIP

Ask your subjects to bring a few different tops to the shoot, in colors they feel best in.

CONNECT WITH YOUR SUBJECT

When you capture a person's true character and essence in an image, the result is a great portrait. Unfortunately, however, most people aren't comfortable revealing their true

character and essence to a total stranger, meaning you. That's why finding a way to connect with your subject is as important to the success of your photo session as the lighting, your gear, or anything else.

Begin by conversing. Find some common ground. Talk with your subjects about their concerns regarding the portrait session process and outcome, and try to allay any fears they may have. While you're at it, set the proper expectations. Let them know that you need to take quite a few pictures, and that it might take some time. It doesn't have to be elaborate, just an acknowledgment of how intimidating and uncomfortable it can feel to be photographed and a caring response to any questions. Above all, foster an atmosphere of mutual respect. It may take a little longer to get started, but the initial time you invest always pays off in the final results.

As the shoot progresses, continue to converse with your subject. Keep her talking and laughing. This makes it easy to capture candid shots (which you learn more about in a moment). Also, get your subject involved in the photographic process by enabling him to review a few of the shots you captured on your camera's LCD viewfinder. Often, allowing people to see the results of the shoot relaxes them. This is especially true when working with children; showing them what's happening behind the lens helps them feel more important and invested in your photo project. Keep in mind that it's not a good idea to show all the images to your client on the LCD viewfinder. It's difficult to see if an image is out of focus when looking

at the small LCD screen, and you don't want to show them something that may be unusable later. Just give them a preview of a few images when you're starting out to help loosen them up.

CHOOSE THE BEST LIGHT

It's important that you make your subjects look their best. A big part of that is seeking out the best light. Maybe that means shooting indoors with constant lights or strobe lights. Alternatively, it could mean running your session outdoors with natural light. Or you could use a combination thereof.

Natural light

I often shoot portraits using natural light. I find it enhances the contours and shading that reveal a person's facial expressions and nuances. But because the direction and quality of natural light can vary significantly during the course of the day, it's important to know how to plan for, find, and create beautiful light.

NOTE — You can always supplement the existing light with artificial light as needed — using a flash, strobe, or continuous light.

Here are a few points to keep in mind:

■ **Avoid direct overhead light.** In addition to creating deep shadows under the eyes, it causes your subject to squint — not a very attractive look.

■ **Shoot when the sun is lower in the sky.** The light it produces is softer and more flattering (see Figure 3.14) during early morning and late afternoon. These are the optimum times for beautiful natural light. During these hours, you can position your subject anywhere, even facing the sun.

■ **Use reflectors and diffusers to manipulate the existing light as needed.** You can reflect light into the dark areas and diffuse any harsh light falling on your subject.

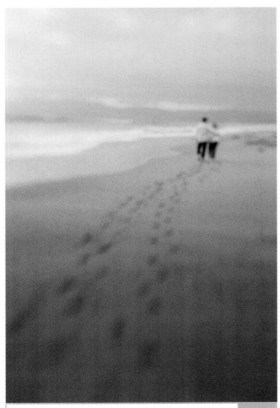

A late afternoon portrait session at the beach makes it easy to capture a beautiful image.
© Erin Manning

3.14

Backlighting Your Subject

I like to create a hair light by backlighting my subject in the late afternoon light. To light my subject's face, which is in the shade because his back is to the sun, I use a reflector. In addition to filling in the shadows, this creates a catch-light in the subject's eyes. A *catch-light* is a reflection of light in the iris that looks like a twinkle. Note that when working with backlighting, you must make sure your camera is gauging the exposure from the subject and not the light source. Set your camera to spot or center-weighted metering for the best results.

■ **If your session must occur when the sun is high in the sky, look for areas in open shade.** Open shade is soft, even, and indirect light where you can position your subjects with their backs to the sun. Tree-filled parks, a covered porch, or a lawn shaded by a large building are all good options because they provide even lighting while eliminating harsh shadows and bright highlights. The diffuse light that results from an overcast day can also work well for portraits.

TIP

If necessary, you can use a flash to fill in any shadows that result from overhead light, although you should do so sparingly. Using a flash flattens out your subject's features and may overpower the subtle nuances of her expression.

■ **Use natural light when indoors.** Soft, even, natural light can also occur indoors (see Figure 3.15). Try positioning your subject by a north-facing window, in an open doorway, or under a skylight.

I positioned this model in an open doorway, looking out into her backyard. The soft light of the open shade evenly illuminated her face.
© Erin Manning

3.15

Artificial light

As you learned in Chapter 2, artificial light can come from either flashes and strobes or a continuous light source.

Shooting images indoors with artificial lights can seem a little intimidating, but it's really safe and easy to do with the right lights. There are many different lighting kits on the market with varying degrees of quality and brightness, and they sell for anywhere from a few hundred to thousands of dollars.

Studio lighting basics

When you're taking pictures of people, think about how you want the image to look: bright and happy, dark and mysterious, or somewhere in between. You can control the look by controlling the amount of contrast in your image. You create contrast with highlights and shadow. The relationship between the highlight and shadow in your scene is called a *lighting ratio*. This lighting ratio is measured in numbers — 1:1, 2:1, and 4:1 are just a few examples.

It's easiest to begin with one or two lights — a main light and possibly a fill light — depending on how moody or bright you want the image to look. The main light is the strongest and has the most influence on your scene. You should place the main light close to the subject and off to a 45-degree angle, slightly above the subject's eye line. You should place the fill light at an angle on the opposite side of the subject and use it to fill in the shadows.

A lot of professional photographers prefer to use a light meter to calculate and adjust the proper ratio of light falling on their subject, but you can also do without a light meter. Simply change the distance of the fill light to the subject and observe how the contrast changes.

To emphasize the difference between the various lighting ratios, I'm going to use these close-up pictures I took of my Mom (see Figure 3.16). I used two lights in this scene — the main light or keylight and the fill light. The main light is the strongest and has the most influence on your scene. It's placed close to the subject and off to an

1:1 2:1 4:1

These three images of my Mom reveal how you can achieve different amounts of contrast in your scene just by adjusting your fill light. © Erin Manning.

3.16

angle, slightly above their eye line. The fill light is placed at an angle on the opposite side of the subject and used to fill in the shadows. The fill light is the only light I moved.

- **A 1:1 lighting ratio is created by placing the main light and fill light at an angle to your subject and equal distance away.** In this case each light is approximately 2 feet away from my Mom. Since these lights are cool to the touch, you can place them pretty close. The effect is bright and somewhat flat, but this high-key look does tend to even out skin tone and diminish imperfections.

- **A 2:1 lighting ratio is created by leaving the main light where it is and backing the fill light away approximately another 6 inches.** Observe the brighter side of the face; it should appear twice as bright as the shadow side of the face. Now you can begin to see how light and dark can create dimension and form in your image.

- **A 4:1 lighting ratio has more contrast and looks more dramatic because I've backed the fill light away even farther — now it's about 3.5–4 feet away from my Mom.** You should see approximately four times more light in the highlight areas, than in the shadow areas.

Here's a good starting point with your camera settings: Set the mode dial to Manual, the ISO at 400, the aperture at f/5.6, and your shutter speed at 1/100 sec. Take a few shots; if things look too dark, you can adjust

61

your shutter speed and aperture to allow for more light. Just remember that if you use a shutter speed less than 1/60, you need a tripod so that your images aren't blurry.

TIP

If you'd like to learn more about portrait photography, I suggest reading *Portrait and Candid Photography*, by yours truly. And if you'd like to learn more about studio lighting, I recommend that you read *Lighting Photo Workshop* by Chris Bucher. Both books are published by Wiley Publishing.

TIP

It goes without saying that your posing suggestions should not make anyone feel inappropriate or uncomfortable!

POSITION YOUR SUBJECT

When conducting a portrait session, I try to include a variety of poses. Whether formal or informal, posing is an art, especially when the intent is to create a natural-looking portrait. Although some people seem to instinctively know how to pose in front of a camera, most don't, and so they need you to guide them. Here are some suggestions for standard poses:

- If your subject wants to sit, place her on a stool that is hidden from view in the frame or in a chair that complements the scene. And of course, remind her not to slump.

- If the subject of your portrait is standing, ask him to put his weight on his back foot and to stand at a three-quarter angle to the camera. If there is a wall in the scene, try different leaning poses.

- Avoid letting your subject's arms hang flat against the sides of her body. Instead, ask her to bend her arms slightly, cross them, put one hand on her hip or in her pocket, or try other poses that involve different arm positions until you find one that works best, as in Figure 3.17.

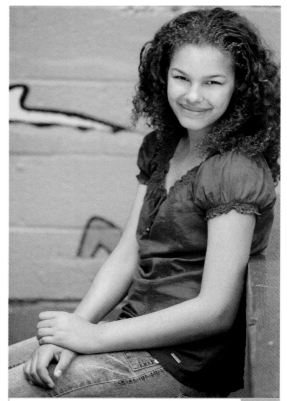

Many people show tension in a photograph in their arms and hands. I had this model shake out her arms and let them fall naturally by her side. © Erin Manning

3.17

- Try slanting your standing subject's shoulders at an angle toward the camera.

- Instruct your subject to bend slightly at the waist and lean in toward the camera. This can result in a more engaging photograph.

TIP Avoid poses in which your subject leans away from the camera with his chin tilted up high. These types of poses appear snooty.

■ Some people have a nervous habit of looking down their noses when having their portrait taken. This not only makes them appear rather snooty, but it also reduces their eyes to tiny slits. As you might imagine, this is not very attractive. Ask your subject to tilt her chin down slightly to open her eyes, but not so much that she develops an extra chin (see Figure 3.18).

In addition to helping your subject strike just the right pose, as a photographer, there are many strategies you can use to ensure your subject looks her best. For example, if your subject is overweight, you can shoot her from the side to de-emphasize her size. If she is underweight, you can photograph her from the front to add a bit of visual bulk. If your subject is very tall, you can make her appear smaller by shooting from a high angle. If she is very small, you can shoot her from below to make her appear taller.

TIP Although most portraits are taken a few degrees above the subject's eye line, make it a point to experiment with different chin positions while adjusting your camera angle to find the most pleasing perspective. Be aware, too, that the opposite sides of a person's face photograph differently. Change angles and find the side that works best.

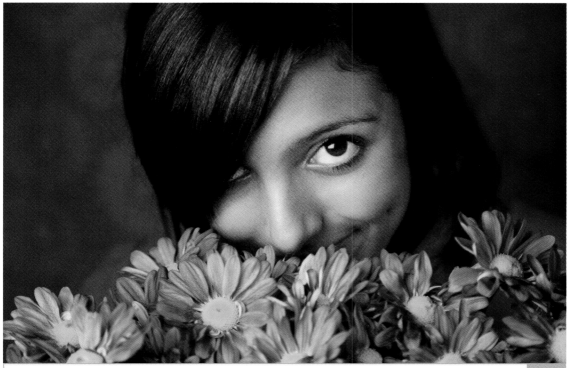

Tilting the chin down helps to fully open the subject's eyes. © Erin Manning | 3.18

Finally, if your subject has prominent ears, ask her to turn her face three-quarters of the way toward the camera; this serves to hide one ear behind the head.

TIP As you position your subject, consider the background. You don't want to wind up with a photograph in which a plant appears to be growing out of your subject's ear or a lamppost seems to be emerging from the top of her head!

During the portrait session, be sure to give positive feedback. If the subject's position is unflattering or just isn't working, don't say, "No, I don't like that," or worse, "That's awful." This only deflates your subject's confidence and weakens your connection with her. Instead, say, "That looks pretty good, but let's try another position."

NOTE Be sure to communicate clearly and loud enough so your subject can hear you. It's difficult for people to hear what you're saying when you're behind the camera or photographing them from a distance.

CAPTURE CANDID MOMENTS

Not every portrait is posed. In fact, some of the best portraits are candid images — photographs captured during a moment when the subject was not aware of the camera (see Figure 3.19). They could depict an emotion shared between people after a formal pose is struck or the natural reaction

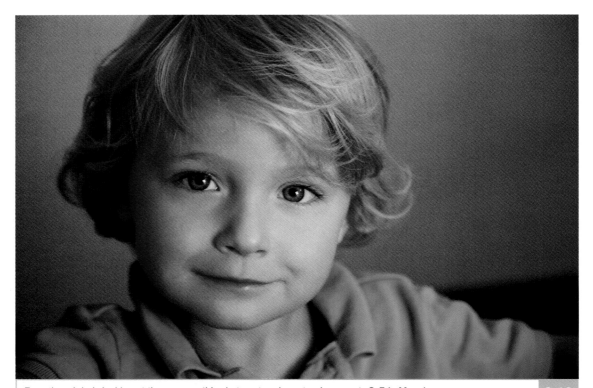

Even though he's looking at the camera, this shot captured a natural moment. © Erin Manning 3.19

to something funny that has occurred during the shoot. Candid portraits capture a subject's authentic human essence, which is so sought after, yet so difficult to catch. The moments depicted in candid portraits simply happen; you must be fully present in the moment, keenly aware of what is happening around you, capable of anticipating when something special might occur, and technically prepared to capture it.

GENERAL TIPS

Here are a few more tips to keep in mind as you shoot your subject:

- **Eliminate autofocus lag.** Thanks to the digital camera's autofocus system, you can concentrate on composing an image rather than manually setting the focus. Unfortunately, it's difficult for the autofocus to work correctly in low-light situations or in low-contrast scenes, such as white walls or blue skies. The result may be autofocus lag. Here's what happens: You're pressing the shutter button, your lens is battling to lock in the focus, and the shot is delayed, or "held back" by your camera. The solution is to find some contrast in your scene and focus there, or set your lens to manual focus.

- **Get close.** A photo where the subject fills the frame has a greater visual impact (see Figure 3.20). Images composed in this way emphasize the subject by eliminating any distracting

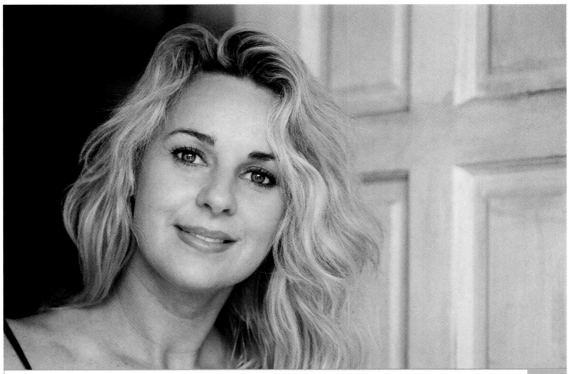

Fill the frame with your subject for greater impact; just don't get too close with a wide-angle lens. © Erin Manning. **3.20**

background clutter that might be present. Unless you intend to create a wide-angle, big-nose effect, use a longer lens to zoom in.

■ **Experiment with different angles.** Photograph your subject from different distances and perspectives — from above, from below, from the side, and so on. Don't forget to turn your camera from horizontal to vertical to capture the space above and below your subject.

TIP

Whenever you want to fill the frame with your subject, remember the phrase "room to zoom." Stand back and give yourself room to zoom into the subject and fill the frame. A longer focal length compresses space, and results in a more flattering perspective.

■ **Focus on the eyes.** When viewing a portrait, the first place people look at is the eyes. Even if every other part of the image is out of focus, the eyes must be sharp. To ensure that they are, use the autofocus lock on your camera. Press the shutter button halfway down to lock in the focus on the eyes, continue holding the button until you achieve the composition you want, and then press the button down the rest of the way.

■ **Not all portraits have to depict faces.** Consider how other physical details might convey something about your subject. If your subject is very old or very young, photographing his

hands might strike just the right note. If your subject is a dancer, a photograph of her feet might convey more about her than one of her face.

■ **Shoot in continuous mode.** Shooting in continuous mode enables you to capture a sequence of shots in quick succession. This is especially handy if your subject is emoting or reacting to someone around him (see Figure 3.21). With continuous mode, you capture the "moments between the moments," which are often the ones you absolutely want to record. The number of pictures you can take in this mode is limited only by the capacity of your camera's media card. To shoot in continuous mode, simply press the shutter button and hold it down.

Photographing Pets

Photographing pets can be incredibly challenging; it's often next to impossible to get the animal to sit still. Although arming yourself with treats and toys can improve your chances, the best approach is to simply let the animal do its thing during the session rather than trying too hard to control the action. If you can, conduct the shoot outside; that way, you need not resort to using a strobe, which can really alarm animals and may also result in an unnatural reflection in the animal's eyes, which is not flattering. If shooting outdoors is not an option — for example, if the subject is an indoor cat — then try to conduct the shoot near a north-facing window or under a skylight or set up an artificial, continuous light source.

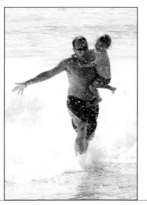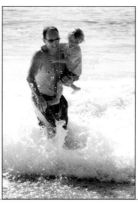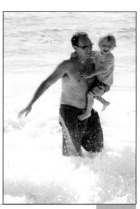

It's easier to capture the full effect of an event when the action is shot in quick succession using the continuous mode setting. © Erin Manning

3.21

PHOTOGRAPHING BABIES, KIDS, AND TEENS

Kids grow up so fast! Recording their fleeting childhoods with digital photography enables you to capture priceless memories for the future (see Figure 3.22). Rather than having babies, kids, and teens pose before the camera, which will be excruciatingly boring (if not impossible) for them, try to capture authentic moments. Encourage play, action, and activity with friends, family, pets, or toys, and then try to capture their spontaneous behavior. When you take this approach, you'll discover that photographing babies, kids, and teens is a lot of fun because they display myriad expressions, convey a lot of different emotions, and inevitably possess incredible energy.

At the same time, you should be aware that babies, kids, and teens generally have short attention spans, and can quickly become cranky and uncooperative. Especially if you are photographing a small child, be prepared with your setup and equipment *before* bringing the

Baby Love

When photographing babies, there are a few key points to keep in mind:

- It's crucial that you plan your shoot around their schedule. You don't want to try to conduct your portrait session right when Junior usually goes down for his nap. Ask the baby's parents what time of day works best.

- Don't forget to capture close-ups of baby's tiny fingers and toes!

- What's cuter than a naked baby? Nothing, that's what. For babies, the simplest and best outfit is often nothing at all.

- When photographing babies, make sure they are completely clean beforehand. Although you can certainly clean up dirty fingernails, nose crusties, eye goop, stray blanket fuzz, and forgotten food in post-production using image-editing software, you'll find this process to be incredibly tedious and time-consuming.

TIP

Kneel or sit down and position your camera at a child's eye level when photographing her. You capture more of her personality and less of the top of her head.

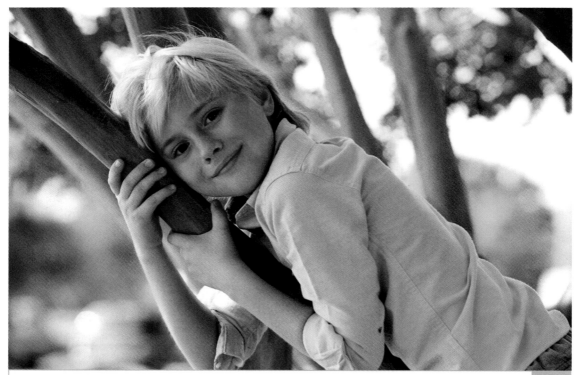

This authentic moment was captured just by encouraging Dylan to play around on the tree. His smile wasn't coaxed; he was genuinely happy to be there. © Erin Manning **3.22**

child into the picture-taking area. That way, you don't waste precious face time setting up your gear before the inevitable meltdown. And if a baby is your subject, remember that keeping her comfortable is the key to ensuring your shoot goes well. The temperature in the shooting area should be just right for baby, which will feel a little on the warm side to everyone else. Music can also add to the ambience.

Children react differently to the camera depending on their ages, so an awareness of children's general developmental stages goes a long way in ensuring you have a successful portrait session. To put it simply, the techniques you use to elicit a smile from a nine-month-old are different from those used with a nine-year-old!

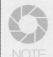

NOTE

Be warned: Most groups' patience is fleeting at best. Keep everyone happy, together, and interested by clearly communicating how long you need the group to remain intact before the shoot and by taking control of the session in a firm, friendly manner.

When photographing multiple children at once, such as a family portrait with siblings, try to capitalize on the natural dynamic that occurs between them (see Figure 3.23). Be on the lookout for the special moments that occur when siblings interact, whether that interaction is positive or negative.

These three sisters were having a fun time playing together at the beach. It was easy to capture the natural dynamic happening between them. © Erin Manning **3.23**

PHOTOGRAPHING GROUPS

When there is more than one person in front of the camera, a different dynamic occurs. Suddenly, instead of having to capture the essence of a single person, your role expands to recording how each person relates to the others. All this is to say that when you photograph a group, whether it's composed of kin at a family reunion, classmates at a

graduation, or the bridal party at a wedding, you must consider all the points that relate to photographing individuals and then some.

Various factors help you determine how to arrange the group. The most obvious, however, is the number of people in the group. Is the group composed of 50 members of the same high-school class; a dozen bridesmaids; or, a mom, a dad, and two kids? If it is a large group, your posing choices are somewhat limited to lining people up in rows, staggering your subjects on steps, or something similar (see Figure 3.24).

Smaller groups offer more flexibility in terms of placement. For example, rather than positioning the members of a small

Maternity Photos

Recently, more and more women have sought to document the period of time before they have a baby by having their portrait done. These sittings often involve nudity or semi-nudity, so it's crucial that you conduct them in a private, safe, and calm environment. When you conduct a shoot of this kind, whether it occurs in your studio or in your client's home, seek out soft, natural indoor light, such as next to a window or under a skylight.

group as though they are in a police lineup, you might ask some of them to sit in chairs and have others stand. Or you could cluster them together, with the taller members in back and the shorter ones in front. The idea is to create some variation in the subjects' eye levels in order to keep the viewer

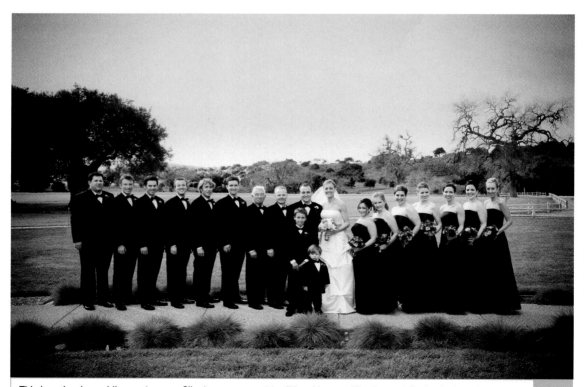

This is a classic wedding party pose. Clients may request traditional images like these at the beginning of the shoot, and then allow you to get creative with posing once the basic shots are captured. © Robert Holley

3.24

engaged. For example, you might attempt to position your subjects so that the placement of their faces create a triangle.

The same goes for photographing couples: Try to mix up the eye lines. It's also a great idea to get them to interact. Have them hug, run down the beach, dance, or twirl each other around (see Figure 3.25). That way, you can convey the relationship they share.

Here are a few other points to keep in mind when photographing groups:

- Make sure that everyone in the group enjoys the same even, diffuse lighting. Avoid positioning the group such that some are in sun and others are in shade.

TIP

When you position subjects at different distances from the camera, they are on different focusing planes. To ensure that they remain in focus, use an aperture setting that provides a deep depth of field, such as f/8, f/11, or f/16.

- To keep group members relaxed, let them talk and interact until you are ready to take the shot.

- Take as many shots as possible. That way, you increase the chances that in at least *one* of them, no one is blinking, talking, or glancing away from the camera.

- Use the time between shots to praise the group, bring them closer together, or adjust their positions.

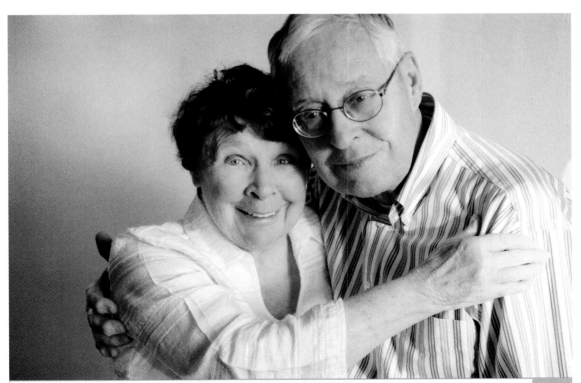

This couple has been married for many happy years. I was able to coax them into interacting just by asking them questions about when they were married, and how many children they have together. © Erin Manning

3.25

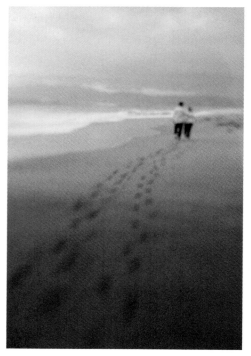

CHAPTER REVIEW

A People always look better when photographed using a longer lens. Opt for a lens with a focal length of at least 80mm.

B Environmental portraits should reflect the subject's life or personality in some way.

C Try to schedule portrait sessions during the early morning or late afternoon to capitalize on the beautiful natural light.

D Whether formal or informal, try to include a variety of poses in your photo session.

sports photography

A youth sports photographer shoots individual and group photos for everything from sports and gymnastic teams to ballet and martial arts organizations. Then the images are sold to parents, coaches, schools, and more to commemorate the game and capture the child's experience. This may sound like an easy way to make some extra money, but it does have its challenges. For example, lightning-fast action, limited access, less-than-ideal lighting conditions, and harsh weather can conspire to frustrate even the most experienced photographer. Not only must you be fiercely observant and know the game in order to anticipate the action, but you should have the proper equipment to capture the moment with technical proficiency, and know the optimum places to position yourself for the best shots. This chapter includes tips for overcoming some of these difficulties, suggestions for taking great photographs, and the inside information required to market and sell compelling youth sports images.

© Erin Manning

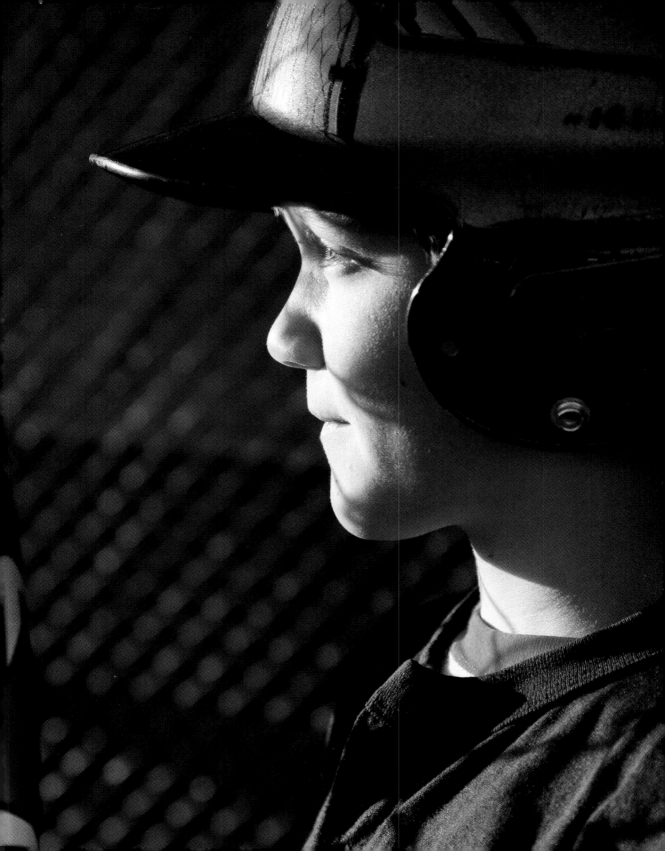

Whether you're related to the child playing the game or simply a sports enthusiast, you've probably found yourself in a situation where you've taken photos at a youth sports game, have been asked to take photos, or you have photos you've taken that other people want. If you've been giving your photos away, you may now see an opportunity to reap the financial benefits of your labor. After all, you're contributing toward documenting a special memory, your images have value, and people are willing to pay you for it.

Keep in mind one caveat. The advancement of digital photography has allowed many more relatives and friends to capture images on the sidelines of sporting events and give those images away for free. As a result, profits have diminished for the professional youth sports photographers.

If you want to be financially successful, you need to stand out from the pack. Some of the ways current professional youth sports photographers compete is by improving their technical proficiency, making sure they have the necessary equipment, offering prints on the spot, employing large numbers of photographers to cover tournaments, and generally remaining open to new opportunities in the market. Be creative and imagine new ways to do things. You have to create and adapt to be successful in this field.

I have taken quite a few images of my friends' kids during their sporting events and although my personal experience is limited, I quickly became aware of the challenges and limitations regarding gaining access to capture the shot, the politics of children's sports, and marketing and monetizing the images.

For this reason, in addition to hearing from a full-time professional photographer at the end of this chapter, I thought it might be helpful for people considering sports photography on a part-time basis to hear Reid Sprenkel's story.

LESSONS FROM A PART-TIME SPORTS PHOTOGRAPHER

With degrees in biology, environmental studies, and entomology, Sprenkel enjoyed a career with a Fortune 500 company that spanned more than 26 years. As he climbed the corporate ladder, Sprenkel's growing family and passion for photography also led him to become one of the best parent photographers on the sports field. At first, he took pictures of his own children along with photos of their teammates and friends. As the years passed and the kids grew older and more proficient in specific sports, Sprenkel shot images in support of the team and players, often taking large group shots and action photos (see Figure 4.1) that generated a lot of interest in reprints. As this effort grew and became more time consuming, he felt justified in charging more for reprints and enlargements than just print-cost reimbursement.

When film cameras were still the norm, Sprenkel developed his photographic reputation because he was able to capture shots that a typical parent could not. Today, even though other parents can now afford a range of digital cameras and technologies that allow them to more easily take good-quality pictures, Sprenkel's technique, observant eye,

and ability to get close access to the game and players have produced the kind of images that most people can't capture, but are willing to pay for. He also believes that many parents want to enjoy the game in full play as opposed to viewing it through a camera's viewfinder.

Early on, Sprenkel experimented and struggled to find the best way to show his images to parents and teams for them to select reprints. His methods ranged from CD slide shows that took too long to create, deliver, and view, to contact sheets that ended up being too much work and impractical. He eventually placed his images on a Web site specifically formatted for photographers, www.ifp3.com, and has found that medium to be the most effective.

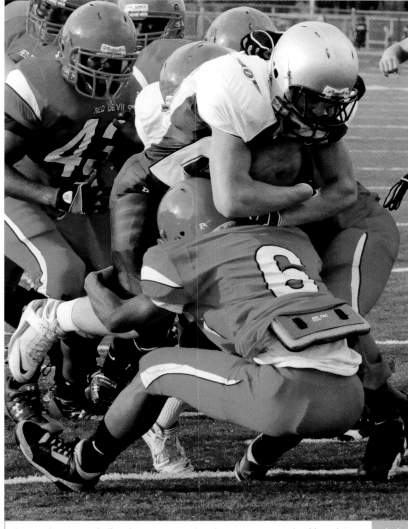

Action photos are challenging to capture, but they can generate healthy print sales. © Reid Sprenkel

4.1

He promotes his photo services through personal relationships and referrals, the local newspaper, local high-school sports magazines, and his Web site. The following list offers suggestions from Sprenkel for promoting a sports-photography business and creating income from sports photos:

■ **Take photos of more than just your own kids.** Take the time to sort through, edit, and share good action shots of other players with the coach, team, and parents as seen in Figure 4.3.

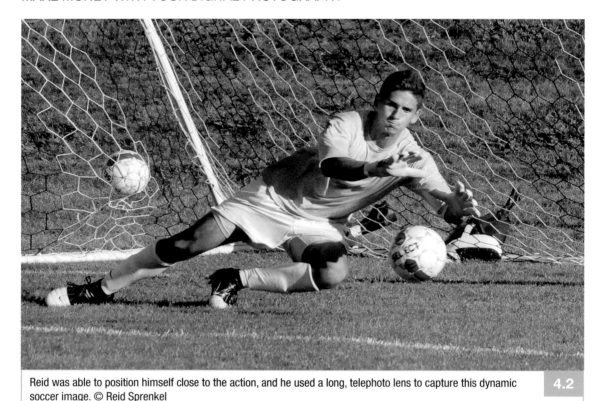

Reid was able to position himself close to the action, and he used a long, telephoto lens to capture this dynamic soccer image. © Reid Sprenkel 4.2

- **Contact the "team mom" to generate awareness and interest.** This can also lead to opportunities for using your photos and services for special events such as Senior Night, sports programs, and end-of-season slide shows.

- **Contact your local high-school athletic director and offer your services.** This can help get admission to games and access to the field or court.

- **Offer to submit images from games to your local newspaper and regional high-school magazines.** This is good for a few reasons:

 - **Personal promotion.** Be sure to ask for a photo credit on your image. Promotion can lead to

assignments, which ultimately leads to payment!

 - **A potential media access pass for games.** This enables you to get closer to the action. It also prevents you from having to battle for space with other parents or amateur photographers at the game.

His business card features a sports photo along with all his contact information, including his Web site address. He creates an occasional "leave behind" postcard or flyer for big events, such as sports banquet dinners. He places business card ads in the high-school sports programs and athletic director newsletters. He also takes advantage of T-shirt marketing, by wearing a T-shirt that features

his Web site address for all to see while he works sporting events.

Sprenkel uses a Nikon D70 and D300 with a Nikon SB-800 Speedlight Flash. His lenses of choice are the Sigma 70–200mm f/2.8 zoom lens and the Nikkor 28–70mm zoom lens. He uses a Sigma 2x teleconverter to extend his focal length when he needs to capture that across-the-field shot. Some indoor events don't allow you to use flash, such as volleyball games and swim meets, so he uses a lens with a wide aperture, raises his ISO, and adjusts his white balance to fit the lighting in the scene.

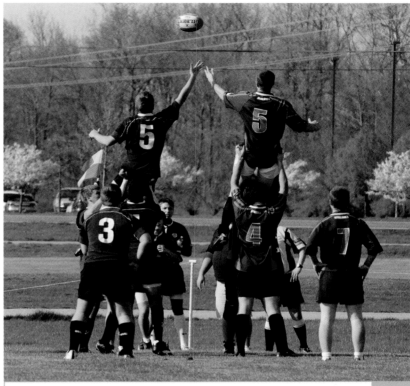

Including many people in your images can result in additional interest and print sales later. © Reid Sprenkel

4.3

He also uses an Apple MacBook Pro laptop and archives his images by filename in folders by year, by sport, and by event. He uses iPhoto for quick image enhancement and uploading to his Web site, and uses Photoshop Elements for more intense photo editing.

Here are some general tips about photographing sporting events from Sprenkel:

■ **Know the rules and strategies of the game.** This enables you to position yourself for the best shots based on the anticipated action. This often means moving from one end of the field or court to the other, or anywhere in between without getting in the way of players, spectators, or officials. Outdoors, positioning may be dictated by the sun, by the direction of play, or both.

■ **If you're not sure where you're allowed to position yourself for photos, ask the referee, umpire, or other officials prior to the game.** Once you are positioned somewhere, be prepared to be asked to move, to be hit with a ball, or to be run over by a player! Sometimes, you may have to position yourself for the shot and ask for forgiveness later.

Although Sprenkel's photography has always been a passion, it's been a sideline business, taking a back seat to his full-time job. He's unclear as to which career will eventually prevail. At this point, he enjoys taking pictures and intends to generate more income doing what he likes to do.

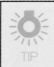

TIP

Some professional sports photographers carry multiple cameras with different lenses, each one configured with the appropriate settings and ready to go. That way, if a quick change in the action or lighting occurs, rather than swapping out lenses on a single camera and making the necessary adjustments to the settings, the photographer can simply switch cameras.

ESSENTIAL GEAR

Sports photographers must record fast action, sometimes in unpredictable light, often from a distance, and regularly out of doors, where weather can be a factor. Not surprisingly, Sprenkel recommends some special gear:

- **Camera.** Perhaps more than any other photographic discipline, sports photography requires a higher-end dSLR camera. Specifically, look for a camera that can capture at least four frames per second, has a buffer capable of holding at least 15 images and supports tracking autofocus. Most dSLR cameras sold today support an ISO of 1000 and beyond and 1/4000 shutter speed or faster, which is plenty sensitive and fast enough for sports photography purposes. If it's in the budget, and if you know you'll be shooting in snow, near the water, or at outdoor events in which weather may be a factor, opt for a water-resistant camera, or even underwater housing for your camera body.

- **Lenses.** Depending on where you are relative to the action and what type of shot you want to compose, you will need different types of lenses.

For example, if you're photographing a baseball game and you want to capture the entire field, you'll need a wide-angle lens (see Figure 4.4). To focus on a single player, or to isolate your aubject from the background, you should opt for a telephoto lens (see Figure 4.5). Alternatively, use a fish-eye lens or a selective-focus lens for very dramatic images that exaggerate the scope of the environment or create other interesting effects (see Figure 4.6). With cost being a major factor, many people opt for a *variable aperture* lens such as the 70–300mm f/4–5.6 rather than the 70–200mm f/2.8 for field sports. When starting out it's a good idea to be prudent with both your budget and your photographic expectations. More specific information about lenses is covered in Chapter 2.

Image Stabilization

Image Stabilized lenses (also known as Vibration Reduction) can help you reduce or eliminate out-of-focus shots caused by using a long telephoto lens, shooting from a distance, and/or employing a lower shutter speed due to low light. Motorized sensors inside the lens detect small vibrations and shift the internal lens element in the opposite direction so it cancels out the motion, resulting in sharper images.

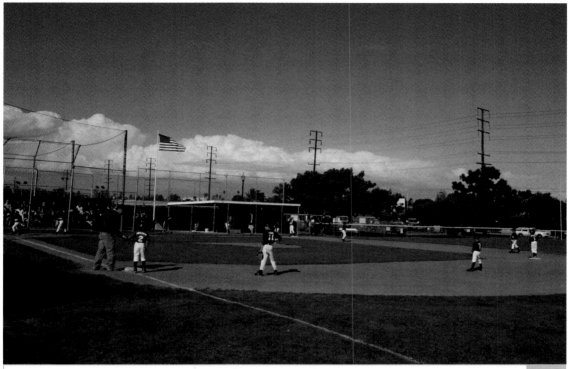

Use a wide-angle lens to photograph the entire field. © Erin Manning 4.4

A telephoto lens helps create a shallow depth of field and isolates your subject 4.5
from the background. © Erin Manning

■ **Filters.** If you are shooting an outdoor sporting event in bright sunlight, attaching a graduated ND filter onto your lens can help to balance overexposed areas of sky. You can use UV filters to cut through haze, which is sometimes a factor in outdoor competitions that take place in large

urban areas. Many photographers also use UV filters to protect their lenses from potential scratches and marks.

- **Monopod.** Especially if you are working with large, heavy lenses, a monopod can help you steady your shot, not to mention alleviate arm fatigue!

- **Protective gear.** When shooting outdoor events, your camera is vulnerable to the elements. Using protective gear, such as covers for your camera and lenses, on a shoot can shield your equipment from such hazards as rain, snow, spray, and so on. Waterproof camera housings are also available.

Big Glass, Fast Glass

Unlike most amateur and semi-pro sports photographers, who typically use zoom lenses because of their relative versatility, some pro photographers — especially those who specialize in field sports such as football, where the action may be occurring some distance away — use very large (400mm or 600mm) fixed lenses. These lenses, called "big glass," feature near-perfect optics and carry a hefty price tag. Unless you're shooting elite or pro sports for which distance is a factor, they're probably overkill.

In addition to big glass, some photographers also use lenses described as "fast glass." A fast-glass lens is a zoom lens with a large aperture. Lenses with large apertures allow more light to pass through, enabling you to use a faster shutter speed. As such, fast-glass lenses generally allow for better shooting in low-light conditions. For example, a 70–200mm f/2.8 lens, or a 16–35mm f/2.8, or a 50mm f/1.8 lens.

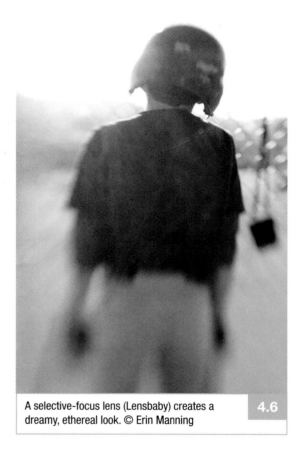

A selective-focus lens (Lensbaby) creates a dreamy, ethereal look. © Erin Manning 4.6

- **Viewfinder Hood.** If you are shooting in harsh light, for example on the water or on a snow-covered mountain, it can be difficult if not impossible to see your LCD screen. Using a small rubber or plastic hood (see Figure 4.7) to view the screen can make it easier to see.

■ **Bags.** A rolling equipment bag is great for carrying gear to a shoot. A large fanny pack is also handy for holding your gear during the event.

■ **Bulb blower and brush.** Especially if you are shooting somewhere dusty, such as at a horse track or a motocross event, you'll need tools to clean the dust from your lenses and your image sensor.

The HoodLoupe is a perfect device for easily viewing your LCD screen in bright sunlight. It also magnifies the image for closer inspection. Image courtesy of Hoodman Corporation USA

4.7

TIP

If you do need to blow or brush dust from your equipment, be sure you do it somewhere that's *not* dusty, or else you will likely make the problem worse. If you can, do it inside your car with the windows up.

BEFORE THE SHOOT

With sports photography, shoots do not take place in a perfectly lit, controlled environment such as a studio. Instead, they occur in locations where lighting is unpredictable at best, and where you may or may not be able to position yourself near the action (see Figure 4.8). Preparing for these shoots, then, is a matter of ensuring you'll have everything you need on hand to get the best shots possible.

When shooting a sporting event, mobility is important. You want to carry as little equipment as you can get away with and still have everything you need. Here are a few things you want to establish before the shoot to help determine what to bring:

■ **Will the shoot be indoors or outdoors?** If it will be outdoors, are there environmental factors to consider, such as rain, cold weather, water, snow, or dirt? The answers to these questions will determine, among other things, whether you need to bring protective gear for your camera and lenses.

■ **Is the event occurring in a large or small space?** How close will you be able to get to the action? The answers to these questions will help you determine what lenses to bring.

■ **What kind of lighting can you expect?** Will you be permitted to use a flash? Are you familiar with the white balance settings on your camera?

A Word on Lighting

It will be a rare sporting event indeed where you are permitted to set up a lighting kit or use a reflector or diffuser to manipulate existing light to obtain a more pleasing shot. In fact, event organizers often prohibit the use of a flash, as it can distract the athletes and officials. However, you can use a flash when athletes aren't competing, such as during medal ceremonies, in the locker room, and so on.

■ **Do you need to capture images of any key players?** If so, whom?

■ **Will you have direct access to athletes before, during, or after the event?** Contact other parents and the coach to organize this in advance.

Knowing the location of your shoot will help you determine how to prepare for it. © Erin Manning

4.8

- **Do you need special permission or credentials to take photos during the event?** If you're not sure, contact the organization managing the event.

- **Do you need model releases?** In general, news articles do not require a model release; the same goes for images for your own private use. But if you plan to use them as fine art, or for a commercial purpose, you need a model release. This becomes increasingly important if minors are involved. If you are ever in doubt, it's best to get a model release; better safe than sorry! You can learn more about model releases in Appendix A.

- **Will you be in danger during the shoot**? If you might end up hanging out of a moving vehicle, balancing on a rock face, parachuting out of an airplane, or sitting in the path of a line drive (see Figure 4.9), make sure to take any necessary steps to ensure your physical safety.

Some shoots are dangerous, so take steps to ensure your physical safety! © Erin Manning

4.9

AT THE SHOOT

Sports photographers have little, if any, control over their environment. To name just a few challenges involved in photographing sports, you cannot control the lighting; you cannot instruct your subjects to pose; the action may occur on the opposite side of the area of play; and fans around you may bump you or obstruct your view. That being said, there are steps you can take to ensure you get the best possible shots:

- **Arrive early.** This gives you an opportunity to familiarize yourself with the venue.

Establishing Yourself with a Sports-Photography Service

Many sports organizations, especially youth sports leagues, contract with professional sports-photo services to handle formal team and individual photos, and sometimes action shots. The sports-photo service sends a photographer to an event to capture any requested photos; athletes and parents can then purchase photos from the service. Many services also sell customized posters, trading cards, key chains, pennants, and other photo-oriented items. Aligning yourself with a sports-photography service can be an excellent way to find steady work in the sports-photography field.

■ **Locate the best vantage point for photographing the action.** Knowing where you're most likely to catch the action is as important to capturing a winning shot as having the right exposure. Be creative with angles and perspectives (see Figure 4.10). Sometimes, situating yourself as near to officials or coaches as possible can yield great shots; just be sure you don't get in their way.

■ **Be observant and keep your eye on the camera's viewfinder.** Every moment counts when the game is in play, and also before and afterwards. Don't miss out on an important moment by taking your attention away from the game.

Know the Sport

Having a firm understanding of the sport you are photographing helps you determine the best, most creative vantage points for capturing the action. It also helps you make educated guesses during play as to what might happen next and frame your shot accordingly. For example, if you're photographing a baseball game, and there's a runner on first with no outs, you might focus on second base. That way, if a double play or attempted steal occurs, you're in a position to capture it.

■ **Watch the light.** Photographing an outdoor event during daylight hours is less challenging than shooting an indoor event. Position yourself so you're between the sun (or stadium lights) and your subject. This helps illuminate your subject and rids faces

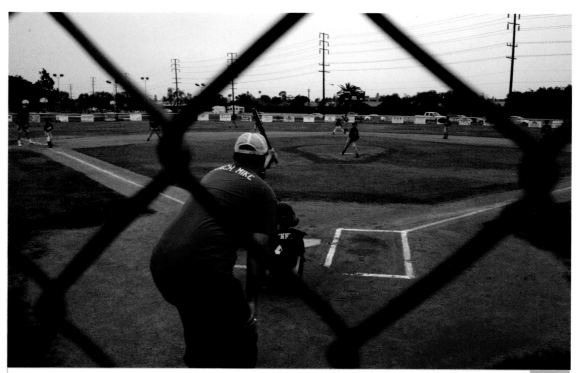

Locate a vantage point that enables you to be creative with angles and perspectives. © Erin Manning

4.10

of shadows. Late afternoon and early morning light provides a beautiful rim light in the hair; watch to see how it falls on the players on the field. If you're shooting near sunset, take note of which parts of the field are illuminated the longest and plan your shots accordingly. Once the sun goes down, it's impossible to use a fast shutter speed using only natural light.

If you're shooting indoors, using a flash or other form of artificial light is generally prohibited. Indeed, the lighting in indoor sport venues can be downright abysmal. On the plus side, this lighting, while often bad, is constant, meaning you don't need to worry about frequently changing your camera settings to account for changing light.

■ **Assess the weather.** If you're shooting an outdoor event, determine if weather will be a factor. If you anticipate rain or snow, take measures to protect your gear.

GENERAL TIPS

There are many things to consider when photographing a sporting event, from equipment to timing, positioning, and light. Because a sporting event is about moving around and playing the game, capturing the action and telling a story are important considerations. The following list offers a few helpful tips:

■ **Take a lot more shots than you think you need.** With digital photography, you don't need to pay for film or processing; in fact, your only limit is the amount of space on your camera's

Cold-Weather Considerations

Cameras don't like extremely cold weather. For one, cold weather shortens the camera's battery life. For another, you may find that your LCD screen loses contrast or displays images more slowly. And if the mechanisms in your camera are lubricated, they may become stiff and unreliable. To avoid some of the problems associated with shooting in very cold weather, tuck your camera inside your jacket to keep it warm. Also, be cautious when changing lenses, flash cards, and batteries; you don't want any snow to blow into your camera. To prevent condensation from forming on the lens when you move from a cold environment to a warm one (and vice versa), seal your camera inside a plastic bag and leave it there until it adapts to the temperature.

memory card. Remember, you can always delete images, but you can't add them!

■ **Shoot in continuous mode.** Shooting in continuous mode enables you to capture a sequence of shots in quick succession, which is great when photographing sporting events. Higher-end cameras enable you to capture several frames per second. The number of pictures you can take in this mode is limited only by the speed and capacity of your camera's memory card.

■ **Change your angle.** If the athletes are small children, get down on your knees to capture the most meaningful expressions. Purchase a pair of knee pads from the local hardware or gardening store to make the shoot a little more comfortable.

■ **Use the fastest shutter speed possible.** This ensures that you stop the action in your image with minimal blurring. If you are shooting an indoor event and you can't get the right

exposure, increase the ISO setting. Doing so can introduce digital noise, but you can also fix this with image-editing software.

■ **Consider other camera settings.** Continuous servo autofocus, lock the center focus sensor, center-weighted metering, a wide open aperture (f/2.8, f/3.5, f/4), AV (Aperture Priority) or TV (Shutter Priority) are all options.

■ **Use a monopod.** Eliminate camera shake by stabilizing your camera with an unobtrusive monopod. Tripods are sometimes difficult to use from the stands, or on the field, and sometimes prohibited.

■ **Capture a rounded set of images.** Try to depict the venue, the action, athletes' personalities, spectators, officials, the moment of victory, and the sting of defeat. Having a compelling and rounded set of images creates visual interest and helps tell a story to the viewer.

■ **Take detail shots.** It's nice to have the wide view of an event, but close-ups of expressions on the athletes' faces reveal the intensity and concentration in the moment. Also take pictures of baseball gloves, bats, or any other object that will help tell a story about the day (see Figure 4.11).

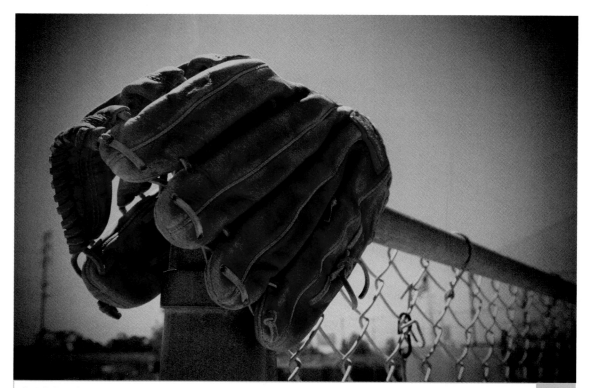

Detail shots from the event can help convey a story. © Erin Manning 4.11

- **Shoot tight.** Filling the frame with your subject as much as possible, even if parts of the athletes are cut off, adds drama to the composition (see Figure 4.12). Using a telephoto lens is a great way to achieve this.

- **Blur out background clutter.** Use a shallow depth of field to dramatically highlight your subject by blurring the background (see Figure 4.13).

Shooting in Snow

All cameras have built in metering systems that are designed to deliver a well-exposed image assuming the contrast range is normal, but snow is highly reflective and can fool your camera's metering system. This results in underexposed images that appear dull and grey. You can adjust the outcome and control the brightness in your image by setting the Exposure Compensation to +1 or +2 stops.

Create visual interest by filling the frame with your subject. © Erin Manning **4.12**

Blurring out background clutter helps focus the viewer's eye on your subject. © Erin Manning **4.13**

Q&A WITH A WORKING PRO

Serge Timacheff is an official photographer for the Olympic Games and is the chief photographer for the International Fencing Federation (FIE). In addition, Timacheff teaches workshops and leads seminars on digital photography. He is the author of several successful books on photography, including *Total Digital Photography, Digital Sports Photography*, and *Canon EOS Digital Photography Photo Workshop*. To see examples of Timacheff's work, visit his Web site at www.FencingPhotos.com.

1. Can you tell me about your background — your personal, professional, and educational history? How about your continuing self-education?

I grew up in Europe, the son of a father descended from Russian nobility and an American mother. As a young teen, I moved to the USA and later graduated from the University of Houston and did graduate work at Golden Gate University in San Francisco.

In the 1980s, I worked as a photojournalist for a regional newspaper and was a CBS radio reporter. Later, I became an editor in technology, ultimately working as senior editor at *InfoWorld Magazine.* I migrated to the corporate side, where I ran global marketing communications at Logitech and subsequently led the launch of the world's first consumer digital camera. I continued to work in technology for a decade as a PR/branding/marketing executive, while at the same time I pursued an artistic photography career based on world travel and held several exhibits in the Pacific Northwest.

I have written multiple books; one of the first was *The Personalized PC*, which was about how to make your computer more like you through the use of sound cards, images, and so on. After 2001, and after writing a book on brand methodology used by MBA programs globally, I launched a photography studio near Seattle and also started a fencing academy, both of which are still thriving today.

2. What attracted you to sports photography?

After rediscovering the sport of fencing in 2001 (I had been a fencer in my youth), I realized there was very little exciting photography of this sport, and yet I was seeing exciting action and moves that I had not seen in the sport when I was a teenager. I fenced in a tournament in Las Vegas, called Duel in the Desert, and took photos of the action; the shots I got there inspired me to believe that the world deserved to see more of this sport and its passion, athleticism, and excitement.

3. How did you start your business? How did it evolve? Did you have a studio or did you shoot on location?

I was sponsored to shoot the Aurora Borealis by Leica in 2003 on a trip to a fencing tournament in Lapland and by chance got to spend several days with the president of the International Fencing Federation, a member organization of the International Olympic Committee. After he saw me fence and saw

my images on display, I shared with him my philosophy of how I wanted to promote the sport. Afterward, he invited me to become the official photographer for the FIE for the Olympic Games and World Championships. He then sent me an invitation to shoot the World Championships in Cuba that fall, which began my efforts.

A German with the FIE who primarily managed world TV broadcasting but who was also a photographer, Mr. Jochen Faerber, took the time to critique my work in detail and provide feedback on my photos from Cuba. This critique prepared me to shoot the 2004 Athens Olympic Games. It was there

that I took what is still my most famous fencing image. Since that time, I have captured more than 1,000,000 images of fencing. My photos have been published widely throughout the world and seen worldwide. Today, I am also editor-in-chief of *American Fencing*.

4. What was the toughest thing about getting started? What was your worst experience when you began? What did you learn from it that helped you in the future?

Making the transition to digital while learning to shoot the fastest Olympic sport, under subdued light, was a challenge.

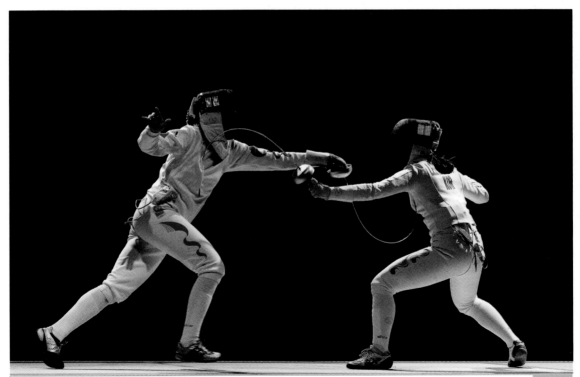

A dynamic image captured at the 2004 Athens Olympic Games. © Serge Timacheff 4.14

Understanding depth of field, leveraging the full extent of a camera's capabilities at a number of levels, using the right lenses, and also developing a deep understanding of an Olympic sport was critical. The fact that I was a competitive fencer helped — but shooting Olympic-level competition was, at first, a challenge.

One of the worst experiences I've had shooting was accidentally deleting a CompactFlash card. Until I was able to find some reasonably good rescue software while in Cuba, I had to just sweat it out, wondering if I had lost critical images of a World Championship final. Another bad experience was dropping a lens in China; afterward, I had to buy and use my own tools to try to get it to operate again (which worked…kind of).

Shooting fencing was hit-and-miss at first until I really learned to manipulate how and where I was focusing, all the while shooting with very narrow depth of field. It was a percentages game that required thousands of shots to improve.

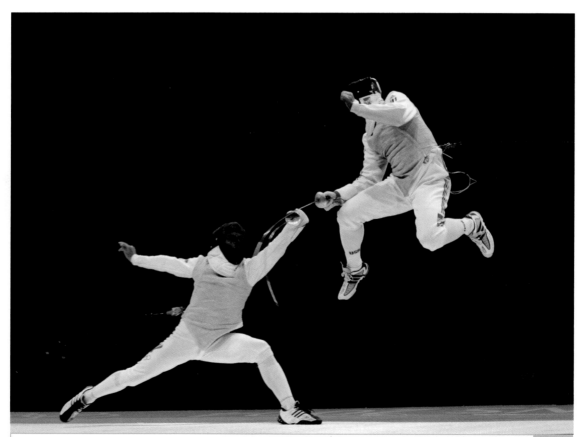

Serge's best-selling image was captured at the 2004 Athens Olympic Games. © Serge Timacheff 4.15

5. What tactics and strategies were most useful in developing your photo business? Was there anything that marked a turning point in your business — a contact, a realization, an idea?

Printroom.com was vastly helpful in allowing me to easily display photos and sell them, both for personal and editorial uses. I also signed with Corbis (a Seattle-based stock photography agency); they were very helpful with the first Olympic Games. (I still shoot fencing for them.) My big turning point, clearly, was when the president of the FIE invited me to be its photographer after hearing my vision and seeing my images. Today, I look back at those photos and realize how far I've come in being able to shoot the sport and how much better the digital camera technology has become.

6. Do you have any sports photography tips for better photographs?

If you want to get really good at something, you have to focus. It's very tempting to shoot a lot of subjects and sports (or other things); photographers are jacks-of-all-trades by nature. But to cross the proverbial threshold, you really have to beat something to death — to the point where your camera ceases to be a mechanical/electronic device and becomes an instrument that you play while focusing on a subject. Striving to reach this point is the only thing that will really allow you to soar in your career, to where it is very obvious to others that you are shooting with a unique eye, style, and high-level performance. It is also essential to develop a deep level of understanding of the sport and learn what various consumers of images think is a truly awesome photo. Your perspective on this will change as your skills are honed.

7. Do you shoot RAW or JPEG? What software programs do you use to review, edit, organize, and enhance your images? How do you handle your workflow?

I shoot both. But when shooting fencing action, I almost always shoot JPEG because it is much faster to record JPEG images than RAW ones.

I use ACDSee Pro for all my workflow, including editing, archiving, organizing, and preparation for whatever happens to the photos — be that posting on Printroom.com (which is integrated with my Web site), delivering digital images to clients, or printing. One of my books, *Total Digital Photography*, defined this process and what it takes to manage images effectively.

Today, within about one minute, I can find virtually any photo from any semifinal, final, or medal ceremony from every World Championship and Olympic fencing event ranging back to 2003. This is due to my extensive use of ACDSee Pro, and has become a very valuable asset to both my own work and to the FIE because we have a highly accessible image record of events.

8. Can you name some of your favorite equipment (cameras, lights, computer, software, printer, and any photo-related gadgets)?

Here are some of my favorite pieces of equipment:

- Canon EOS 1D Mark IV

- EF 70–200mm L f/2.8 IS USM lens

- EF 17–40mm L f/4.0 USM lens

- Speedlite 580 EXII flash

Additionally, I like the Hoodman Loupe for shooting outdoors, in particular.

9. What feeds your creativity? Where do you find your inspiration — for example, other photographers' work, art, or any particular travel experiences?

My creativity is fed by the need to constantly look at the same sport in new, original ways. That might mean climbing into a catwalk above a venue or exploring long exposures. I've also taken fencers into interesting situations, such as putting them on camels, fencing in Roman ruins, or fencing by the Egyptian pyramids. However, my best creativity comes from simply shooting the hell out of top-ranked athletes doing their thing.

10. How do you market your work (newspaper, referral, Web site, online marketing, social networking, printed collateral)?

My work is published in virtually every fencing publication worldwide, linked from the International Fencing Federation and United States Fencing Association home pages, and through Corbis. Additionally, a variety of manufacturers use my images to promote their products, and my own Web site (FencingPhotos.com) has developed a strong global following. Also, my work appears in a variety of other publications and Web sites worldwide. I have a Facebook page that gets followed a lot and I often post Blackberry snapshots showing wherever I happen to be on the planet.

11. Are there multiple ways that you make money with your sports photography? Which area of distribution have you found to be the most profitable?

Making money in sports photography, unless you're a full-time employee for an agency like Reuters or AP, is like any other business where you have products that must serve a range of clients with various needs, timelines, budgets, and interests. In addition to taking and processing the photos, you must also have an infrastructure that serves these clients and is able to provide them with the services and products they need.

As a result, I've created a rather complex set of services and vendors, as well as employers and clients, that require ongoing, day-to-day management. Here is a cross section, with some explanations of what they are and what they provide/need:

- **I use Printroom.com to sell prints and digital images.** This is the e-commerce component of my online gallery sales. Because this service is

uniquely suited to the pro photographer, I am able to post indexed, searchable galleries of thousands of images from dozens of events ranging back a decade or more. I set the prices, upload photos, integrate it with my Web site (although I could use them standalone) and they do everything else — pro lab processing, customer service, order fulfillment, shipping, payment processing, and so on — and send me a monthly check. They provide 100-percent satisfaction; they refund or replace anything, no questions asked. I can post a wide variety of prints ranging from regular paper (pro-lustre, matte, or glossy) in addition to canvas, metallic, black-and-white, and a variety of products (such as coffee mugs or mouse pads) and the biggest one, especially for international sales, high-resolution digital downloads.

- **I use CafePress.com to sell other boutique items.** Because there are a few images everyone wants to buy, I have created a boutique of products that goes beyond what the lab can do. CafePress provides on-demand photo and design-related products that let me set up a storefront. I also use CafePress to set up photo-related boutiques for some clients, such as the International Fencing Federation and some equipment vendors. Again, I get a percentage of sales. In this area, however, you have to be careful because selling commercial products with images on them requires model releases and in no way can I use Olympic images for these kinds of sales.

- **I sell a world calendar each year.** For this I use my own designer, whom I pay, and the calendar is sponsored by a fencing equipment supplier in Germany. I provide calendars, which contain 12 months of images from the previous year's world events, to the vendor, to the International Fencing Federation (the dates of major events are on the calendar also), and to various other distributors who sell the calendar directly (they buy it from me at a wholesale price).

- **I've published a coffee-table book on fencing that is distributed worldwide.** I am currently working on a second book, which has already been pre-purchased by a number of country federations, equipment vendors, and sponsors (such as Tissot watches).

- **I work with Corbis.com** as well as with other agencies, such as China Photo Press, to provide images of fencing at major world events, and in particular the Olympic Games. These are editorial images, and need to be uploaded to the agency very quickly after the event so they can be accessed, purchased, and used quickly virtually anywhere in the world in publications, Web sites, and so on.

- **I work directly for the International Fencing Federation.** They pay my travel costs, a per diem, and a day rate for me to shoot at multiple events per year.

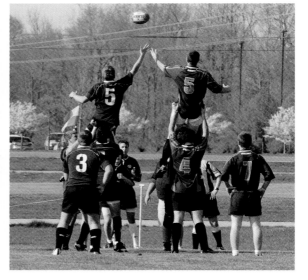

CHAPTER REVIEW

A Depending on where you are relative to the action and what type of shot you want to compose, you will need different types of lenses.

B Knowing the location of your shoot will help you determine how to prepare for it.

C Offer to submit images from games to your local newspaper and regional high-school magazines.

D Filling the frame with your subject as much as possible, even if parts of the athletes are cut off, adds drama to the composition.

wedding photography

Wedding photography has become an increasingly popular way to create an income for aspiring and professional photographers alike, but successfully photographing a wedding can be a very demanding endeavor. It's an important life event for everyone involved, and the photographic outcome is in your hands. You must capture this auspicious occasion with personality, creative passion, and technical ability. It requires planning, preparation, and setup prior to the wedding date; long hours and hard work during the wedding and reception; and the post-production and follow-up afterwards. The bride and groom, as well as their families and friends, will all be counting on reliving moments you have captured of the special day, and the images will be cherished for generations to come.

© Robert Holley

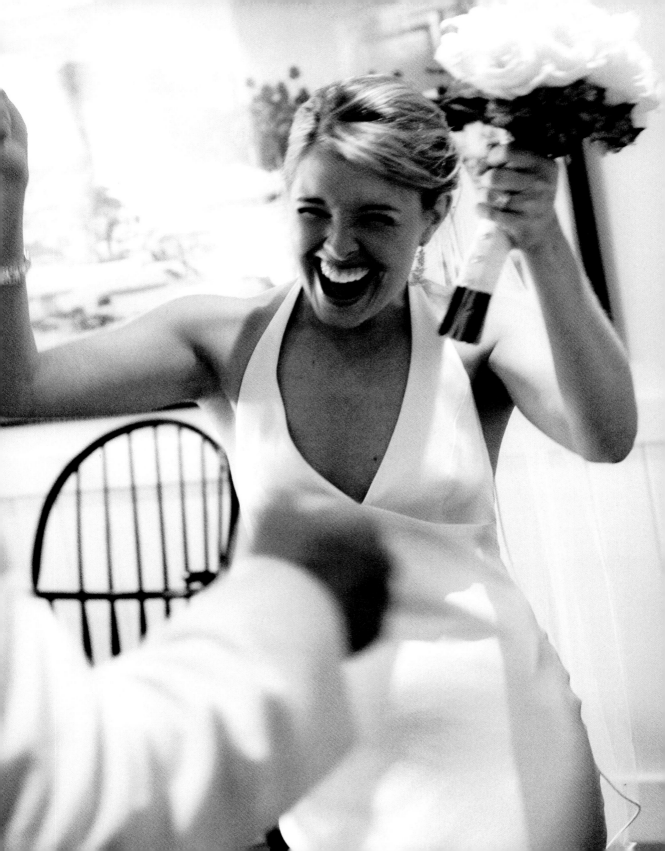

Weddings can also be a very rewarding experience for a photographer. From feeling personal gratification for a creative labor-of-love well done, to a continuing business model, there are many positive factors that can override the challenges if you decide to go this route with your photography.

Q&A WITH A WORKING PRO

Award-winning, Virginia-based wedding photographer, Robert Holley, began his career by photographing Olympic champions in Lake Tahoe, athletes for *Sports Illustrated*, auto racing, and children at Mattel Toys. His belief in capturing a depth of emotion in every photograph brought him great success in the wedding industry. Robert was named Northern Virginia Photographer of the Year just 18 months after moving from Los Angeles, received second place in the Digital Wedding Forum Photographer of the Year Awards, and has been recognized four years in a row by the prestigious International Lucie Awards. He currently teaches at the Boston University Center for Digital Imaging Arts in Washington, D.C.

1. Can you tell me about your background — your personal, professional, and educational history? How about your continuing self-education?

Photography has always been a part of me. I can remember as a ten-year-old saving all my money to buy enough film to photograph the yearly family vacation. My senior year in high school, I quit the soccer team to be the head yearbook photographer. I recall reasoning with the coach that I thought I would get more out of photography than soccer in the long run. In college I was a business major, but had a minor in photography.

I strongly believe that my success in photography is the direct result of following my heart. My interests have always been in sports, so I combined my first love (photography) with my second love (sports) and headed out into the world. My first stop was Lake Tahoe where I shot for the ski industry in the winter and photographed different sports all summer. I was quickly published in all the major national magazines such as *Powder, Ski, Skiing*, and *Snowboarder.*

When the weather turned warm, I would shoot white-water rafting, mountain bike races, motorcycle races, and Indy Car auto races. The experience was priceless. I learned how to anticipate "the moment," and how to get the most out of my camera. At this point in my career, I was returning from a trip to the country of Georgia in the old Soviet Union. I had been photographing for a TV show which took us helicopter skiing in the Caucasus Mountain range.

It was fantastic, but I thought I needed to learn more about photography. The following Fall, I enrolled at Brooks Institute of Photography to further my education. At Brooks, I learned about medium- and

large-format cameras as well as studio lighting. I then decided to mix in some real-world experience and moved to Los Angeles to assist established pros. I got to see firsthand how everything worked: how the photographer interacted with the client, what equipment was needed to accomplish certain jobs, and the size and scope of each project. I assisted many types of photographers, including studio product, fashion, automobile, children, architecture, and lifestyle photographers.

My next move was to follow my love of photographing children. I got a job at Mattel and did studio product work in addition to shooting kids. Having an opportunity to work on numerous children photography shoots quickly taught me about the best method for maximizing a kid's shoot. There is a need to move quickly because a child's attention span is extremely limited. If you drag the shoot out at all, you risk losing the model and getting nothing.

As far as continuing education, I mainly improve my photography these days via the Internet. There are some great Web sites that are dedicated to improving photography skills. Lightroom Killer Tips (http://lightroomkillertips.com) is my favorite. Lightroom is a program that you can use to manipulate and organize digital photography. I cannot say enough about this fantastic program. It allows the user to have more control over the image than I ever had working in the darkroom hand printing my images.

2. What attracted you to wedding photography?

When I first started making a living with photography, I was often recruited by friends to shoot their weddings. It was not something that I pursued; it just happened. I actually turned down more wedding requests than I shot. I was not enthusiastic about embracing this photography avenue because I thought wedding photography was stifling — it seemed to be too posed, staged, and boring.

3. How did you start your business and how did it evolve?

A few years later, a friend begged me to shoot his wedding. I finally agreed, but with the condition that I would be allowed to shoot it any way I wanted. The end result was a combination of photojournalism and fine-art photography. Figures 5.1 and 5.2 are examples of images I shot with the intention of demonstrating the fun, joy, and emotion of the day.

It was like the light had been turned on in a dark room. Suddenly I saw wedding photography in a whole new way. Gone was the notion that I had to follow a script and shoot the same boring, posed images. I was now free to explore the beauty of the day — the smiles and tears of friends and family sharing this special day, the anticipation of a groom, the power of the white dress, the little personal details that make each wedding slightly different from the last. I love being able to capture unusual and poignant moments such as in Figure 5.3.

The love and joy that each couple shares and how they express it to each other — these are the elements that make up a wedding.

The fact that a couple allows me to be a part of one of the most important days of their lives is a privilege.

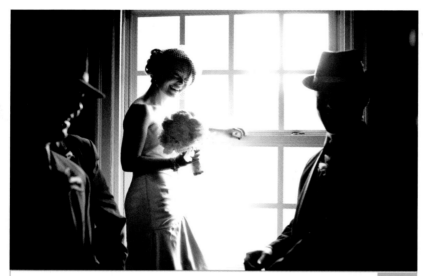

This wedding image portrays a photojournalistic style, capturing an authentic moment. © Robert Holley

5.1

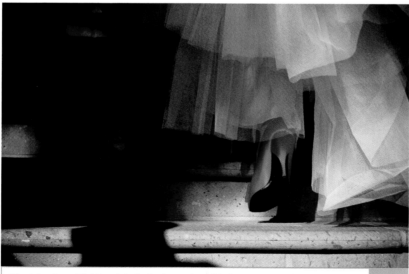

The interplay of light and dark shadows gives this image a creative edge. © Robert Holley

5.2

4. What was the toughest thing about getting started and how did you learn from it?

When getting started in any business, the most difficult aspect is experience. It takes a while to build up the confidence and know-how to handle any situation that comes your way. A wedding is one of the most emotionally packed days of anyone's life. This can work in your favor in the most fantastic ways, or it can be a disaster.

Your response to the situation dictates how the client judges you. The worst thing you could do is add to a deteriorating problem. You must be supportive, enthusiastic, and agreeable no matter what happens. You can only learn these skills by being there. The more experience you gain, the easier everything becomes.

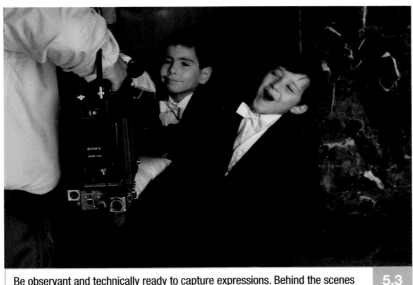

Choosing the right clients is the key element in everything that happens on the wedding day. In the beginning of a career, every business person's instinct is to book as much business as possible. It is only when you have a bad experience that you realize that not everyone is a good match for your personality.

Be observant and technically ready to capture expressions. Behind the scenes shots add to the visual story of the day. © Robert Holley 5.3

Early in my career, I had a bride who changed her mind about having me shoot her wedding after giving me a deposit and signing a contract. She was willing to allow me to keep the deposit if I let her hire another photographer. My ego would not allow this. I reasoned that I could do such a good job that I could win her over. That was a big mistake! She had already made up her mind that she was not going to be happy with me. The pictures were fantastic but she complained about all of them — that was a huge lesson learned.

5. What tactics and strategies were most useful in developing your business?

My business is run with an emphasis on communication. My goal is to develop a strong rapport with my clients, and so my work starts well before the wedding day.

With all my clients, I schedule an engagement photo session, which allows me to get to know the couple and establish an atmosphere of relaxation. I like to equate an engagement session to a dress rehearsal before the "big show." It is designed to be a more casual photo session of the couple, but lessons are learned that serve us well on the wedding day. In Figure 5.4, the bride and groom practiced their dance steps during the engagement photo shoot.

Most couples hire me for my creative approach, but the engagement shoot helps me to determine just how creative the couple wants to be. My ability to produce a unique view of any wedding is greatly enhanced by an understanding of the personalities of the bride and groom.

Following the engagement shoot, I meet with the couple to share the photos and compare notes. I find that a thorough discussion of the

engagement session photography enlightens both the client and me. They are then more confident in my abilities to achieve the goals they had set forth. This meeting also gives me a detailed understanding of the timeline of the event and an awareness of all the "can't miss" shots. Most important, it provides me with another chance to observe the clients together. I look for the ways that their love and commitment expresses itself, so I can document some of those same emotions at the event. In my view, good wedding photographers are paid to capture love. Great photographers also archive the hopes and dreams of a couple about to start their journey in life together.

6. Do you have any tips for creating better wedding photographs?

Shoot what you feel, not what you think. Do *not* do what everyone else has done. Avoid clichés! Think in terms of the emotions of the day: love, commitment, joy, beauty, a new beginning. Let the day unfold. Be empathetic to every situation and become seamless with the event. Utilize the relationship you have developed with the couple to understand their needs. Anticipate special moments and always be prepared with your camera, as shown in Figure 5.5, so you don't miss the important details.

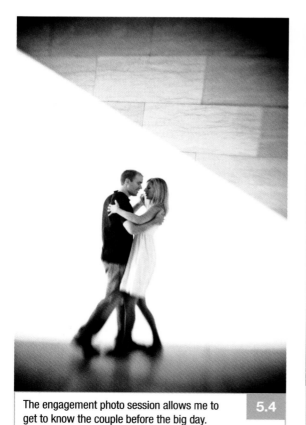

The engagement photo session allows me to get to know the couple before the big day.
© Robert Holley

5.4

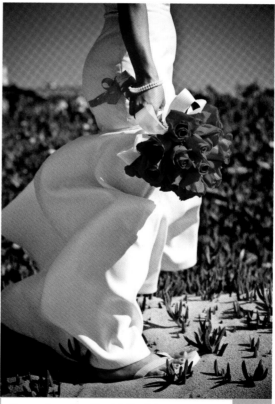

Be sure to capture the details of the day.
© Robert Holley

5.5

7. Do you shoot RAW or JPEG? What software programs do you use to review, edit, organize, and enhance your images? How do you handle your workflow?

I always shoot in RAW and utilize Adobe Lightroom to review, edit, organize, and enhance my images. When the event is finished, my second shooter hands me a disk with RAW images. (I normally work with a second shooter, so it is important that we sync the time and dates on our cameras before the event begins.) I import only the second shooter's images into Lightroom and then create subcategories (for example, ceremony, reception, cake cutting, and so on). I then sort the images into the smaller subcategories. It is easier to work with a group of 100 pictures rather than 1400. My first edit is very quick as I am looking for obvious mistakes like the flash not firing or someone closing their eyes. I then review the images more closely and remove the ones I do not feel hold up to the level of quality I am trying to produce. Next, I go through each image individually and determine what it needs to look its best. Some need exposure changes, some need color balancing, and others need color denaturation. This can only be determined by examining each image. At this point I am also determining which ones would look best as black and white, and changing them over. When I finish with this process, I export the images (still in a subcategory) to my desktop. I then repeat this for all the other subcategories. It is important to note that these files are named after the second shooter (for example, Jen_001.jpg).

When it is time to work on my own images, I follow the same steps as previously outlined. The only change is that when I export the finished images to my desktop, they are named Rob_001.jpg for example, and sent to a folder named Rob.

When I finish with Lightroom, there are two folders on my desktop: Rob and Jen (my second shooter). Each folder has identical subfolders within it which are the subcategories created earlier. Now I use a program called "A Better Finder Rename" to copy the date the photo was taken to the creation date. The software program can be downloaded from www.publicspace.net/ABetterFinderRename/index.html. The site also offers a Windows version called "Better File Rename." I am still working with one subcategory at a time. After the image timing is corrected, I can put the Jen photos and the Rob photos in the same category. I will then use the A Better Finder Rename program again to rename the images using the clients' last name (for example, Smith_001.jpg). But this time, all the Rob images and Jen images fall into place based on the time they were originally shot. The end result is a seamless transition between photographs shot at different perspectives.

8. What are your favorite pieces of equipment?

For most of my life, I used Nikon equipment. When I switched to digital gear about eight years ago, I went with Canon. I love my EOS 5D, and I almost exclusively use Canon lenses. The only exception is my Lensbaby.

The Lensbaby has a bellows built right into it so you can change your focal point by tweaking the lens. The beauty of this lens is that it is the digital equivalent to a Holga camera. There is not much sharpness, but it is great for blurry mood or emotional shots, as shown in Figures 5.6 and 5.7.

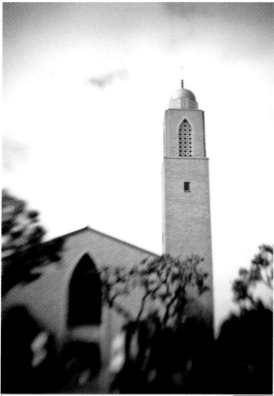

A selective-focus lens allows the photographer to blur certain areas of the image for creative effect. © Robert Holley

5.6

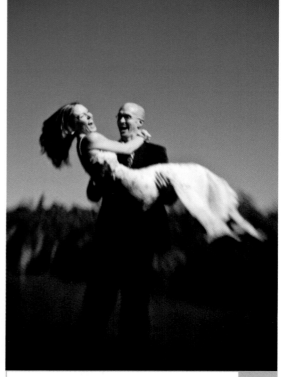

This image captures the passion, emotion and the fun we often associate with weddings. The dreamy effect was created with a Lensbaby lens. © Robert Holley

5.7

NOTE

The Holga camera is a low-cost, medium format toy camera made in China. It produces images with vignetting, blur, light leaks, and other distortions. These limitations also create unique, artful images that have won awards in art photography.

A lens that comes in handy at receptions or in tight spaces is the Canon 24–70mm. I try to shoot with as much natural light as possible, but when a situation calls for it, I use an off-camera flash attached to a Pocket Wizard remote triggering system.

The only computers I have ever owned have been Apple, and as of this writing, my new iMac is only a few days old. I am a huge fan of all things Apple, as I also own a Time Capsule backup drive and wireless hub. My favorite Apple device is the iPhone. I cannot say enough great things about it. The iPhone is the perfect instrument for a small business owner. Of course, with a portable phone you never miss an important call, but you also have access to your calendar, your contact list, and many methods to stay in communication.

As an example, I was once waiting in an airport security line when I received an e-mail from a client wanting to change the time of a meeting. I was able to check my calendar to see if the new time was available, send a text message to my second shooter informing her of the change, and, once I got the confirmation back, change the time in my calendar. I then quickly composed an e-mail to the client confirming the new time before going back to listening to my music, all while waiting in the airport line!

9. What feeds your creativity and where do you find your inspiration?

A photographer can never look at enough images. I am constantly looking through magazines (I once had a total of 28 subscriptions) and surfing the Internet for images that move me. I find that the work of fashion photographers is easily the most creative and interesting to look at. Matthew Rolston is one guy who I am constantly amazed by; he shoots fashion and celebrity portraits and his work is constantly fresh and relevant. The pages of *Vogue* and *Vanity Fair* magazines are also filled with incredible photography.

I was really moved by the film *Moulin Rouge!*, starring Nicole Kidman. Every scene of the movie was conceived as if directed by a fashion photographer. It was the type of movie that you either loved or hated, but I was so entranced by the visuals that I really do not remember the story. It was simply visually satisfying. The paper umbrellas used in the wedding shown in Figure 5.8 reminded me of an elaborate design on a movie set.

10. How do you market your work?

A good, strong Web site is the basis for marketing. You need to be able to show off your style in a quick, impactful manner. The site should emphasize your photography, but also be easy to navigate. Think of it as a portfolio which shows off your creativity and diversity and provides enough relevant content to entice further communication. My Web site is pictured in Figure 5.9.

I never advertise. I do not want to be lumped in with hundreds of other photographers fighting over each job. I work strictly on word of mouth. If you provide great service and great images, your clients do your advertising for you. (For additional advice on marketing your work, see Chapter 9.)

11. Are there multiple ways that you make money with your wedding photography?

I use Pictage.com for my event hosting and order fulfillment. Pictage provides a Web site for your clients to look through their photographs, which they can share with friends and family. Anyone can order enlargements, books, DVDs, cards, albums, and many other items. Pictage handles everything; you just tell them how much over cost you want to sell things for, and the difference is your profit.

There are three basic photographic styles when shooting weddings: traditional, photojournalism, and portrait journalism. These can be mixed and matched, and there is a lot of overlap with various photographic styles.

Traditional wedding photography is carefully controlled, arranged, and formally posed to portray people in their best "light."

Photojournalistic images, on the other hand, require a photographer with keen observational skills who can predict and capture authentic moments and expressions in a stealth-like fashion as they happen, with little or no direction as in Figure 5.10. This intuitive and creative style is gaining in popularity due to the advent of digital photography and the contemporary feel of the resulting images. A photojournalistic style allows the couple and guests to enjoy the day without being directed or forced into a photo shoot. Portrait journalism is a blend of traditional and photojournalistic techniques, resulting in a combination of fashion and fine art. You can shoot in a photojournalistic style when there is a lot of activity, and then pose people

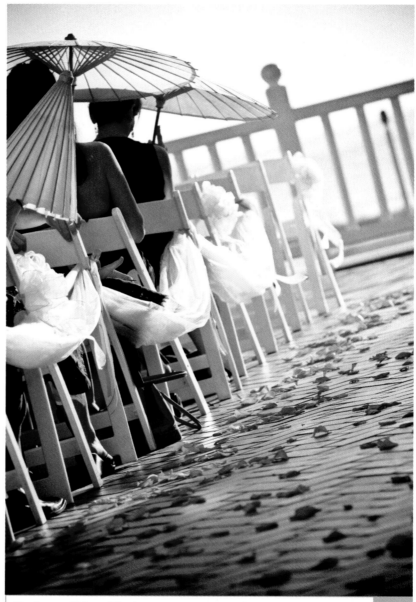

The theme of this wedding included paper umbrellas and the tilted perspective created visual interest. © Robert Holley

5.8

formally or informally when there are quiet moments in between.

There are two revenue models for wedding photography: a lower fee up front requires a more controlled, sales-oriented follow-up in order to generate a profit from print, album, digital frame, iPads, and DVD slide show sales. A higher fee up front, also known as the creative fee model, allows for greater creative freedom for the photographer and less follow-up afterwards for sales. Instead of thinking about what the bride and groom will buy, you can concentrate on capturing what the couple wants to remember about the day. You can also skip hiring additional staff to handle the sales and administration

required for profit and use an online service for posting, proofing, and print production sales. Which of the two is more lucrative? It depends on how you would prefer to handle your business. The low-fee-up-front model is more traditional and may attract that sort of client. Print and product sales could bring in quite a bit of money, but it is a risk. By charging a creative fee, both the wedding photographer and the bride and groom have more control over the budget and profits.

A good way to test the waters is to find a reputable wedding photographer in your area and offer your photo-assisting services during an engagement photo session or an actual wedding. Depending on your present

A strong Web site is one of your best marketing tools. www.robholley.net. © Robert Holley

5.9

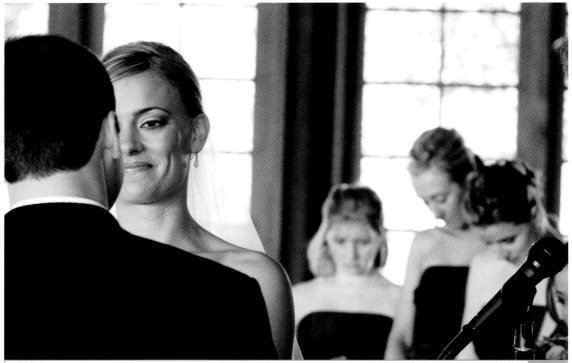

Being a keen observer allows for capturing an authentic moment with photojournalistic style. © Robert Holley | 5.10

photo skills and experience, you may offer to assist for free or for a nominal fee. If you're more experienced, you might ask to be hired as a second photographer. This allows you to test the waters, see how other wedding photographers work, and gain experience by learning all the nuances about photographing a wedding. Above all, you must be able to take the unpredictable in stride and thrive amidst challenges.

ESSENTIAL GEAR

Whether you plan to shoot a few weddings on the side or jump into wedding photography as a new career, you need the right equipment to do the job. Not only is it

important to have the best equipment you can afford, but it's also wise to have backup equipment, just in case something breaks or suddenly becomes inoperable during the event. These are once-in-a-lifetime moments that you cannot afford to miss due to technical glitches. Along with the basic equipment mentioned in Chapter 2, there are certain items that you might find helpful when photographing a wedding.

CAMERA

A dSLR camera is an absolute necessity when photographing weddings. You can interchange lenses for different perspectives, capture images at lightning speed, and quickly make camera adjustments to capture a fleeting

moment. There are many different manu-facturers and camera models available, and the offerings are constantly improving and changing. Because selecting a particular digi-tal camera is a very personal decision, and everyone's budget varies, I suggest checking out the online reviews at DPReview.com for up-to-date information on digital cameras and lenses.

LENSES

The lenses you use are a very important part of your photographic cache. This is one area where you should not scrimp. If you are just starting out, your budget may not allow for a fixed, wide-aperture lens, such as an f/2.8 lens. Although this lens contains more glass, can produce sharper images, and has the ability to capture images in low-light sce-narios, it's also much more expensive.

Because different lenses create different effects, it's wise to experiment with various lenses and create a style that's all your own. Do you like the wide-angle vistas of environ-mental portraits, the shallow depth of field created by using a telephoto lens, or both? There are some must-have lenses and "artsy" selective-focus lenses you should consider. The basic lenses are a wide-angle zoom in the 17–35mm range, a medium zoom in the 35–135mm range, and a telephoto zoom in the 70–200mm range. Weddings often happen quickly and in low light, which means you'll need some "fast" lenses in order to make a proper exposure without using a flash. Here are two very affordable prime lenses that also produce beautiful images:

■ **The "nifty-fifty" — a 50mm f/1.8 lens.** This is a great lens for portraits and all-around shooting. It is also a bargain for under $100.

■ **The 85mm f/1.8 lens.** This lens cap-tures beautiful portraits and allows a very shallow depth of field.

■ **Lensbaby.** This selective-focus lens is shown in Figure 5.11. There are many different models available that produce different effects. Check out www.lensbaby.com.

LIGHTING

Whether you're approaching wedding pho-tography as a traditional photographer or a contemporary photojournalist, you will almost always find yourself in a situation where you need to illuminate the scene. The kind of lighting equipment you carry depends on the style of images you shoot. Traditional-style photographers are known for their posed, indoor images that require elaborate flash setups. Photojournalistic-style photographers often shoot less formal photographs and carry only an external

The Lensbaby lens "Composer" is an affordable way to create dreamy, selective-focus effects in your images. Photo courtesy of Lensbaby

5.11

flash. No matter where you fall between the different photographic styles, you need to bring some sort of flash to shoot weddings.

The possibilities range from an external flash to a larger studio flash that sits on top of a stand and requires a larger power source. Some large flash units, as shown in Figure 5.12, are powered with either an AC wall plug or battery packs, while others are portable.

Although most digital cameras have a built-in flash to cover basic lighting needs, the light they emit can result in images that look flat and lack subtle gradations of tone. A better option is a portable external flash. You connect an external flash to your camera via

a *hot-shoe*, a mounting bracket located on the top of your camera. If the flash is designed to work with your camera, you can use the camera's TTL (through the lens) metering features to light your scene.

Flash systems are easy to use and have become so popular that many lighting manufacturers have created accessories to utilize these flashes off-camera and enhance their effect, like the Apollo Speedlite kit that includes a soft box, stand, and a bracket to hold the Speedlite flash, as shown in Figure 5.13. You can find more specific information about flashes and strobes in Chapter 2.

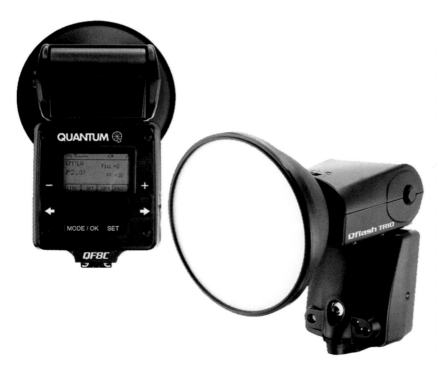

BEFORE THE SHOOT

You can capture creative, innovative, and unique imagery through careful observation and technical proficiency, but it often requires a lot of thought beforehand in order to set the scene and create the opportunity to shoot something unique and compelling. From wedding photo tips to current trends, it helps to have some inspiration and guidance.

Known as a "Q-flash," this high-powered flash can illuminate large groups of people. Photo courtesy of Quantum Instruments | 5.12

■ **Create a master schedule.** Arrange a pre-wedding meeting with the bride to plan out a 15-minute incremental schedule of the wedding shoot. This should include wedding preparations; bride portraits, bride and bridesmaids portraits, the groom and his groomsmen, the full wedding party, the family portraits, and the bride and groom together. If you aren't experienced at shooting weddings, plan for extra time so you won't be rushed or distracted by the time pressures.

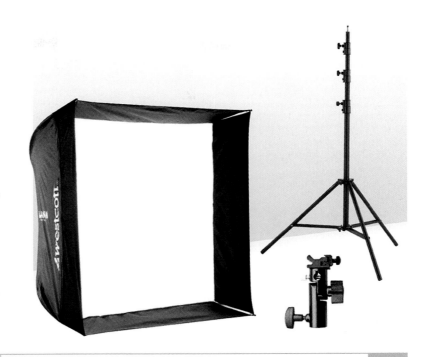

The Speedlite kit can help you get creative with your flash and modify the light. Photo courtesy of F.J. Westcott Company | 5.13

■ **Create a shot list.** The bridal couple will have certain shots they want. Generally, the couple will stress the importance of photos with family members attending and the bridal party. Once you have this initial list, you can build a more detailed list for your own reference. A shot list will keep you focused and on top as you go about the 5 to 8 hour shooting day. As you refer to your shot list throughout the day, you won't have to worry about forgetting anything.

■ **Scout the location.** Walk around the church or reception site and look for any architectural details, such as arched windows, stone steps, or balconies that would add a special element to your photographs. Consider how to arrange groups in an interesting way so that you can capture the personalities of those involved and the place they chose to celebrate their marriage. Arrive at the venue at least an hour before you are to begin shooting. Once you are on location, map out your location flow. Where will you start out and what shots will you take in that area? Where will you go next? What distractions must you watch out for in each location? Where is the light? If you have a flow plan for your shoot, then both you and your clients will stay relaxed through the day.

■ **Hire help.** When shooting a wedding, it is best to have another primary shooter, or at least an assistant. An assistant will help you keep track of your shot list, schedule, and managing the individuals for large group photos. At the very least, an assistant can carry equipment, keep track of the cell phone, and hold reflectors. Some wedding photographers hire at least one additional assistant photographer, either to capture the basic shots that every bride would expect, or to capture more creative and unique photographs.

AT THE SHOOT

Once you've arrived at the venue, there are a few things to remember in order to capture the best images. If it's too much to remember, keep some note cards with you for reference.

■ **Put on your game face.** Remember that no matter what happens on the wedding day, there will be a lot of uncontrolled variables. Your job is to roll with the punches and remain calm and positive. The mark of a good wedding photographer isn't a perfectly executed wedding shoot, but rather a shoot where the photographer quickly adapts to each situation and captures the beautiful moments of the day.

■ **Add time buffers.** Weddings go quickly, and almost every wedding has a snag or two. If you allow for periodic 15-minute buffers, you can avoid stress.

■ **Watch the light.** If you are shooting outside, capture the formal images before the sunset. If you wait until the sun is actually setting, you'll encounter a fading light source with a window of 30 minutes. Be sure to allow enough time in case you run late.

TRENDS

A popular creative trend right now is called "Trash the Dress," (TTD) also known as fearless bridal or rock the frock. I met Matt Adcock and Sol Tamargo a few years ago while teaching at a photo workshop retreat. Besides being wonderful people, they are award-winning, international destination wedding photographers, based out of the Riviera Maya Mexico. They have had overwhelming success with the TTD phenomenon since it started back in 2005. Their photo studio receives thousands of inquiries each year, and more than half of them are interested in a TTD session. A typical session is shot after the wedding day, and before the dress is cleaned and goes into storage, the bride poses while getting her wedding gown dirty for the camera. Exactly how dirty depends on the bride. Some walk through the woods, while others wade through puddles of mud, swim in pools, or dive underwater, as shown in Figure 5.14.

A popular Trash the Dress style theme contrasts elegant clothing with an unexpected environment. Location ideas could include a beach, city streets, rooftops, garbage dumps, fields, or an abandoned building. Sometimes the groom is also part of the TTD experience, as shown in Figure 5.15.

This underwater Trash the Dress shot was taken the day after the wedding. © del Sol Photography

5.14

Trash the Dress images are known for being very unique. © del Sol Photography

5.15

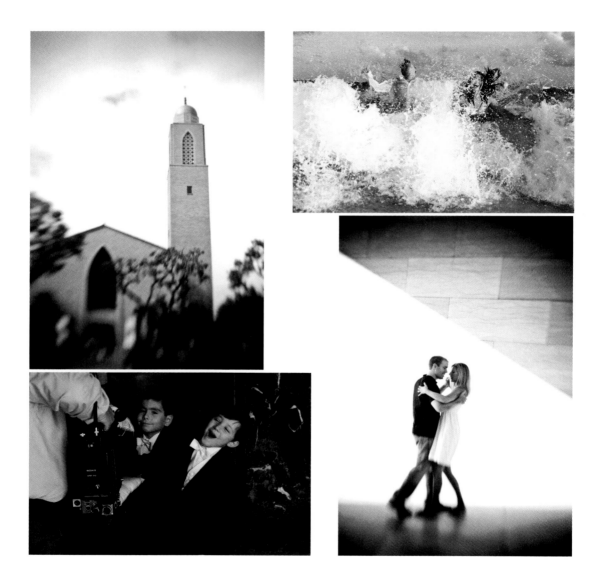

CHAPTER REVIEW

A Schedule an engagement photo session so you can get to know the bridal couple and establish an atmosphere of relaxation.

B Anticipate special moments and always be prepared with your camera.

C Experiment with various lenses and create a style that's all your own.

D Plan creative photo shoots and strive for innovative imagery.

6

food and product photography

The job of the food or product photographer is to elicit a desire — whether for a delicious steak, a gorgeous pair of shoes, or the latest electronic gadget. Capturing the perfect food or product image requires a creative eye, a great sense of style, a keen attention to detail, and considerable photographic skill.

Q&A WITH A WORKING PRO

Food photographer Lou Manna has spent more than 35 years creating images of all things edible. Throughout his career, which includes 15 years as a photojournalist for *The New York Times*, Manna's photographs have appeared in more than 40 cookbooks. Major companies and institutions such as Kraft Foods, Dannon, and the Culinary Institute of America, as well as leading industry publications including *Wine Enthusiast* and *Food Arts*, have used Manna's photographs in their marketing campaigns and magazines. He has also shot for many celebrity chefs, including Bobby Flay, Jacques Torres, and Lidia Bastianich. Additionally, his numerous television appearances have included segments on the Food Network and ABC-TV's *World of Photography*. In 2002, Manna was honored as an Olympus Visionary Photographer and currently lectures and teaches for Olympus.

In addition to being an award-winning photographer, Manna is an established public speaker and educator. His highly acclaimed book, *Digital Food Photography*, published by Cengage Learning, is in its fourth printing. This is the first book about food photography to focus exclusively on digital technology. Manna is currently writing and shooting for his next book, *More Digital Food Photography*, which provides more details on lighting setups, equipment, composition, food styling, resources, and other related topics. Manna also teaches workshops on food photography, where he delights in sharing the tricks of his trade.

1. Can you tell me about your background — your personal, professional, and educational history? How about your continuing self-education?

Growing up in an Italian neighborhood in Brooklyn and being of Italian descent, I developed an early affection for food that was soon matched by my passion for photography. I always loved taking photographs. This interest developed and led me to study photography in high school and college, join photo clubs, and take pictures for my respective schools' student yearbooks and newspapers.

While in college, I started working for several Long Island newspapers and sold my first photos. I realized that if I could make a living doing something I loved, I should pursue it as a career. I formally switched my major from Electrical Engineering to Communications. I graduated with a degree in Communications from Stony Brook University, where I studied photography, film, video, art history, and psychology, among other subjects. I believe that my well-rounded education has been an asset to me throughout my career. I also feel strongly that continuing photographic education is imperative, and I regularly educate myself through workshops, seminars, online, and at trade shows.

2. What attracted you to food photography?

My early work during college allowed me to create a portfolio for photojournalism. In 1975, I began shooting news, food, and feature stories for *The New York Times*,

where I worked for 15 years. Many of my early assignments involved covering culinary events at the home of Craig Claiborne, a world-renowned food reporter and restaurant reviewer for *The New York Times.* Famous chefs from all over the world would come to his house to prepare their favorite dishes, which I not only photographed but got to eat as well. It was then that I realized that I was blessed to be in the presence of fabulous chefs while I enjoyed their delectable cuisine. It was great! I know it's a tough job, but somebody's got to do it.

Another benefit was that the chefs would later ask for more photos and other pictures of their restaurants, food, and so on. Such environments allowed me to combine my interest and skills as a photographer in a dynamic setting filled with a vibrant and diverse set of people, including chefs, stylists, designers, and other artistic individuals. I just fell in love with food photography! It is edible and beautiful!

Craig Claiborne said, "The important thing about being a real photographer is not only having a great lens, but having a feeling of

Having a sense of style helps when you're photographing food. © Lou Manna 6.1

warmth, collaborating, and bringing out the best of a subject. It requires a sense of style and a feeling of creative arrangement. Lou is marvelous at this." But food photography is only about 60 percent of what I do. I also do a lot of other photography of products, interiors, portraits, and events.

3. How did you start your business? How did it evolve? Did you have a studio or did you shoot on location?

While at *The New York Times*, I also did some freelance work on my own from a small studio within my home. During that time, I met many influential people who were in a position to hire a photographer, and I was able to get new clients and build up my freelance business by networking with my contacts, showing my portfolio as much as possible, and sending out promotional pieces. A major newspaper strike occurred that allowed me the opportunity to do freelance work on a more regular basis. In 1990, I opened up my own studio on New York City's 5th Avenue, where I currently photograph food, products, and people. I also shoot on location for restaurants, hotels, corporations, and agencies.

4. What was the toughest thing about getting started? What was your worst experience when you began? What did you learn from it that helped you in the future?

Like any business, buying equipment and establishing a client base can be challenging. I was fortunate in that I was able to gradually build my own business while still having a position at a prestigious newspaper.

I did have one terrible experience when I was shooting film. The photo lab that I was using called to tell me that they had a problem with their machinery and that my film was ruined. I had to shoot the whole job over and absorb the expenses. I learned not to process all my film at the same time and to spread it out. This same concern has carried over to the digital world such that I download my memory cards right away and back up my data as often as possible.

5. What tactics and strategies were most useful in developing your photo business? Was there anything that marked a turning point in your business — a contact, a realization, an idea?

Of course, client satisfaction is a key element for success. Making a client happy will almost certainly guarantee return business. I have spent more than 30 years developing my techniques. The niche of food photography often requires elaborate styling and lighting setups that are essentially unique for each shot depending on the food and purpose.

The combination of the quality of my work and my relationship with clients helps ensure they will stick with me even in difficult times. I try to provide them with something different that they may not envision but that exceeds their expectations. Clients often come to me with an idea of how they want a shot to look. In addition to shooting according to their specifications, I also offer them a few shots of my own. They almost always reply with, "Wow, I didn't know it could look that good!"

With the high-quality photos I shoot, some of my clients have claimed that sales have gone up more than 100 percent. People are attracted to the food because of the way that I capture it in my pictures, and that keeps driving my current clients back to me and proves that investing in a professional photographer is certainly worth the cost.

Delivering a unique and artistic image is the most important strategy for success. Other "best practices" include networking to meet people, joining professional organizations, going to conferences, and attending workshops. Besides improving my skills, I make connections in the industry, which lead to jobs. In today's world of the Internet, a diverse online presence via a Web site, blog, and other social media outlets is also essential.

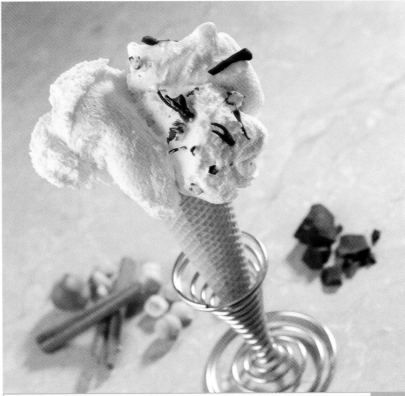

Shooting from various angles helps add visual interest to the image. © Lou Manna 6.2

6. Do you have any food photography tips for better photographs?

In food photography, you eat with your eyes first. You have to create a composition that keeps your eye in close to the food. My photographic style is clean and simple. Lower camera angles, a sharp focus area, and shallow depth of field help to achieve this. For me, specular highlights (pinpoints of white light) are very instrumental to get food to jump off the page. Whether the effect is achieved with lighting and mirrors or with any number of other techniques, the key is to create images that tantalize viewers and satisfy clients. The goal is to shoot pictures that are simple, fresh, and natural-looking without a lot of other distracting elements. Often having less is more — and better!

Here are some helpful tips for styling food if your budget does not allow you to use a food stylist to make food look more appetizing:

■ Strive to obtain contrasting colors and shapes of the food items.

- Undercook the food so it doesn't look dried out.

- Brush food with vegetable oil to add shine and highlights.

- Spray a 50-50 mixture of glycerin (available at most drug stores) and water to create moisture droplets to make fruit and vegetables look fresh and drinks appear cold.

- Manipulate small elements with tweezers.

- Clean up plates with Q-tips, paper towels, and glass cleaner.

If possible, try to work with a prop stylist. A prop stylist can help enhance the setting by selecting props and elements to create an appropriate mood for the image. If you can't work with a prop stylist, consider these points:

- Use props that are small, light, and soft in shades of color.

- Experiment with solid and textured background cloths rather than stripes and patterns.

- Try to keep any props simple so the food is the star.

Having the ability to control light on the subject is the key to successful food photography. It creates a great photo that makes your mouth water! Here are some lighting tips:

- Avoid using direct flash because it flattens the subject.

- Bounce the flash or light off to the side of the subject to give the food more dimension and some shadow for depth.

- Put detail in the shadows and create highlights with mirrors and reflectors.

- Use household items such as aluminum foil as a reflector and wax paper as a diffuser.

- Take a custom white-balance reading off a white or gray card for accurate color rendition.

- Create warmth in a photograph by using gold reflectors.

- Minimize unwanted reflections in silverware by using a small piece of putty underneath to slightly angle it.

Another important aspect of food photography is framing. When composing a food-photography image, think right: that is, because you read from left to right in English, a spiral, clockwise composition draws the eye in and makes the image more appealing. Creating a diagonal composition or using the Rule of Thirds helps to make a more dynamic photo. Experiment with the angle of the shot and depth of field to make the photo interesting and captivating. Simple, clean images without distracting backgrounds are always best.

7. Do you shoot RAW or JPEG? What software programs do you use to review, edit, organize, and enhance your images? How do you handle your workflow?

I shoot both RAW and JPEG with my Olympus cameras and RAW with my Phase One Back. I like to have the JPEG file for quick viewing and to e-mail to the client. I shoot tethered to a laptop or a 40-inch, high-definition monitor so the client can

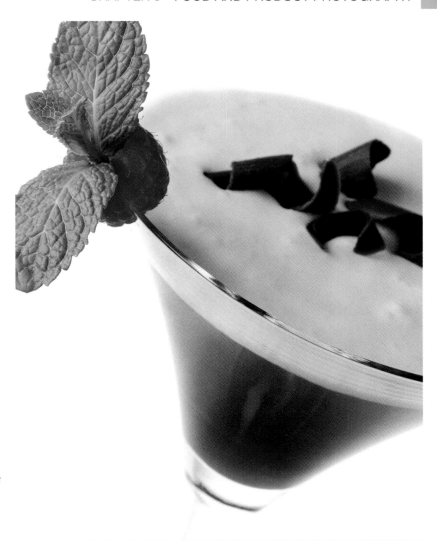

choose the photos together and save some time in editing and selection later. I download the images and store them in a folder that I name with the year, month, day, client name, and job title. Within this main job or client folder, I create four other folders titled Originals, Selections, Print, and Web. In the Originals folder, I save the original captures. I copy the photos we decide to work with from the Originals folder into the Selections folder. Then I open up the selected images in Adobe Photoshop and begin retouching, and label them as working files. The name of the working file retains the original image number in case I need to refer back to it. After final retouching is completed, I resize a working file to make one

This composition uses the Rule of Thirds for visual interest. © Lou Manna 6.3

with high resolution for printing and one with low resolution for use on Web sites or in e-mails. These files are saved in their respective Print and Web folders. I back up jobs chronologically on DVDs and store copies in the studio and offsite, just to be safe.

8. Can you name some of your favorite equipment (cameras, lights, computer, software, printer, and any photo-related gadgets)?

I use Olympus cameras and lenses because I love the quality of the digital lenses and sensors that are automatically cleaned by

an ultrasonic wave filter. The cameras are easy to use and are ergonomically well designed. The edge-to-edge sharpness, reliability, and accuracy of the exposure are ideal and especially important to me when shooting food. To be more specific, I can't get enough of the Olympus E-P2. It's a new, small, user-friendly camera that fits in my pocket, but with a sensor that is the same size as the one in my Olympus E-30 and E-620. The Olympus E-P2 is similar to the E-P1, which was my primary camera on a recent shoot that I did of the luxury suites at Yankee Stadium. I also used it exclusively when I shot the US Open. My favorite lenses are the 50mm Zuiko digital f/2 macro lens and the 50–200mm Zuiko digital f/2.8–3.5 zoom lens. The most recent addition to my Olympus family of cameras is the Olympus E-5, and I'm including it more frequently in my photo shoots. In addition to Olympus equipment, I use a Phase One Back for my Hasselblad system with a Carl Zeiss 120mm macro lens.

As far as lighting equipment, I use Norman power packs and heads with various reflectors. Elinchrom is one of my favorite brands of monolights. Assorted reflectors and grids round out my lighting instruments. For light modifiers, I use a Photek Illuminata II Octagonal light bank and softboxes that are 2-by-3 feet and 3-by-4 feet; umbrellas that are white, silver, and zebra; and grid spots with varying degrees. I have many mirrors and reflector boards of various sizes and shapes with different surfaces and colors.

9. What feeds your creativity? Where do you find your inspiration — for example, other photographers' work, art, or any particular travel experiences?

When I travel and visit restaurants, I notice how the food is presented, which helps my creative process when shooting. I also watch the food stylists in my studio and chefs on TV as they prepare dishes, and I observe interesting trends and styling techniques that I can incorporate in my images. One day I will shoot pasta and the next day brownies, so the variety keeps my mind and stomach satisfied. I never find it hard to remain passionate about my work because each day is unique, loaded with new subjects to photograph. I love what I do and I have been told that my enthusiasm is infectious.

I enjoy going to the museums to view all types of images, from Renaissance still lifes to the work of photographic masters such as Henri Cartier-Bresson. I often go to photo exhibitions and galleries in New York City to see current work that inspires me. There are several food events throughout the country that I attend, where many chefs and clients provide innovative presentations and exhibits.

My technical skills are balanced with inspiration from within. As a food and commercial photographer, it is my clients who select the subject matter of the shoot. It is my job to take something ordinary and make it extraordinary. Typically, I take the shots my clients request; then I go beyond that with what I like to call "Lou shots." These blend

my style, experience, and vision with my clients' commercial goals. Most of my images are different because of the angles, lighting, and attention to detail in the highlights and shadows. I strive to create specular highlights with mirrors when I photograph food and still-life subjects.

I always advise photographers to shoot every day and to vary the subject matter. Try different lenses, lighting, and angles and look to shoot even the most ordinary subjects in a different way. As a photographer, you really do need to think outside the box and get creative.

10. How do you market your work (newspaper, referral, Web site, online marketing, social networking, printed collateral)?

The old adage, "a picture is worth a thousand words," still rings true. I use my photographs on my Web site and blog as my main marketing tool. I often post photo updates to social media sites such as Twitter, Facebook, and LinkedIn. When I attend various events and network, I present a beautiful business card with a mouth-watering food photograph on the front. The importance of a photograph in our society is now greater than ever before.

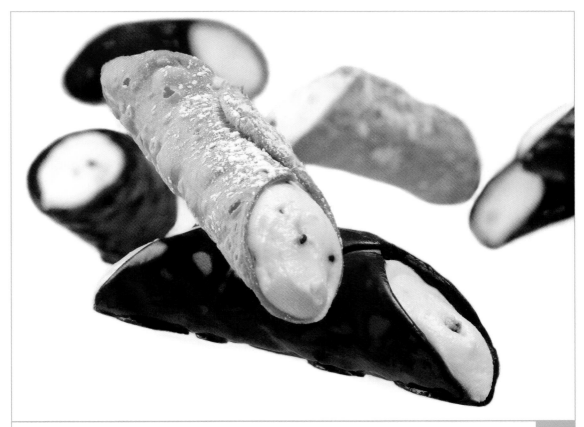

Attention to detail and a creative composition help to enhance to appeal of this dessert. © Lou Manna

6.4

127

My book, *Digital Food Photography*, has also helped me to establish a reputation as an authority on the subject. At networking events I carry a copy of my book to illustrate my expertise and to promote my business. I also use digital devices such as an iPad and iPhone to easily present high-quality samples of my work.

11. Are there multiple ways that you make money with your product and food photography? Which area of distribution have you found to be the most profitable?

The main way that I make money is through jobs for clients, and a small portion is through stock photography. Teaching and writing have been other sources of income for me. I give private and public workshops in my studio and at various locations. My book, *Digital Food Photography*, has been a good source of income and publicity.

ESSENTIAL GEAR

Food and product photographers tend to shoot still-life images, often with complicated lighting setups. Key pieces of gear include the following:

- **Camera.** A dSLR camera is the way to go when photographing food and products. The ability to interchange lenses gives the latitude to produce unique and visually compelling images. Read more about cameras and lenses in Chapter 2.

- **Lights.** Many food and product shoots take place indoors in a studio setting, with a full complement of lighting gear. A truly professional approach involves the use of an external flash, strobes, soft boxes (a special type of lighting device that casts soft, diffuse light), and so on. Strobes in particular bring out the subject's detail, color, and texture.

- **Reflectors.** To add specular highlights to your subject, you can use both lights and reflectors. (*Specular highlights* are bright spots of light that appear on shiny objects when they are illuminated, giving them life and dimension.) The shape of the reflector dictates the shape of the specular highlight on your subject. For example, using a round umbrella reflector yields a round highlight, while using a rectangular reflector results in a rectangular highlight. The distance of the reflector from the subject will affect the size of the highlight. As mentioned in Chapter 2, store-bought reflectors are available in white, silver, and gold; alternatively, you can create reflectors from white cardboard, mirrors, and the like.

TIP Avoid using direct flash. In addition to creating awful shadows, it flattens the subject matter, obscuring its color and texture. Instead, bounce the light off a ceiling, wall, or reflector.

When photographed with a wide-angle lens, elements in the foreground appear larger than those in the background. A wide-angle lens also exaggerates distance and perspective. In contrast, telephoto lenses compress distance and make objects in the foreground and background appear similar in size. Using a telephoto lens also results in a shallower depth of field.

■ **Light tent.** You can use a light tent to create a soft, diffused environment when photographing small objects. Made of a transparent white fabric or plastic, light tents are available in various shapes and sizes (see Figure 6.5). You can produce beautiful images of small products using a light tent lit with natural light or a simple lighting kit.

■ **Lenses.** Food and product photography can involve a standard complement of lenses — a wide-angle lens, a normal lens, and a telephoto lens. You may also need a macro lens, which enables the camera to focus at very close range (see Figure 6.6).

■ **Backdrops.** Many food and product photo shoots require the use of backdrops ranging from plain, white paper to sets with carefully selected objects placed to both complement and emphasize the subject of the shoot.

■ **Tripod.** To ensure a sharp photo, use a tripod whenever possible.

A light tent can easily be used in natural light. I placed this tent out in my backyard on a sunny day to capture images of small products. © Michael Welch

6.5

Using a macro lens enables you to focus at very close range and create a shallow depth of field.
© Erin Manning

6.6

BEFORE THE SHOOT

When preparing for a product or food photography shoot, your first order of business is to ask your client what the photo will be used for. The answer to this question will determine your entire approach to the shoot.

Most likely, the answer will be one of the following:

■ **Advertising.** Photos taken for use in advertising, such as in magazines, billboards, product brochures, point-of-purchase displays, and so on, are designed to entice people to buy the product, and so must be perfect in every way (see Figure 6.7). As such, the shoots for these photos are by far the most labor- and time-intensive, often involving stylists and props. Note that when shooting a photo for advertising purposes, you are generally guided by the vision put forth by the campaign's art director.

■ **Product packaging.** Often, a product's packaging includes a photo of the product. This photo is usually a close-up view of the product in sharp focus. Props are kept to a minimum. Note that when photographing for product packaging, you must adhere to a very precise layout in order to leave space for type, product logos, and other graphics, as shown in Figure 6.8.

TIP

Images shot for product packaging are often reproduced on a variety of surfaces, including plastic, paper, and cardboard. To ensure that the proper level of detail is maintained on each surface, you should photograph these images with a lower-than-normal contrast range.

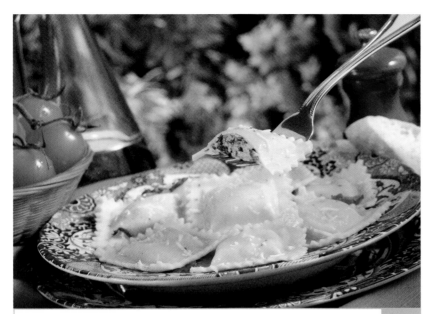

Photos for advertising must be perfect, with attention paid to every detail.
© Lou Manna

6.7

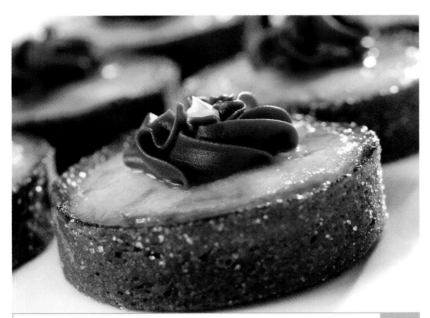

Photos for product packaging usually omit props in order to focus attention on the product. © Lou Manna

6.8

■ **Media usage.** Food and product photos to be used with editorial content — for example, alongside articles about the item or, say, a recipe — typically reflect reality more than images destined for use in advertising (see Figure 6.9). You do not need to achieve perfection. Note that taking photos for use with media content usually allows for more creativity and freedom on the part of the photographer than creating images for other purposes.

■ **Industry publications.** Photos in industry publications are used to introduce a new or improved product or an updated design or package to people in the trade. As a result, they tend to be simple and straightforward, shot against a plain background with little or no embellishment (see Figure 6.10).

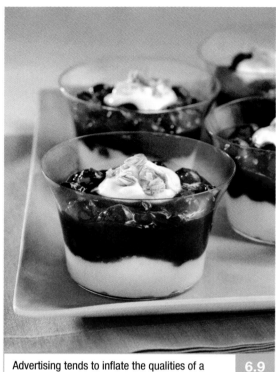

Advertising tends to inflate the qualities of a product, whereas editorial photographs are more straightforward and reflective of reality.
© Lou Manna

6.9

■ **Public relations.** Sometimes, photos taken for PR purposes are distributed to the media as part of a new product launch. Others are used in PR campaigns to communicate something newsworthy about the product. To increase the chances that a PR photo will be selected by a journalist or editor for inclusion in a piece, opt for a more natural, less staged effect with your photo — something simple and clean (see Figure 6.11).

Once you know what the photo will be used for, you are ready to answer the following questions:

■ **What is the budget for the shoot?** You'll find that photos for advertising command the highest budgets because they require the most preparation and resources. Budgets for packaging photos are also high. Photographs for PR relations and media usage have lower budgets, as do photos for industry publications.

Crisis Averted

Years ago, when I was beginning my photography career and trying to expand my business, I agreed to photograph furniture for a friend of a friend's catalog. I had no training as an interior or furnishings photographer; my specialty was taking images of people. But I thought, how difficult could it be? Besides, I needed the money. I hired an assistant and rented some lights.

It was a disaster. The furniture was very dark and heavy and it was nearly impossible to light with the equipment we had available. Worse, the client was on a budget and didn't hire anyone to help with the shoot, so my assistant and I ended up hauling heavy furniture around and dressing the set. We lined up the items one after the other to be photographed, like an assembly line. I quickly realized that I needed more lights, but I couldn't afford to rent them. Needless to say, it was *not* the creative adventure I had hoped for.

I did eventually manage to give the client what he needed, but it took me three days instead of one, a lot of frustration and hard work, and required no small amount of help from my friends. In the end, I didn't make a profit, and I almost damaged my emerging reputation. I did learn one important thing, however: I never took on a job I wasn't prepared for ever again. (Of course, don't let me dissuade you from photographing furniture if that's your interest!)

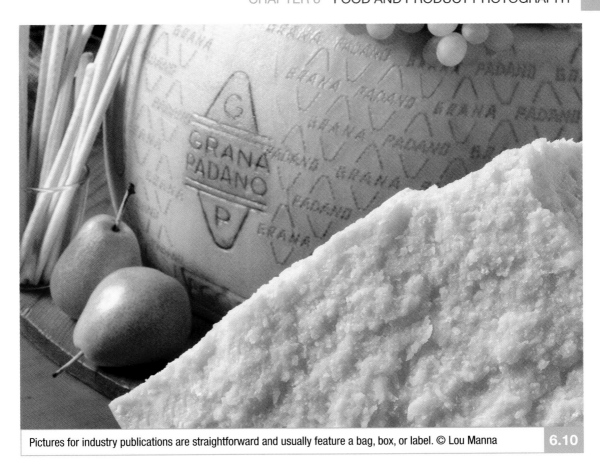

Pictures for industry publications are straightforward and usually feature a bag, box, or label. © Lou Manna **6.10**

■ **Will you need a food stylist?** Styling food — from ice cream to corn flakes and everything in between — is a specialty. A food stylist seduces the viewer by creating food that appears exciting, enticing, and effortless to prepare. If you can't afford a food stylist, consult a gourmet friend, look at food magazines, and perhaps even take a class in food styling. You could try asking caterers who are food stylists to trade their services in exchange for pictures.

■ **What props, if any, should you use?** A prop stylist is responsible for designing the set in which you will photograph the product or food item. If you're just starting out, a prop stylist might not be in the budget. In that case, get creative. Come up with your own ideas. A prop might be anything from a bunch of flowers to a

TIP — Lou Manna's interview at the beginning of this chapter provides a lot of helpful information on food styling. This is especially helpful if you're on a tight budget.

Go with a more natural-looking photo when shooting for PR purposes. © Lou Manna

6.11

special fork to a colorful serving plat-ter — anything that sets the tone and provides context for your food and the message you want to convey. For ideas, check out Italian Renaissance still-life paintings that involve food and peruse the pictures in the various high-end food magazines. Analyze what makes them work.

■ **Will there be people in the picture?** Some food and product images also feature models, often holding the item for emphasis (see Figure 6.12). This

Shooting Food

Shooting food involves some special considerations, specifically that when you place food under hot lights, it can quickly lose its visual appeal. For this reason, many food photographers use stand-in food or other items — such as a crumpled-up paper napkin in lieu of vanilla ice cream — when setting up the scene, replacing it with the actual dish when they're ready to capture the shot.

type of image can be perceived as a hard sales technique, but the ultimate goal is to seduce the viewer into want-ing to be part of the scene — eating

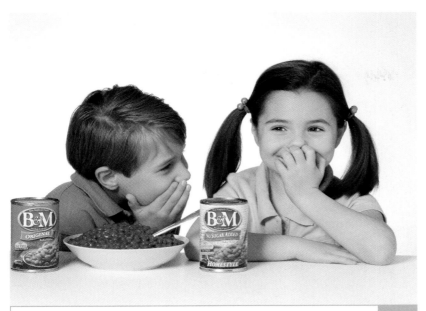

If you are including a model in the food or product shot, be sure to secure a model release! © Lou Manna

6.12

at a table filled with wonderful food, surrounded by friends, in a place they always wanted to be. Look at travel magazines that incorporate food to see how other food photographers use models in their images.

■ **How large will the image be when it is reproduced?** An image bound for a two-page advertisement spread in a magazine will require a composition with a more complex background, the addition of props, and so on, as shown in Figure 6.13. An image destined to appear on one square inch of a brochure will require a simpler composition, as shown in Figure 6.14.

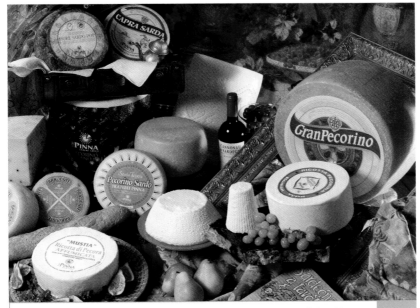

An image for a two-page ad requires a more involved composition. © Lou Manna

6.13

This simple image would work well if it was cropped for a brochure.
© Lou Manna

6.14

AT THE SHOOT

A food or product photo shoot typically occurs in a controlled environment — often in a studio where the set, lighting, and other aspects are carefully planned. That being said, there are often several cooks stirring the pot. At any given shoot, you may have to contend with input and feedback from a prop stylist, a food stylist, and if the photo is destined for use in an advertising campaign, the art director, as well as from any of their assistants. No matter what, remain professional *and* personable.

TIP

Most clients will come to you with some idea of how they want the shot to look. Take a few shots that reflect their vision, and then add a few of your own ideas to the mix.

Here are some general tips for shooting products and food:

■ **Tilt the camera.** This places the subject slightly off center while creating movement and flow, resulting in a more dynamic image (see Figure 6.15).

■ **Frame the subject.** Having darker elements in the perimeter with lighter elements in key areas serves to frame the image, drawing the viewer's eye toward the parts you want to emphasize (see Figure 6.16).

TIP

Experimentation is a good way to discover what you like and what you're good at, but be careful about how much of your time, money, and reputation are on the line.

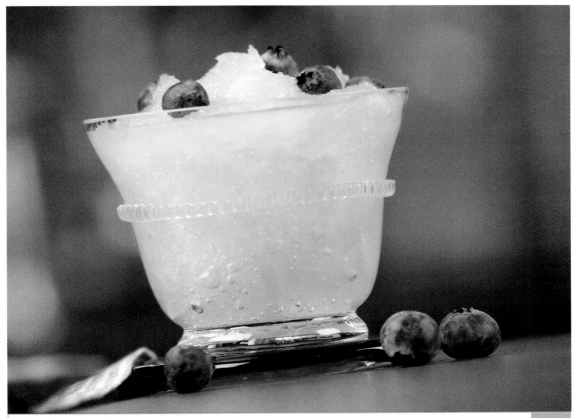

For a more dynamic image, try tilting the camera. © Lou Manna 6.15

■ **Keep it simple.** When it comes to product and food photography, less is almost always more (see Figure 6.17). Avoid including too many objects; you don't want to crowd the space.

■ **Shoot tight.** Filling the frame with your subject adds impact (see Figure 6.18).

■ **Blur out background clutter.** Using a narrow depth of field blurs the background, which can serve to dramatically highlight your subject (see Figure 6.19). With this technique, the viewer is naturally drawn to the sharper elements of the image, with the out-of-focus elements complementing the subject and adding visual interest.

Frame to draw attention to the subject.
© Lou Manna

6.16

Fill the frame for greater impact.
© Lou Manna

6.18

This simple composition provides interest and
draws attention to the pecan pie. © Lou Manna

6.17

Although the emphasis of this chapter is food photography, there are other areas of product photography that you might want to pursue. You should be aware, however, that product photography can be a very technical and expensive endeavor, and can require a lot of training and experience.

If you want to explore product photography, start small and allow yourself room to grow rather than tackling projects beyond your capabilities and budget. Don't take a job photographing for a print campaign for diamond necklaces; that will require

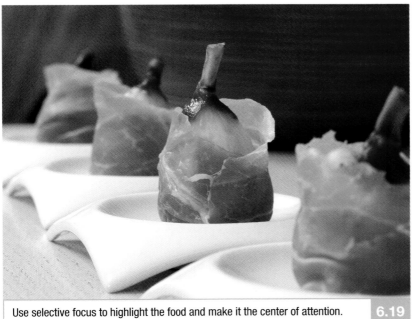

loads of experience, not to mention expensive equipment. Instead, photograph costume jewelry for a friend's Web site — something you can do with a creative eye, an entry-level dSLR camera, and natural light (see Figure 6.20). Otherwise, you may wind up damaging your burgeoning reputation as a photographer.

Use selective focus to highlight the food and make it the center of attention. © Lou Manna

6.19

This necklace image was taken for an online Web site using a translucent white light tent. © Erin Manning

6.20

CHAPTER REVIEW

A Often, what a food or product photo will be used for — advertising, product packaging, media usage, industry publications, or public relations — dictates your approach to the shoot.

B If your budget allows, seek the services of stylists — a prop stylist and, if the subject of your photograph is food, a food stylist — on your shoot.

C Tilting the camera, framing the subject, keeping the scene simple, shooting tight, and blurring out background clutter are great ways to focus the viewer's attention on the product in your photograph.

D Product photography can be a very technical and expensive endeavor, and can require a lot of training and experience. If you want to explore product photography, start small and allow yourself room to grow rather than tackling projects beyond your capabilities and budget.

7

travel photography

Travel photography requires that you know how to capture many types of images: portraits and candids; journalistic street photography at festivals and celebrations; architecture and cityscapes. Becoming accomplished in this genre requires that you bring forth all your talents, utilizing what technology has to offer while developing an eye for composition and a feel for being in the right place at the right time.

This chapter gives you real-world advice from a professional, working travel photographer. He shares his secrets and insights about how to create travel photos that convey a powerful sense of place and capture rare moments, as well as techniques for capturing and marketing your photographs. If you enjoy travel photography and are willing to invest some time learning the ropes, it is possible to make a profit.

© Lorne Resnick

Q&A WITH A WORKING PRO

Lorne Resnick is an award-winning photographer who is based in Los Angeles. His passion for travel and photography keeps him moving around the globe, exploring different cultures and countries, and capturing unique moments. Resnick's striking commercial and fine-art images have been exhibited in galleries across Europe and America, and have been used commercially for annual reports, billboards, television, Web sites, and worldwide advertising campaigns. He currently has nine fine-art posters published of his travel work. He recently won the Travel Photographer of the Year award, as well as first place in the International Photography Awards.

1. Can you tell me about your background — your personal, professional, and educational history?

I was born in Toronto, Canada and got involved with photography by the same manner I continue to be involved: shooting my passions. I was, and continue to be, a passionate music fan — of blues and rock, like Buddy Guy, Van Halen, Led Zeppelin, and so on. Toronto was a major stop for all the big bands and I started going to all the concerts and shooting. I felt compelled (obsessed) to find that one moment that would summarize and capture the feelings I had during the show — the power, the noise, the intense energy. Years of this led to my first book, *Live in Concert: 10 years of Rock 'n' Roll*. Soon after the book came out, a friend of mine approached me and said he was going to backpack around Europe. It sounded good to me. I finished my first and only year in college and started travelling with my camera and have never looked back.

My obsession with travel and capturing unique and compelling moments has stayed with me. In the ensuing decades, I have traveled to 22 countries in Africa during a one-year trip, visited Papua New Guinea, China, Europe, Vietnam, Greenland, and spent more than a year in Cuba over 14 different trips, just to name a few places.

While I never had a formal photographic education, I always try to sharpen my skills by reading books and magazines, attending seminars, talking to other photographers, and looking at photographic books, of which I have a large collection. While I think having a formal education in photography can be useful, I also feel it is vital for a photographer to generate the skill of critically looking at her own work and understanding what is already out there. In this way, you are able to move your own work forward. Attending a photographic school and asking a lot of people for advice on your work can be a double-edged sword. It can very useful but also leads to the production of a camel — a horse designed by committee. If you ask enough people about your favorite image, pretty soon you're going to think it's not worth the paper it's printed on. You need to develop the ability to analyze your own work while taking limited, selective feedback from others.

In his book *Travels*, Michael Crichton says: "Stripped of your ordinary surroundings, your friends, your daily routines, your refrigerator full of food, your closet full of clothes — with all this taken away, you are forced into direct experience. Such direct experience inevitably makes you aware of who it is that is having the experience. That's not always comfortable, but it is always invigorating." This is a powerful

notion. When I started to travel, I kept on having similar powerful experiences of "peak moments" (see Figure 7.1). These were moments when I felt fully and deeply engaged in life, when I felt clear, balanced, and powerfully alive, whether walking the Malecón in Havana with the warm sun on my back, dog sledding in Greenland, climbing Mount Kilimanjaro, rowing down the Mekong Delta in a scissors boat, or having a quiet coffee in a café on Leidseplein in Amsterdam. And, capturing as many of these moments as I can helps me to crystallize and hold onto those beautiful, precious memories. In the end, it can all be summed up in one word: fun.

2. How did you start your business and how did it evolve?

I started from the outside in, instead of the inside out. However, I think a lot of people follow the route that I recommend to them: that of learning from someone else in the business by becoming an assistant or an intern. I did it the other way around, which was by basically traveling around the world for 15 years, taking photos because I enjoyed it (see Figure 7.2). I think this may have led to my grasping a sense of my own vision more quickly, but definitely also led to my business skills suffering and me having to work harder to bring them up to speed.

I really like the Michael Crichton quote, "Often I feel I go to some distant region of the world to be reminded of who I really am." © Lorne Resnick **7.1**

This one instant conveys the unique, sexy swagger only the Cubans are capable of.
© Lorne Resnick

7.2

The financial end of my work started with submitting my images to stock agencies and selling my own stock. To this day, that remains one of my main sources of income. From there, I started selling limited edition prints of my work and moved into shooting travel- and non-travel-based commercial work for ad agencies, design firms, and various companies.

I have never really had my own studio. I have my own digital studio where I work on my images and generate my limited

edition prints. When I need a bigger space, or have a commercial shoot, I simply rent a bigger studio.

3. What was the toughest thing about getting started and what did you learn from it?

For me, the toughest thing about getting started was the business end of photography. A lot of that had to do with the way I got started. I'm sure if I had done more assisting or had an internship, I would have understood more about the business side a lot faster. Unfortunately, the business of photography can often appear like equal parts economics and voodoo. How much do you charge a client if they want to use your image for a series of posters that will be sold worldwide? What usage license do you estimate for a client if they want you to generate images for them that will be used in North America, for Web sites, brochures, and billboards for a period of three years? It can get very complex and there is not really a handbook one can refer to.

4. What tactics and strategies were most useful in developing your business?

Some photographers can be secretive about their techniques and business practices. Once of the best things I ever did was to join a local photographic organization and start making friends in the community that I could reach out to when I had a question. For example, you may never have shot hot tubs before, but someone else has. Developing a network of peers is vital in moving your business forward. I have found time and time again, almost without fail, the

most successful and brilliant photographers are invariably the most open to sharing their "secrets" and knowledge. A fundamental turning point in my career occurred when I understood the concept that I could pick up the phone and reach out to other successful photographers, who had more experience than I did, and ask for help.

Another concept that I am continuing to explore is the critical analysis of photos. I have always been a huge fan of great photography, but once I started to *really* look at my own and other photographers' work with two words in mind, my work started to accelerate. Those two words are *why* and *where*. Why is that photo so good or impactful and where did that photo end up? In other words, what were the elements that made that photo so good that it found its own market? This analysis fundamentally changed the way I look at images and was a huge leap forward for me. It is important to develop your own formula for what you feel goes into making an impactful image and how to move that image forward in a very competitive marketplace.

5. Do you have any travel tips for better photographs?

While I'm sure everyone who shoots for a living is interested in creating great, beautiful, gorgeous images, I believe the key is to create impactful images. An impactful image is an image shot for, or targeted to, a specific audience from which you desire a certain outcome.

For example, you have an image hanging in a gallery, and someone views it and is so impacted by it that he pulls out his checkbook and utters the magic words, "How much for that one?" Or you send an image or a series of images to an art buyer at an agency. As a working photographer, you don't necessarily care if she thinks the images are beautiful, awesome, or amazing. You hope she is so impacted by the work that she *needs* you to shoot a campaign for them.

So, how to create more *impactful* images?

- **Find out what other photographers have done.** If you don't know the kind or quality of work that previous photographers have shot, how can you provide the marketplace (magazine/ book editors, stock agencies, art galleries, and so on) with something different or better?

- **Understand why you are shooting something.** Are you shooting for the commercial market? If so, then maybe you need some models with stylists and makeup. Are you shooting for the fine-art market? Maybe you need to try some interesting effects, as in Figure 7.3 (black and white, Polaroid transfers, blurs, and so on). Also, understand that while iconographic images are always in demand (Eiffel Tower, Egyptian pyramids, and so on), everyone and their mother have shot them, so you need to study what's out there and come up with a unique view if you want to succeed.

- **Learn to look critically at your work.** Examine other photographers' work as well as your own to understand why certain images work and others don't. Go beyond just looking at composition and consider other aspects of your image. What did you

147

include and exclude in your frame (see Figure 7.4)? What kind of light are you using (golden light, midday)? What technique are you using and why? Does the Eiffel Tower seem more impactful in black and white or color? Examine the moment that you captured that image. Is that the best possible expression of your subject?

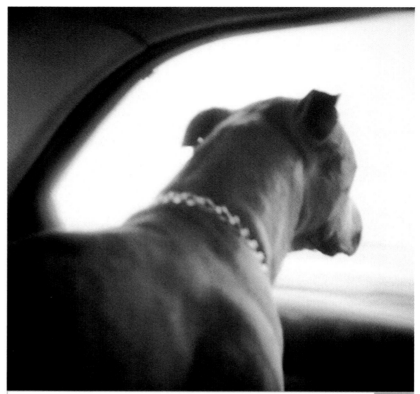

The out-of-focus dreamy effect adds to the emotional impact of this image and the feelings it evokes from the viewer. © Lorne Resnick

7.3

6. How do you fund your travels?

At the beginning, they were all self-funded. I'd work, save enough money, and then travel and shoot — basically shooting my passion. Eventually, my travels became funded by the images I put into stock agencies, my own stock sales, fine-art print and poster sales, and commercial shoots.

7. What are your favorite pieces of equipment?

Over the last 25 years, I think I've tried out most of the big camera manufacturers. In the end, I settled with Canon. I initially shot with film and now I shoot strictly digital. My opinion is that for the most part, if you say that digital is not up to the same quality as film, then you don't understand how to use your digital equipment. I can blow up a digital file (properly processed from a good camera) to 8 feet and most people ask if I use medium format. Digital is now that good. It's also way more fun than film, which always leads to better images.

I'm a big fan of the full-frame professional Canon digital cameras. I use the EOS-1Ds and 5D bodies and am now shooting video when I travel.

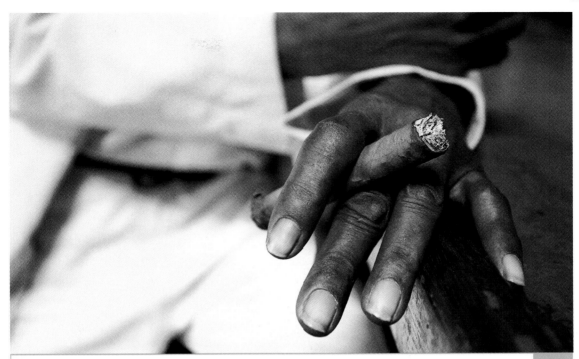

This image is one of several that establish a sense of place by focusing on an isolated detail — the hand holding the cigar. © Lorne Resnick

7.4

I think one of the ways you can generate impactful images is by expressing the world in very different ways than how people usually see it. Some of my favorite lenses are the more extreme ones that alter that perspective: the 14mm f/2.8 lens, the 85mm f/1.2 lens (for amazing selective focus), and the 90mm f/2.8 tilt-and-shift lens (for gorgeous blurs). All of these give you a radically different view than normal vision.

On long trips, I always have a digital storage device. After a lot of testing, the best, by far, is the HyperDrive, which is reliable and fast. I have three 500GB units, and I always make two backups of every file in the field.

eSATA Drives, RAID Arrayed

RAID is an acronym for Redundant Array of Inexpensive (or Independent) Disks. A RAID array is a series of multiple drives which together act as a single storage system. In most configurations this storage system can tolerate the failure of a drive without losing data and depending on how it is configured, can rebuild once the failed component is replaced.

Once back in the studio, I have a Mac computer system that I rely on. I now use a series of eSATA hard drives in a RAID array. At this point, I have about 12TB worth of drives, but as the size of digital files keeps

increasing and the cost of hard drives keeps decreasing, that capacity goes up yearly.

The biggest change in my workflow has been the addition of a 30-inch Apple monitor. The screen space has really changed the way I work and enabled me to save huge amounts of time in editing and working with images. I could never go back to a smaller monitor. To paraphrase, you'd have to pry that monitor out of my cold, dead hands.

I always use the latest version of Photoshop (new versions always have some great creative and workflow upgrades). Lightroom has become my *de facto* editing application. FileMaker has become invaluable to me for tracking business contacts and images submitted to agencies and galleries.

Like every other photographer on the planet, I am a huge accessory aficionado (geek). Along with a selection of lenses, there are a couple of accessories that I never leave home without: Variable neutral density filters for video; close-up filters, which I often put on my 85mm f/1.2 lens; and, my sensor-cleaning gear, including brushes from VisibleDust and contact dust-removal tape from Dust-Aid. You quickly learn how to perform the somewhat delicate task of cleaning a sensor after having spent hours spotting dust in your images.

8. What feeds your creativity, and where do you find your inspiration?

For the last five years, I have been reading books on creativity. At first, it was to generate content for a monthly newsletter that I send out as a promotion. In the end, I found that, like a lot of things, educating yourself

on subjects that are pivotal can make a huge difference (see Figure 7.5). So, I have learned a tremendous amount by reading books by renowned creativity experts such as Roger von Oech, Edward de Bono, and Mihaly Csikszentmihalyi.

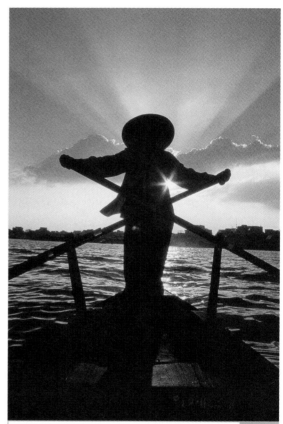

Shot on the Mekong Delta in Vietnam, this image comes as close as any to pure pre-visualization. I was walking around the market and saw all these scissor boats on the delta; I saw the sun going in and out of the clouds and this image popped into my head. I knew exactly what I wanted. I hired a woman to ride me around in one of her boats until I got the shot I imagined. It took about two hours and she probably thought I was nuts — but I got it. © Lorne Resnick **7.5**

Understanding the structure of what creativity is, where and how to find it, and how to spark it, is a huge help in addressing a client's needs and taking my own image making to the next level. Beyond that, I find tremendous inspiration from the joy of traveling and the work of other photographers. I really enjoy visiting my local bookstore and browsing the shelves. The only downside is to my wallet, as I can rarely leave the bookstore without making a purchase.

9. How do you market your work?

Every way I can think of. I do my monthly e-mail newsletter on creativity (which I send out myself); I try to work on my Google ranking for relevant keywords; and I network both with social media and in person. Things are changing rapidly, and I feel the social networking aspect of marketing is becoming more important. I rarely do printed collateral anymore as I feel the cost/benefit analysis is not favorable — it is too expensive for an ongoing campaign that would make a significant impact.

10. Are there multiple ways that you make money with your travel photography?

I really believe it's vital to look at your photography career with synergy in mind. How can I take this image and place it in several different markets as well as apply it to different uses? I'm standing in the middle of Death Valley and shooting an image on assignment for a major commercial client. One shutter click. The image goes first to the client. Then that same image goes into my stock library for future sales, it goes into my fine art portfolio for print sales, it gets submitted to poster companies for a possible

poster, and then gets paired up with another image and goes up on my commercial Web site to promote my business. One image, multiple markets — synergy.

11. How do you determine what conveys a sense of place? Do you research your locations prior to traveling?

For me, a sense of place (which is very hard to define) comes from the ability to shoot emotion over content (which is a little easier to understand). Shooting emotion instead of content is the same; it's difficult to define or describe, but you know it when you see it. You need to critically look at your own images and say to yourself, "Emotion or content?" Repeat it over and over like a mantra. Look at other photographers' work and evaluate it — did that photographer shoot emotion or content? Eventually you will start to see it more clearly and then incorporate it into your image-capturing skills. Emotion doesn't have to come from a person. The lines of a building can be shot in a static way or full of emotion, depending on angle, light, cropping, lens use, and so on.

NOTE The term emotion as it is used here refers to the feeling the image causes in the viewer. In this case, it's not about the content itself, but the feeling that comes from viewing the image. This feeling is created in a variety of ways by the photographer.

I generally research my locations before traveling there, but not too much. I don't want to get so familiar with a place that I can't see it with fresh eyes or am not surprised by it when I get there. But I do like to know how that place has been represented

before so I'm just not repeating the same old views as other photographers have. I want to generate fresh looks for the marketplace.

Figure 7.6 was an image I pre-visualized after spending some time in Cuba. It seemed to say a lot about the place. This view of the city was from a lighthouse tower across the bay. I knew I wanted the waves crashing against the Malecón and the sun on the buildings. Unfortunately, the only time the waves were up and crashing was during a winter storm, and usually that meant cloud cover. On top of that, because of the position of the sun

during the winter, there was only an hour or two during the afternoon when it was possible for the sun to strike the buildings. But I was determined. I must have gone up into that lighthouse tower 30 or 35 times over a period of two years and four separate trips to Cuba to get the image I wanted. The lighthouse guard must have thought I was insane; after a while, he just shook his head at me carrying all that equipment up several hundred feet of tiny, circular stairs to the top of the lighthouse. But I got the image I was after. The red car was a bonus, but really makes the image.

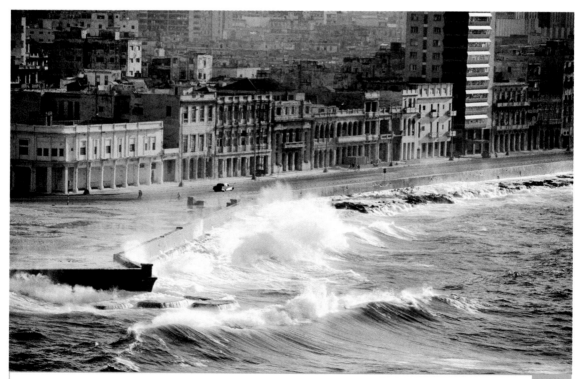

Five years after I took this image, I asked my fiancée to marry me in that lighthouse tower. That same guard was so happy for us that he called his brother on the phone to tell him, and then told us that we didn't have to leave at closing time but could just lock up after ourselves! © Lorne Resnick

7.6

Figure 7.7 is an image that speaks to the old adage, "Luck favors the prepared," and to knowing your gear. I spent months on end, sunrise to sunset, walking the streets of Cuba looking for unique, impactful moments. On this day, I happened to be visiting friends in a small three-story building in Havana. After some nice, strong Cuban coffee, I made my goodbyes and walked down the stairs into the courtyard to hit the streets for more photography. For some reason, as I was leaving the courtyard, I turned around and looked up, and there it was — I literally had a fraction of a second. I raised the camera to my eye (it was already hanging off my shoulder, turned

on, and ready to go) and clicked one frame. It's one of my (and many Cubans') favorite images.

12. What essential gear do you pack when going on a travel photography trip?

Airline travel is always a challenge, or as I like to call it, a pain in the @#!. The bottom line is that you can't check your camera gear, so you have to pare it down to one airline-legal photo backpack or case, and one smaller backpack for some of your digital gear. Unless the plane is really full or it's a bad airline, it's usually never an issue. I have

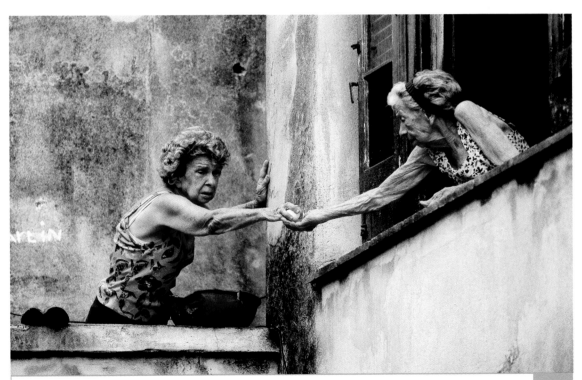

Seven years after I took this image, I returned to the same building and discovered these women were sisters.
© Lorne Resnick

7.7

153

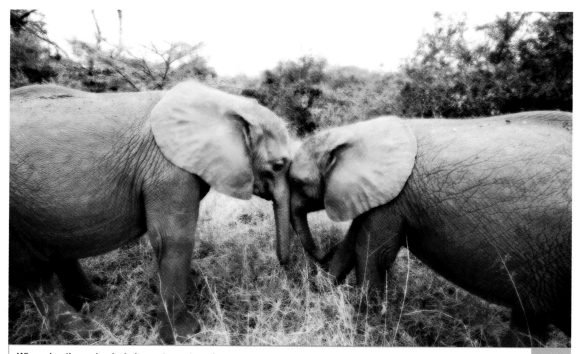

When shooting animals, I always to capture those moments that we recognize as human behaviors or are evocative of human emotions. I can't count the times I have put my forehead up against my two sons'. I wonder if these two young elephants were expressing a gesture of tenderness, or if they were only playing. © Lorne Resnick **7.8**

been confronted before, but after an explanation of my professional status and the cost of the equipment, they usually let me on board.

My essential travel gear consists of:

- Two camera bodies (Canon 1Ds Mark III) and batteries
- Canon lenses; 14mm, 16–35mm, 70–200mm, 85mm f/1.2, 90mm TSE
- A tripod (although I'm finding I use it less often)
- Sensor cleaning gear
- Digital storage devices
- A compass
- A good book

13. What is your best-selling image and why? Also, how long did it take you to begin making money?

I see images that I have turned into posters and sold as fine-art prints turn up on my stock sales sheets time and time again. Many of my images from Africa have sold well, including a billboard for a telecommunications company and a national ad for DuPont. The image in Figure 7.9 has been sold to Toyota for an advertisement. I think they sell because they speak to a universality of emotion and offer a lot of flexibility with captions. I started making money very quickly in stock, but not a lot. It took some time to develop my library of images before it produced any significant income.

I captured this image in Freeport, Bahamas. I was shooting my ex-girlfriend's sister and her baby girl.
© Lorne Resnick

7.9

ESSENTIAL GEAR

The scout motto is "be prepared," which means you are in a state of readiness to do your duty, and in this case that means creating and capturing beautiful photographs. Knowing what equipment to bring along to ensure you're ready and able to capture great images is just as important as knowing your gear inside and out.

DSLR CAMERA AND LENSES

Pack thoughtfully and travel light. Whether you are shooting with an entry-level or a professional dSLR, your lens selection is going to determine your mobility, comfort, and the quality of images you're capturing.

Years ago, I was packing well into the wee hours before departing on a photography cruise through northern Europe, and I must have been too tired to think straight, because I had packed a telephoto, a macro, and a 90mm tilt-and-shift lens, but neglected to bring a wide-angle lens. Due to my last-minute mistake, I wasn't able to capture the European landscapes and beautiful interior shots in the manner I had envisioned. This was a hard lesson learned, and I have regretted it ever since! Now I begin packing my camera gear at least one week prior to departing on any travel photography adventure. In Figure 7.10, I was in Edinburgh, Scotland, holding my trusty 70–200mm f/2.8 telephoto lens, which I love, but it

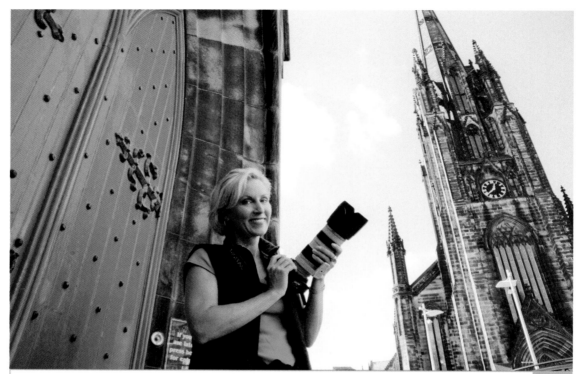

Remember to pack a variety of focal length lenses when you travel. You don't want to miss out on the many perspectives that a wide-angle lens affords. Fortunately, my friend had a wide-angle zoom lens and he captured this image of me near a church in Edinburgh, Scotland. © Stephen Poffenberger | 7.10

wasn't the best lens to use when trying to capture wide-angle shots of interiors or landscapes.

COMPACT CAMERAS

It may seem silly to carry around a compact camera when you have a dSLR that captures great images, but there are times when a compact camera comes in handy. Some examples include going out to dinner, dancing, running, swimming, or any other time you don't feel comfortable carrying around a dSLR and a big lens. It helps if you can find a small compact camera with a longer optical zoom (for example, 10x optical zoom),

because this allows you to zoom in closer to your subjects from a greater distance than most 4x or 6x optical zoom compact cameras. Typically, compact camera images are not considered to be of high enough quality for potential print or stock photography sales, but you may find a way to be creative with your imagery, such as digital compositing or a printed collage of images.

I captured Figure 7.11 when I was out for a late-night walk on the streets of Paris after dinner. I didn't expect to be taking serious photographs that evening and I was traveling light, so I carried only my compact camera in my purse. As I rounded the corner,

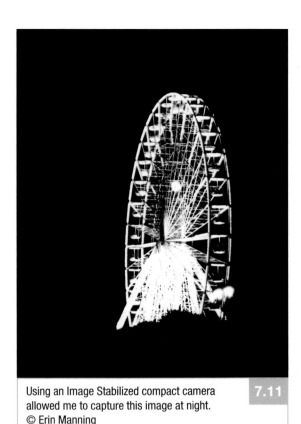

Using an Image Stabilized compact camera allowed me to capture this image at night.
© Erin Manning

7.11

I was surprised to see a magnificent Ferris wheel illuminating the night sky. If I had not brought my compact camera, this image opportunity would have passed me by.

FILTERS

Filters are a piece of glass or optical resin that you place in front of your lens to change the appearance of your image. Most dSLR cameras use a round filter with threads that allow you to screw it onto the front of your lens. They are quite helpful when shooting outdoors and can also serve as a protective device for your lens. Following are a few filters you should carry in your bag:

- **Circular polarizer.** A *circular polarizer* helps remove reflections from water and glass, allowing you to "see through" to whatever is beneath or behind, respectively. Figure 7.12 shows an example of a polarizing filter. To use it, just screw the filter onto your lens, aim it at something reflective, and then rotate the circular ring at the end of the filter until you eliminate the glare. A polarizing filter has a double duty — it also allows you to capture more saturated and slightly darker skies. This effect is most successful with the sun at a 90-degree angle to your lens. The downside of using a polarizing filter is that it absorbs 1.5 stops of light. For example, if you set your shutter speed at 1/180 second and then add the filter, you will find yourself at 1/60 second. This limits the use of this filter in low-light situations.

Using a polarizer can help you cut down the glare in your image. Photo courtesy of Tiffen

7.12

■ **UV filter.** A *UV filter* is a clear, glass filter that attaches to the front of your lens and helps cut down on atmospheric haze, producing a clearer shot. This filter also serves as a protective shield against scratches and dings on the front of your lens glass. The logic behind using this protection is that a $20 filter is easier to replace than an $800 lens.

■ **Neutral density filter.** A *neutral density (ND) filter* does not affect the color in your scene, but it does reduce the amount of light entering your lens. These filters are available in varying degrees of strength, and you use them when you want to achieve certain effects but the light is too bright to allow the exposure effect you want; for example, you would use them to blur action in your scene by using a slow shutter speed, or to produce a very shallow depth of field by using a wide-open aperture.

■ **Graduated ND filter.** *A graduated ND filter* is dark on one end and then gradually fades to clear on the other end. This filter is useful in conditions where you cannot have both the sky and the land beneath the horizon exposed correctly at the same time. You simply position the dark area of the filter over the bright area of your scene. With a graduated ND filter, a more balanced exposure is possible.

TRIPODS, MONOPODS, AND HEADS

You don't need a tripod for everything, but if you are shooting in low light or at night, your exposure will require a slow shutter speed, and so you will need a tripod. If you have the space in your pack, and a few extra minutes to set up your shot, using a tripod is a good way to improve the sharpness of your images. Trying to handhold a camera using a shutter speed below 1/30 second will not produce sharp images, and using a long focal-length lens further increases your chances for image blur. A lightweight titanium tripod that collapses into a small, transportable size is a little more expensive, but as you lug around your equipment from place to place, you'll be thankful you invested in an easy-to-carry accessory. If titanium is too expensive, check out the aluminum or carbon tripods. There is a good chance you can find something that is only slightly heavier.

TIP — A good rule of thumb with hand holding a camera is to use a shutter speed that matches your longest focal length (for example, 1/100 second with a 100mm lens, 1/200 with a 200mm lens, and 1/20 second with a 20mm lens, and so on).

Every December, I photograph the local pier dressed up in holiday lights after sunset, as shown in Figure 7.13. I use this image on my personal holiday cards and market the extras to a local greeting card shop. Not only have they become an annual source of local pride and a little extra money in my pocket, but they are also good marketing pieces. My Web site address is on the back of every greeting card and is a subtle reminder of who created the image and how people can reach me.

Make sure your tripod has a *quick release plate*; I also suggest purchasing a good *tripod ball-head*. The plate allows you to quickly release the camera from the tripod. It consists of two

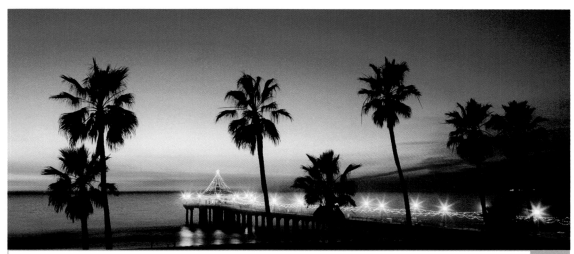

My annual low-light holiday photo of the local pier has become an anticipated tradition. © Erin Manning 7.13

parts: a plate that mounts on the bottom of the camera, and a clamp on top of the tripod head that enables you to quickly attach and detach the camera from the tripod plate. Without a quick release, you are left to unscrew your camera from the tripod head, which can become cumbersome and impractical.

A ballhead is a spherical ball that can be mounted to the platform of your tripod, and when attached to your camera, it allows you to adjust the camera in a fluid, multi-directional way, until you lock it into place. Without a ballhead, you can still adjust your camera, but you have to use a series of knobs that require independent adjustments for directional camera movement.

When traveling by car, you might consider a window-clamp tripod, which allows you to shoot photographs from within your vehicle; this is especially useful if you would like to avoid being eaten by lions while on safari.

The Giottos Professional Heavy Duty All Metal Car Window Mount has a pivoting head, allowing for a full range of motion. The heavy-duty window mount attaches to any car or truck window with a padded clamp and won't scratch the glass, yet provides a steady shooting platform. It accommodates most cameras, features a rugged, all-metal construction, and has a street price of around $55.

I often travel with a mini tripod, a monopod, and a remote shutter release. They are light and unobtrusive, yet allow me to steady my camera in various situations. A mini tripod comes in handy for macro shots, self-portraits, and any other instance when you need a little more stability; the cable release ensures that camera shake from pressing the shutter button does not occur; and a monopod is especially useful when visiting museums, plays, sporting events, and other public places that don't allow tripods. In most

public spaces, tripods have been declared a potential risk for tripping, falling, and damaging property, hence, a potential lawsuit. Because monopods are not freestanding, they don't fall into the risk category.

LAPTOP

It's easier to review images on a larger screen and safer to back up your images while on the road if you bring your laptop. You can also edit, enhance, and organize your images, saving yourself time later. I carry my 15-inch MacBook Pro with me on all my trips because of its size, durability, and reliability. I also have many photographer friends who swear by their netbook computers, so it's really a personal preference as to the kind of laptop you use.

EXTERNAL HARD DRIVES AND DVDS

The sheer number and size of digital photos, and all the variables of theft and loss when traveling can make digital file storage a major concern. I've found that bringing at least one mini external hard drive, a hard drive photo-viewer, and a few extra high-capacity memory cards allows me to download my images from memory cards, back them up for safekeeping, and easily view them while on the road. The hard drives are an exceptional value; they are inexpensive, sturdy, reliable, and with each new release, smaller in size. The photo-viewer has a 4-inch screen and 100MB of storage, and memory cards can serve as an extra backup that I can mail home from

faraway locations. If I'm staying in a hotel with a fast Internet connection, or I stop at a coffee shop with Wi-Fi, I also upload my images to a subscription-based photo-sharing Web site such as www.smugmug. com, or my Web host's FTP server, where I can access the high-resolution digital files at a later date.

GEOTAGGING

Have you ever taken a photo, but couldn't remember exactly where it was, even just a month after taking it? This is where *geotagging* comes in handy. With geotagging, your photos are automatically labeled, or tagged, which embeds the location information into the EXIF data, showing where you took each photo. You can also view your tagged photos on Google and other Internet map applications. At the time of writing this book, there are a couple of ways to geotag your images. One way is to use a GPS data logger. A GPS data logger does not tell you where you are, or how to get there; instead, it keeps a log of where you've been. This device is small (see Figure 7.14) and can usually hang off the side of a camera bag or belt loop so you don't even notice it's keeping track of your every step. When you upload images and data to your computer, the supplied image tracker software synchronizes the photos with latitude, longitude, and time, reading from the data logger unit.

Another way to geotag your images is by using the Eye-Fi card. It fits into your digital camera just like any other memory

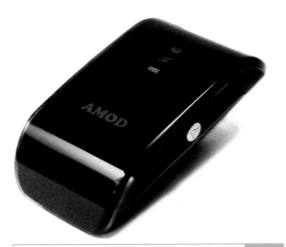

I carry a data logger unit because it works with most digital cameras and is both Mac- and PC-compatible. Photo courtesy of AMOD Technology Co. Ltd.

7.14

EQUIPMENT BAG

Hauling around a lot of camera gear can become heavy on your mind and back. It's worth investing in a durable, well-designed, carry-on-size roller bag that protects your equipment, yet doesn't scream, "Please steal me, I'm an equipment bag!"

If you're traveling into questionable territory or just want a little more peace of mind regarding your camera gear, consider investing in some Pacsafe anti-theft travel products. They have slash-proof straps and tamper-proof zippered bags.

TIP — Before plugging anything electronic into an outlet in a foreign country, check to make sure that your charger and the outlet are compatible. Research the power situation at your destination, and if you need a converter, visit Magellan's (www.magellans.com) to find the right adapter. It could save you from frying your charger and your batteries.

card and has 4GB of flash storage, but it's also a Wi-Fi unit that allows you to automatically transfer your images from your digital camera to your computer or most major photo-sharing Web sites. Each time you upload your images, the geotagging is done for you.

Several online photo sites already support geotagging and even have visualization tools that let you map your images. Check out Flickr, Picasa, my Picturetown (from Nikon), Phanfare, and SmugMug to see what geotagging can do. Many desktop photo management programs also make good use of geotags, including Adobe Photoshop Elements, Ovolab Geophoto, and Microsoft Pro Photo Tools.

Memory card technology continues to improve; now it's possible to purchase a high-capacity memory card (16GB and more) at a relatively low price. Just be aware of the "speed" of your memory card and how it relates to the digital camera you are using as well as your image quality settings. For example, I use high-speed memory cards when I'm shooting RAW+JPEG files and I want to shoot fast, and I use high-capacity memory cards when I plan on shooting thousands of images and don't want to change cards during the day. Consider your options when purchasing, and select the capacity that fits your shooting style.

With cameras such as the Canon T2i that use SD cards for still images and video, use a high-capacity, high-speed memory card.

NOTE

BEFORE THE SHOOT

No matter how much you plan, you never know what you're going to capture as you depart on your photography travel adventures, and that is part of the thrill. Perhaps you are building your portfolio and want to express your inner vision, or maybe you're hoping to happen upon found objects or unusual people or situations, and document them in a unique way. As you think about ideas and plan your trip, consider some of the ways that your travel images might be sold. Stock photography, consumer publications, and art galleries could be interested in your travel photography. Whatever the situation or photography style you choose, it's worthwhile to do a little research on what these places are looking for in the way of imagery. Resource guides such as the annual *Photographer's Market* give up-to-date, detailed information about what these companies' photography needs are and how to submit your images, and they often include information about contract and payment terms.

By planting and cultivating a few of these directives in your head prior to departing, you are feeding your creative intuition some practical information, and you are making yourself aware of the technical specifications. Don't let this information direct your photo shoot or overpower your creativity; just be aware of it.

TRAVEL PLANNING

Before you leave the house, there are a few things you should attend to:

- Check the Transportation Security Administration Web site (www.tsa.gov) and your airline's Web site for updated rules and regulations regarding your checked and carry-on luggage; check the Federal Aviation Administration Web site (www.faa.gov) for travel restrictions, and the U.S. Department of State Web site for travel advisories (www.travel.state.gov).

- Research your travel destinations ahead of time with Frommer's travel guides and your travel agent, as well as online. Planning ahead of time helps you get the most out of your trip. Be prepared for contingency plans and spontaneity, too.

- Insure your cameras and equipment through your insurance carrier. Specific policies are available for photographic equipment, and some insurance companies specialize in this area. Contact your insurance agent and check to see that your photographic equipment is covered under your homeowner's or renter's policy. If not, you may need to purchase business insurance. Document the make, model, descriptions, and serial numbers of all the gear you plan to take with you. Read your policy thoroughly before you leave on a trip. Pay attention to exclusion clauses such as traveling to dangerous locations and leaving equipment in vehicles.

- Locate your nearest U.S. Customs Office (www.cbp.gov) and fill out a "Certificate of Registration" Form CF 4457. Bring the equipment you plan to take to their offices for their inspection, and they will confirm the information on the form and stamp it. This authorized form proves that the gear belongs to you, and you can bring it back into the country without having to pay a potential duty. According to their logic, just because you say you left the country with it, doesn't mean you really did.

- Review your current healthcare coverage details for travel overseas. Most health plans don't provide coverage, and the ones that do often require you to pay for services upfront and reimburse you only after you return home. For short-term medical insurance, check out **MEDEX** Global Solutions (www.medexassist.com) or Travel Assistance International (www.travelassistance.com).

- Learn some key phrases in the local language, and pack the proper clothing for the climate you're visiting.

EQUIPMENT SECURITY

Digital cameras and all the other photographic accoutrements, such as lenses and laptops, are highly desirable. From a thief's point of view, you are a prime target, especially if you're traveling in parts of the world with poorer economies. It makes sense to take precautions, even if you have your equipment fully insured for the trip. Here is a list of travel security don'ts:

- Don't check your camera gear on an airplane or bus. Always carry your camera and lenses with you in an approved, travel-sized bag.

- Don't leave your camera and computer equipment unattended.

- Don't leave your camera or other gear on the seat of a car with the window down. Traffic lights are the perfect place for thieves to snatch things from your car.

- Don't advertise the fact that you are a photographer when traveling. Be inconspicuous with your camera bags and labels. A well-worn pack or a "non-camera" bag attracts less attention.

- Don't leave a camera or shoulder bag hanging on the back of a chair, especially in busy restaurants, sidewalk cafes, or hotel lobbies.

- Don't leave your camera and computer gear in a car, not even locked in the trunk. Once you are seen with camera gear, thieves will be watching for an easy way to take it.

Being aware of your surroundings and careful about what you are doing is the best way to protect yourself and your gear. I would also recommend placing your equipment either in the hotel safe when not in use, or locked up in your luggage while out of your hotel room.

The good news about traveling with a digital camera and memory cards is that you no longer have to worry about airport security scanners possibly damaging your film. However, many people are still concerned

that the airport X-ray machine, magnetic hand-held wands, and metal detectors will damage their memory cards and the digital files stored on them. According to the Transportation Security Administration: "None of the screening equipment — neither the machines used for checked baggage nor those used for carry-on baggage — will affect digital camera images or film that has already been processed, slides, videos, photo compact discs or picture discs." I have never had any issues with losing image files from airport scanners, or with carry-on or checked luggage, and many of my professional photographer friends report the same. However, if you are still concerned about potential damage, it's always a good idea to back up your images on an external hard drive, or DVDs, and upload them to an online service prior to traveling home. Regardless of your method of travel, keeping your images safe is an important step you should take.

AT THE SHOOT

Whether you're traveling across town or across the world, photographs of cultural and geographic details, such as the landscape, public spaces, traditions, and signage, help you tell a compelling story about your adventure. Following are some tips to remember in capturing these images.

- When traveling in other countries, be mindful of the local religious customs and beliefs, and respect those beliefs in your photographic approach.

- Be a visual storyteller. If you are planning on submitting your images to consumer publications and book publishers, they prefer to see a depth of coverage on a particular subject, so they could possibly use all or many of your images in a publication.

- When you arrive at a new place, you should start by taking wide-angle establishing shots of an expansive area such as a cityscape or landscape. Get in closer with medium shots, and then capture some close-up, detail shots (for example, stone textures, grass, and insects) or other interesting things you see along the way. When you place these images together, they tell an intriguing story and give your viewer a sense of place, from your perspective. This is what makes your images unique. An identifiable, personal style helps you build your identity as a visual artist.

In Figure 7.15 I took a wide-angle establishing shot of the Cayman Islands Turtle Breeding Pond, then a closer shot of a turtle in Figure 7.16, and an even closer photograph of a turtle's shell in Figure 7.17. When placed together, these images convey a story and give the viewer a sense of place. Whether you're thinking of submitting your images for a consumer publication, stock agency, or a layout in your portfolio, shooting a visual narrative of a location is a recipe for success.

Pay attention to the light. A general rule for beautiful images is to plan your photo shoot for early-morning or late-afternoon light because softer shadows equate to less contrast in your scene and more flattering

light for a portrait subject. The directional side light in the early morning and late afternoon creates dimension in buildings and landscapes, which is why most professional photographers choose to shoot images during these times.

Portraits of local people help tell your story about a place, but they require people skills, so be sensitive to their feelings about being photographed. I've found that most people are willing to let you take their photos, if you only ask. If language is an issue, smile, point at your camera, and say "photo?"

Another way to photograph local people is to buy something from them — a hat, a flower, a bagel, whatever they're selling. Then you change from being a semi-annoying photographer into a customer, and they may be more willing. If you plan on using

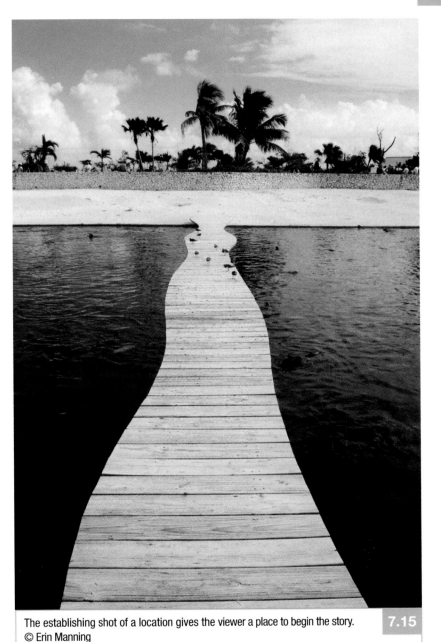

The establishing shot of a location gives the viewer a place to begin the story. **7.15**
© Erin Manning

A medium shot gives the viewer a little more information about the story.
© Erin Manning

7.16

your people images for stock, or for commercial purposes other than self-promotion, it's a good idea to carry model releases in the local language and ask the person you photographed to sign your release. Depending on your location and the social economics, this may require that a few dollars or other local currency change hands, so keep some small change handy.

A close-up shot becomes an abstract image, yet conveys more detail in the story. © Erin Manning

7.17

A wide-angle lens is great for capturing scenes of large groups of people, expansive landscapes, and even cramped spaces. You can even use moderate wide-angle lenses for portraits — especially taking into account the focal-length conversion factor.

In outdoor photography, pay attention to the placement of your horizon line. Generally it should be in the upper or lower third of your image for visual impact. Check to see which area looks more interesting and show more of that area in your image. You can also experiment by tilting the camera up or down to alter the balance of the scene. I emphasized the clouds in Figure 7.18 by placing the horizon in the lower area of the frame.

A quick way to focus attention on a particular subject in a scene is to use some object or shape in the foreground as a frame. You can find framing elements everywhere — doorways, archways, windows, even overhanging tree branches. Frames work best if they are darker than your main subject, so expose for your subject and let the frame fall into

I placed the horizon line in the lower section of the image because the sky was much more interesting.
© Erin Manning

7.18

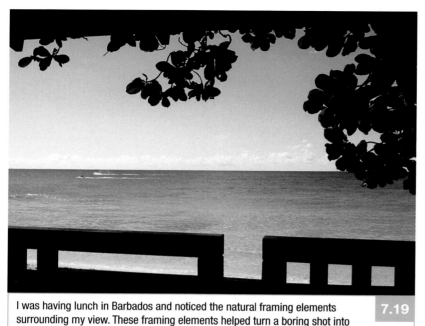

I was having lunch in Barbados and noticed the natural framing elements surrounding my view. These framing elements helped turn a boring shot into something more interesting. © Erin Manning

7.19

darkness. In Figure 7.19 I exposed my camera for the bright exterior scene while the tree branch and interior fence became my dark framing elements.

Mix up your shots and shoot pictures in both vertical and horizontal formats. Using a vertical orientation enabled me to capture the columns shown in Figure 7.20 from an interesting point of view.

The vertical lines of these columns draw your eye through the image. © Erin Manning

7.20

Any time you can include contrasting elements in your image, you create an interesting scene, whether you're combining hard and soft, dark and light, or playing with scale by photographing large and small objects in the same scene. Using scale as a compositional element in your images can be fun! You can use it to amuse, disorient, or inform your viewer. Experiment and see what you come up with. In Figure 7.21 I'm using scale and distance between the seashell and cruise ship to create visual interest and a sense of whimsy.

Take pictures of local signs and buildings, as well as famous landmarks — these are typically useful and saleable images. These "location identifiers" are often unique, colorful, or interesting in some way, as shown in Figure 7.22. They can also add a whimsical punch to your presentations and photo displays.

Using scale and distance creates visual interest in an image. © Erin Manning **7.21**

Follow the action. Visit local markets and street fairs and take plenty of images of the local stalls and sellers and the various foods and flowers. Find out if a festival, pageant, regional fair, local holiday parade, or other current event is about to occur. If you are photographing people and they are identifiable in the image, be sure to have them sign model releases if you plan on selling the images commercially.

Take pictures of signs and labels to record information and reveal your location. This building in the Cayman Islands was colorful and provided some documentation on our location. © Erin Manning **7.22**

CHAPTER REVIEW

A Understand why you are shooting something. Study what's out there and come up with a unique view if you want to succeed.

B Pack thoughtfully. Whether you are shooting with an entry-level or a professional dSLR, your lens selection is going to determine your mobility, comfort, and the quality of images you're capturing.

C Be a visual storyteller. If you are planning on submitting your images to consumer publications and book publishers, they prefer to see a depth of coverage on a particular subject, so they could possibly use all or many of your images in a publication.

D Look at your photography career with synergy in mind. Think about how you could apply your image to different markets and other uses.

8

show me the money

Have you ever noticed images in a book, a magazine, or a newspaper and thought "I could do that" or "My images are just as good, or better?" Or perhaps you have a burning desire to express yourself and you're planning on learning the skills necessary to produce such wonderful imagery? Don't be surprised; it's a common thought for many photo enthusiasts. Unfortunately, a lot people never take the next step and monetize their photography because the path seems too mysterious and full of rejection. Where do you go, what do you do, and who do you contact? Whether it's a current archive of images you've already produced, or photographs created from future inspiration, this chapter covers various channels for selling your imagery. You'll find ideas and some practical information for demystifying even the most intimidating of venues.

© Erin Manning

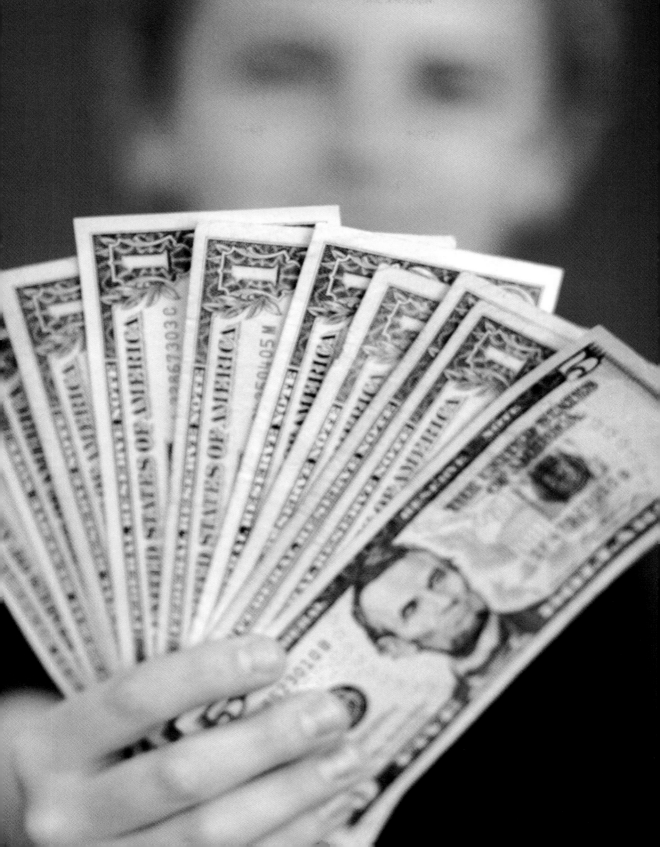

It can be daunting when beginning your photographic journey, but a good rule of thumb is to start where you are, doing what comes easily. For example, when I began monetizing my photography, I lived in a small beach community outside of Los Angeles. I knew quite a few people from working in the entertainment business, and in sales and marketing. I also had connections to many families in my neighborhood (Figure 8.1). Along with studying the technical aspects of photography, I practiced taking pictures of everyone I could, built a small portfolio, and was referred by word-of-mouth and my local newspaper advertisements for family portraiture. In time, I built relationships with people who worked at small design firms and advertising agencies, and I was soon on my way to doing what I loved to do, taking pictures of people for commercial clients, stock photography agencies, and small businesses.

Your situation may be very different, but the message is the same — look around you and take advantage of what your life provides. Are you a Mom who has easy access to photographing children? Do you live on a farm with animals and access to nature? Perhaps you have a lot of business relationships? There are so many possibilities!

SELLING TO CONSUMERS

The quality of your photographic work is key, but establishing relationships with your clients is equally, if not more, important.

Photograph the people you know. My next door neighbors were always willing subjects. © Erin Manning 8.1

They can't just like your work; they must also like, and trust, you. Whether you're selling your photographic services and imagery directly to a person, or to a business, make it a point to create a personal connection with your clients. If you do, they'll seek you out again and again.

FAMILIES

Photographing families could include large groups of people, small groups of people, couples, or individuals. If you enjoy capturing meaningful moments and important relationships in a photograph, family photography can be very gratifying. There are many things to consider when photographing groups of people; lighting, location, background, angle,

distance, and composition, but the key element is in knowing how to find and create authentic moments between people, as in Figure 8.2. Develop your own style, whether it's classic posed portraiture, fashion-type images against a clean, white background, casual lifestyle, or something unusual. Your style, professionalism, and personality are what attract and keep a clientele.

Shooting pictures of families in natural light, whether it's near a window inside, or outdoors in a beautiful location, is an easy way to begin. The only drawback is when the weather isn't cooperating, but with some basic lighting skills you can also produce family portraits with professional-looking

Capturing relationships between people creates a memorable image that results in print sales and referrals for more business. © Erin Manning **8.2**

panache. A casual, contemporary, candid photographic style is conducive to working with natural light in and around the home environment. The baby picture in Figure 8.3 was taken by placing a 5-month-old baby on the bed, near a window, and using a football as a prop. Babies need special care, so be sure to handle gently and have the parents stand behind you, to entertain the baby and direct his gaze towards your camera. The key is to capture people's personalities and expressions, resulting in happy customers, prints sales, and referrals. If you'd like more information about natural light modifiers and artificial lighting equipment, see Chapter 2.

A Web site with current images is a must in order to market yourself. If you can't afford a Web site when starting out, sign up for a blog on www.blogger.com, or on www.wordpress.com. You can open an account for free, or a premium account with a nominal fee. Many photographers are incorporating their blogs into Web sites for the ease of use and the ability to quickly add new images without employing a Web designer. Social media is a free way to gain visibility, so be sure to open a Facebook and Twitter account, and if you have any video content, open a YouTube account too. Chapter 9 covers more information about Web sites and social media.

How long your photo sessions are and what fees you charge will vary. It's important to research the market, find your competitors, and price your services within a range your potential clients will pay. Most retail portrait photography businesses will charge little to nothing for a "sitting fee" and then charge high prices for prints. Many freelance photographers will charge a session fee, or creative fee, and less for prints or high-resolution digital image files. I recommend opening an account with an online photo-sharing and printing service such as www.smugmug.com, or www.pictage.com. These Web sites (and many others) offer services that allow you to upload your images for viewing, charge your clients a retail price of your choosing for the prints, and receive a check for the profit. Taking clients' print orders and packaging up prints for delivery can be very time consuming. Why not use a printer that handles this aspect of the business for you?

Using natural light is a great way to capture someone's personality in a comfortable setting.
© Erin Manning

8.3

BUSINESS PORTRAITS

From realtors to yoga instructors, car mechanics, and corporate executives, anyone involved in business needs a business portrait. The style of the portrait is tailored to fit the type of business your subject is in. For example, your yoga instructor conducts business in a very casual environment and would need a portrait that communicates who she is and what she does. A corporate executive working for a large corporation requires a more conservative approach, and an Internet guru might request a more contemporary look. Do your research by looking at business magazine covers and articles and note the various styles portrayed by different business people. The classic business portrait is shot against a solid or painted canvas background with studio lighting. If this is what your client requests, be sure you know how to capture this style of photograph. If you are not yet studio-light savvy, pursue

business people who desire a more natural, contemporary look and shoot them outdoors in natural light, as in Figure 8.4. You can also incorporate more of the environment if it conveys information about your client's business.

ACTORS

You'll find more actors located near Los Angeles and New York, but there are other markets that employ an active actor community, such as Chicago, Dallas, and Miami in the United States; Vancouver, Canada; and other international cities. Even if you're located in a small town, there are local theater actors and aspiring actors and models that need head shots. A *head shot* is a term for a type of portrait used for marketing purposes in various industries. The entertainment industry requires a head shot of an actor that accurately portrays him or her in a visually pleasing way, such as in Figure 8.5. Styles change, children grow, and an actor's appearance may change over time; that's why it's important for an actor to have an up-to-date head shot. Casting directors, agents, and clients want to see head shots that accurately portray the actor. Head shot photographers often schedule multiple photo sessions throughout the day and they typically shoot in natural light.

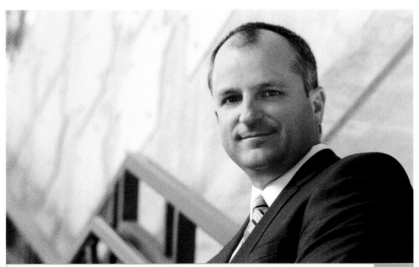

Some business portraits work well when shot outdoors in natural light.
© Erin Manning

8.4

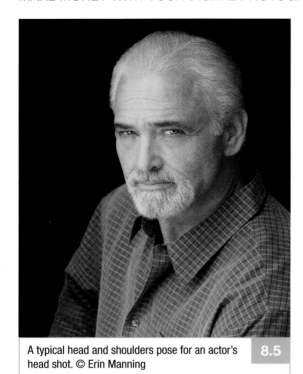

A typical head and shoulders pose for an actor's head shot. © Erin Manning

8.5

Review modeling, acting, and casting Web sites to research the current headshot trends. www.lacasting.com is a popular Web site in Los Angeles and has a "photographers" link you can click on to see what the "look of the moment" is. It's no longer the overly made-up, black-and-white studio portrait that casting directors want to see. Actors are being cast directly from Web sites that show small, color images. It's best to shoot head shots in color and crop in to the head and shoulders.

Advertise your services via social media, local casting offices, online casting services, theaters, acting coaches, dance schools, and modeling schools. If you know any acting or modeling agents, ask to meet with them and show them your portfolio, even if it's only online. Agents often have a test list

of photographers they recommend to their models. The agents want to ensure that you are trustworthy and capable of taking great head shots. You may start out photographing models and actors for free, and then move up the ladder as your relationships and images improve. The worst case scenario? You have some beautiful people photographs in your portfolio. Head shot fees vary greatly depending on your experience and your geographic location. Check the competition to see what the market will bear.

SELLING TO BUSINESSES

There are many areas to consider when selling your photographic services and your imagery to businesses. The following market segments are meant to inspire you with ideas and provide practical information.

TAPPING THE STOCK-PHOTOGRAPHY MARKET

For some people, hiring a professional photographer isn't always feasible. For example, someone who wants to create a brochure for her travel agency probably can't afford to send someone on location to photograph every destination she wants to highlight. That's where stock photography comes in.

Here's how stock photography works: You, the photographer, submit your work to a stock agency. The agency then reviews your work. If the agency likes your work, they agree to market and license it for you. In exchange, the agency takes a commission, usually 50 percent, if your work sells, although the terms of your contract may vary by agency.

There are three main types of stock photography:

- **Rights-managed stock photography.** In this type of stock photography, the stock agency negotiates a separate licensing agreement for each use of the image. With rights-managed imagery, photos are licensed for a certain purpose for a specific period. Some rights-managed licenses guarantee exclusivity, meaning no one else can use the image. Often, an organization that wants to use an image for branding purposes will seek exclusivity, to prevent competitors from using the same image.

- **Royalty-free stock photography.** With this model, which emerged during the 1990s, the person purchasing the rights to a photo pays a one-time fee to use the photo in an unlimited number of ways. This makes the images very popular with designers who can use the same image for many different clients. The downside is that a purchaser has no way of controlling whether a competitor uses the same image.

- **Microstock photography.** The advent of digital photography and the Internet have spawned a new species of stock photography: microstock. Microstock companies, which distribute images almost exclusively via the Internet, license digital images for next to nothing — think 20¢ to $10 (of which the photographer receives half). This is in contrast with traditional stock agencies, which have historically licensed images for hundreds, even thousands, of dollars. The idea is that microstock photography allows for a higher volume of sales. But many professional photographers fear that microstock agencies, which are far more willing to accept work by less-established photographers, are driving down the value of *all* stock photography. Whatever your views on microstock, it appears that it's here to stay! Some popular microstock Web sites are www.istock.com (owned by Getty Images), www.shutterstock.com, and www.fotolia.com.

Keywords are the most important information you can provide to help users find your images on a stock photography Web site. Stock agencies used to provide this service for you, but with lower prices and a large volume of photography contributors, it's now in the photographer's hands to attach the proper keywords to their images. Descriptive keywords include relevant details: the subject, location, and any interesting or valuable information, such as the camera used, scanner, or any special circumstances about the image. Conceptual keywords are words that describe emotions, moods, or ideas associated with an image. While people often know the specific subject they are looking for, concept keywords may help to inspire the client to select your images to represent an idea.

You can increase your stock photography sales by leaving some negative space around your subject. Negative space is a positive thing when it comes to stock photography. Pictures are used in many different ways and may require space for headlines and text. Designers are constantly on the lookout for an interesting image with negative space, as seen in Figure 8.6.

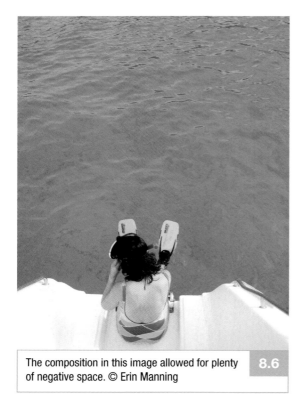

The composition in this image allowed for plenty of negative space. © Erin Manning **8.6**

The last several years have seen significant changes in the stock-photography market. While in the past, the industry supported numerous agencies of various sizes, most of these agencies have since partnered with others or been acquired by larger firms. In fact, these days, only two main agencies remain: Getty Images and Corbis. That means competition among photographers who seek to license their images through these agencies is fierce. That fact, coupled with the effects of the microstock market, means you probably won't make your living off of stock photography, although you can certainly use it to supplement your income.

There are also specialty stock agencies in the marketplace who distribute their imagery independently and through the major stock agencies like Getty Images and Corbis. If you produce images within a certain niche, it would be wise to investigate one of these agencies. For example, Blend Images, as seen in Figure 8.7, is known for its multi-ethnic stock library.

Most stock-photography sites explain submission guidelines in great detail. Although the image-submission process may seem quite involved, it could be worth the investment of time and energy. Leave no stone unturned!

Establishing a relationship with a well-respected stock photo agency can be a way to get your foot in the door with other types of businesses, such as book publishers, calendar producers, and the like. In fact, when you contact these types of businesses, especially those that receive a high volume of queries and submissions, they often would rather see a list of your photos that are available from stock agencies than the actual photos.

Here is a list of general concepts and imagery that stock agencies look for:

- Corporate business shots
- Concept shots (fear, anger, joy, peace, and so on)
- Sports
- Holiday and seasonal themes
- Food and beverages

Stay away from the typical sunset, forest, and flower snapshots. Most stock agencies are overflowing with these images.

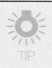

TIP

Concepts are very important in stock photography. A client may request pictures that communicate peace, love, danger, security, anger, loneliness, joy, and other ideas and emotions. Innovative ways of expressing these ideas are always needed.

Blend Images specializes in ethnically diverse business and lifestyle imagery.

8.7

Releases

When photographs of people are used for advertising purposes, a model release is always required. Today our society is so litigious; most agencies won't accept photographs of people without a release. Property releases are required when privately owned property is included in your image, such as boats, homes, animals, and office buildings.

PURSUING PUBLICATION WORK

Editorial photography refers to photographs that appear alongside content in publications such as magazines, trade journals, newspapers, and books. It's often an easier place to begin a photography career and make some money. Compared to commercial photography (photography for use in advertisements and other commercial purposes), editorial photography is somewhat less lucrative. Even so, editorial photography is an area of particular interest for many photographers because of the creative license and freedom of expression it affords. One exception regarding editorial photography is the paparazzo photographer, known in plural as the paparazzi. These are the photographers who stake out celebrities all over the world and sell their images to the highest bidding magazine, newspaper, or Web site. This is a specialized area that requires top-notch equipment, long hours, possible danger, and no guarantee of capturing the shot. It's also a geographically limiting option; you must be located in cities where the celebrities live.

Magazines

Although recent years have seen a cultural shift away from magazines, many do remain, covering a wide range of topics and addressing a highly variable audience in terms of size, location, and interest. Although the market is shrinking, you may be able to position yourself to claim some of the opportunities that remain. This is especially true if you can establish yourself in a particular niche, the way Serge Timacheff, featured in Chapter 4, has positioned himself as the world's premier fencing photographer.

Before you approach any magazine about becoming a contributor, make sure it's a good fit. Visit your local library and read a few issues to make sure your photos are appropriate for the publication. Next, find out if the magazine maintains a set of guidelines for prospective photographers. If so, request a copy, and follow its instructions to the letter. Finally, compose a query letter to the editor that concisely outlines your idea, and briefly highlights any publication credits you may have as well as other relevant information about you, all in one page or less. Get straight to the point; you want to grab the editor's attention right away. Be sure to include a small collection of sample images or a stock list to pique the editor's interest. Choose photos that could reasonably appear in the magazine — that is, don't send an action shot of an extreme skier to the editor

of *Modern Bride*. Most likely, you will submit this query via e-mail, but some magazines do prefer hard copies sent by U.S. Mail or delivery services such as FedEx or UPS.

Trade Journals

A trade journal is a publication that focuses on a specific industry. Examples of trade journals include *Ad Week*, for people who work in advertising; *Variety*, for people in the motion-picture industry; *Restaurant Magazine*, directed at the food-service sector; and *Law Practice Magazine*, for legal professionals. Although many trade publications rely on stock photography to meet their photographic needs, some do work directly with freelance photographers.

Because trade publications are geared toward readers who are very knowledgeable in their fields, the photos they contain must convey an understanding of the subject at hand. Put another way, the more you know about an industry, the more likely your photography will be a good fit. Moreover, if you have expertise in an area and have the ability to discuss it verbally and in photos, you may be able to persuade the editor of a trade magazine to accept a photo/text package from you.

Newspapers

Most newspapers, which tend to focus on regional stories, have historically relied on staff photographers for any necessary imagery. Now the trend is to hire freelancers as stringers. Images submitted by stringers

typically command relatively low prices, although payment for front-page artwork or images that may have a major impact might be negotiable.

 TIP If you shoot a major news event, try to retain resale rights to your images. That way, you can sell them repeatedly to various news outlets, including those with national markets.

The gatekeepers at any newspaper are the various editors, all of whom work in the shadow of looming deadlines. All newspaper editors appreciate a photographer who understands that time is of the essence. These editors also seek photographers who can capture images that go beyond what their readers might expect. If an editor commissions you to shoot an assignment, make it a point to arrive early so you can scout out the setting, and try to capture your subject in a more spontaneous, interesting way.

Books

Book publishers use photography in a variety of ways for covers and jackets, for promotional materials, and to illustrate text; some examples include photographs of a destination for a travel book, images that describe a crafting technique for a how-to book, photos of different breeds of an animal for a textbook, and so on. They also publish entire books of photography — think coffee-table books.

In some cases, a book publisher might opt to purchase stock photos. Alternatively, they might hire a photographer on a project basis. Other times — especially for photo-centric books — they may choose to publish existing images by one or several photographers.

If you're interested in breaking into this market, start by doing some research. Find out which publishers produce books that include photographs. Then browse your library or local bookstore to determine which among those publishers might be interested in your work. For example, if you specialize in wildlife photography, you might focus your attention on publishers who release books that relate to nature. From there, find out which editors at those publishing companies handle which types of titles. With that information, you're ready to connect with the editor by sending a brief, compelling cover letter with samples of your work. If the publisher maintains a set of guidelines for submissions, be sure to follow them.

 TIP If you're just starting out, consider smaller publishers over larger ones. Although they may pay a little less, they may be more likely to work with a less-established photographer.

Greeting Cards, Calendars, Posters, and Other Products

Hauling in more than $7 billion per year, the greeting-card industry represents an enormous market for photographers. And with more than 2,000 companies in the mix — including the Big Two, American Greetings and Hallmark Cards, which account for 80 percent of sales — there's room, and money, enough for everyone. Many of these companies also produce other novelty items, such as mugs, calendars, posters, T-shirts, and so on.

Which company is right for you? That depends. Odds are that you won't make the cut with the Big Two, especially if you're just starting out. Targeting a smaller company that caters to a niche market might

make more sense. Whatever company you choose to woo, the same points apply as with other types of publications. As always, do your research. Find out which companies accept work from freelance photographers, and which of those are most likely to respond to your aesthetic. Then introduce yourself and your work in a cover letter; include samples or a stock list, depending on the company's preferences. Again, if the company maintains a set of submission guidelines, find them and follow them.

Sometimes starting locally can provide a small income and good exposure. Approach your local card shops and stationary stores to market greeting cards, calendars, or prints. Each year, I create holiday greeting cards

using my photographs of the Manhattan Beach, California pier (see Figure 8.8). I print the minimum run of 1,000 at a print shop (www.nextdayflyers.com) with my Web site address, name, and copyright on the back. I have enough cards to send out to family, friends, and business connections, and hundreds of cards left for retail sales at a local upscale card shop in my neighborhood. The contact information printed on the back of the card is free marketing for me, and my printing costs are paid back after selling 200 cards.

TIP

For more information about the greeting-card industry, such as industry news and trends, check out its quarterly trade publication, *Greetings etc.*, or the magazine's Web site, www.greetingsmagazine.com.

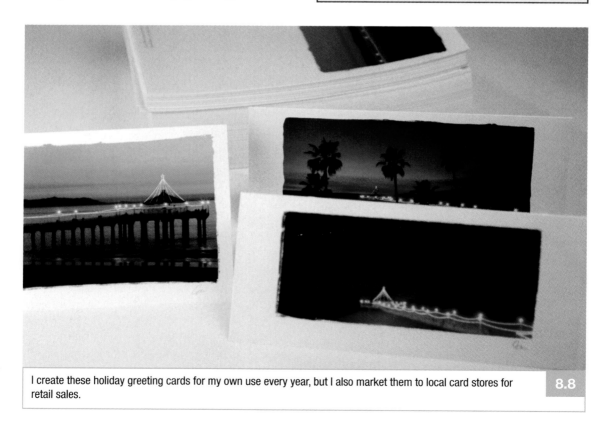

I create these holiday greeting cards for my own use every year, but I also market them to local card stores for retail sales.

8.8

THE FINE-ARTS MARKET

The last several years have seen an explosion in the popularity of photography as a collectible art form — meaning there are more and more opportunities for photographers to generate revenue in this channel, by partnering with a gallery (as in Figure 8.9) or setting up shop on e-commerce Web sites like Etsy or ImageKind.

Partnering With a Gallery

If your photography is polished and on the fine-art side — for example, if it's powerful and thought-provoking — partnering with a gallery might be the way to go. When you partner with a gallery, you display your photos in their space. In exchange, the gallery commands a commission for any pieces sold during your show. Generally, exhibits last for a month, and usually kick off with an opening or reception.

If you want to approach a gallery, you'll need to familiarize yourself with the various types of galleries available, outlined here:

- **Retail or commercial galleries.** These types of galleries claim a commission of 40 to 50 percent of all sales and exist to turn a profit. As such, they tend to work with more established artists who can command greater interest and higher prices. Retail and commercial galleries can generally be counted on to invest in publicity and marketing for any shows they produce.

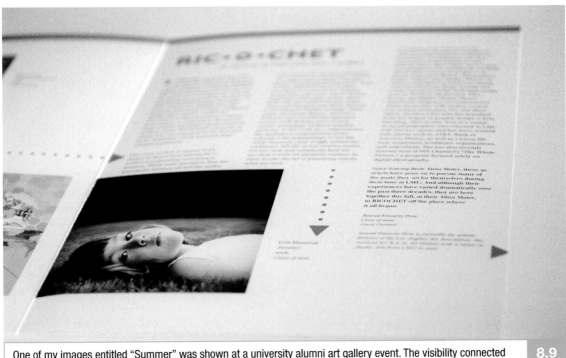

One of my images entitled "Summer" was shown at a university alumni art gallery event. The visibility connected me with art buyers and gallery patrons who became interested in my work.

8.9

This is an example of a fine-art photography show at a nonprofit, museum gallery space. © Kristoffersen 8.10

■ **Nonprofit galleries.** Unlike retail or commercial galleries, nonprofit galleries are not sales-oriented, although they do still command a commission — usually 20 to 30 percent. They do provide you an opportunity to sell your work and garner publicity, but generally do not invest in marketing efforts.

■ **Co-op galleries.** Co-ops are run by the artists who show in them. In exchange for exhibiting their work, members of the co-op share gallery-related responsibilities, such as housekeeping, maintenance, and so on. To cover expenses, some co-ops take a commission of 20 to 30 percent in addition to charging members a fee to exhibit their work.

■ **Rental galleries.** Rather than taking a commission on sales, rental galleries charge artists to rent gallery space. Be

aware that rental galleries are sometimes referred to as "vanity galleries" and can have less credibility than their retail and co-op brethren.

Once you decide what type of gallery you want to show in, it's time to visit the galleries of that type in your area to see which one might be a good fit for you and your work. Each gallery you visit likely has its own look or style. You need to assess whether that look or style meshes with your own.

It's important to align with the most credible gallery possible, not only for your own reputation, but also to ensure that your images are marketed to a solid clientele who can afford to buy your imagery. Gallery owners are often approachable and can offer answers to your focused questions. As long as you're prepared and respectful of their time, you'll probably

find them quite helpful. Once you choose a few spaces that might be a good fit, ask other artists in your area if they have any insight into the reputations of those galleries.

Here are some things to think about when researching a gallery:

- Has the gallery been around for a while and is it likely to stay around?

- Does the gallery have a client base that is interested in the type of imagery you produce?

- Does the gallery carry work compatible with yours in terms of quality, subject matter, status of the artists?

- How does the gallery market the work? Mailing lists, press, newsletters, social media?

- Is the gallery open to showing a new artist's work?

- Does the gallery have a wider connection to galleries in other cities for marketing your work?

TIP Another option is to show your work in less traditional spaces, such as bookstores, restaurants, coffee shops, florists, travel agencies, nursery schools, and the like.

Preparing a Portfolio

After you've determined which gallery you want to approach, it's time to prepare a portfolio. This should include the following:

- **Twenty or so pieces of your best work.** Ideally, these images should focus on one overriding theme, such as portraits of children, images of tractors, photographs containing the color green, and so on. These prints should be of the highest possible quality. If you're not sure which photographs to include, ask trusted friends or family members for their feedback. If several people respond positively to a specific image, even if it's one you might not have chosen yourself, odds are it belongs in your portfolio.

- **An introductory letter.** This should express your interest in the gallery and explain why you feel that you and your work would be a good fit for the gallery.

- **A copy of your resume.** This should include your artistic history — for example, formal education you have received in the fine arts, art workshops or seminars in which you have participated (as a student or as a teacher), exhibits in which you have shown work, and so on. Don't feel intimidated by the formal credits mentioned here. Just honor yourself as a photographer, think about what you've done, and list this information on your resume.

- **An artist's statement.** This brief essay (no more than 300 words) should relay how and why you create your images, what the photographs in your portfolio are about, and what you want to communicate with your work. Don't get too fancy; just be honest and direct about yourself and your work.

- **Sample press releases about your work.** If writing isn't your forte, have these prepared by a professional.

■ **Marketing literature.** Be sure to include several business cards and any brochures for your business with your portfolio. (For more on marketing materials, see Chapter 9.)

If the gallery director likes your work, you may find yourself on track for a solo show in his or her space, or perhaps for participating in a group exhibition. And if the director *really* likes your portfolio, he or she might angle for exclusive rights to represent your work. Note that these agreements are typically bound by geography. For example, you might give a gallery in Los Angeles exclusive rights to distribute your work within a 200-mile radius of the gallery. That way, you can sign a similar contract with a gallery in New York, a gallery in Chicago, and so on.

Every contract varies; you must read every single word. Pay attention to the following:

■ **The terms of representation.** What is the gallery's commission? How will the work on consignment be dealt with?

■ **Handling.** Will your images be framed by the gallery? If there is shipping involved, who pays for it?

■ **Type of shows.** Will your images be shown in a group or solo show?

■ **Time frame.** How will you be paid, and when? When does the gallery return unsold images to you? When does the contract end?

■ **Promotion.** What kind of promotion does the gallery offer? What does it involve? Newsletters, mailing lists, advertising online? Will the marketing costs be shared?

■ **Insurance.** Does the gallery insure your images while they are being exhibited?

■ **Exclusivity.** Does the gallery require that you remain exclusive within a certain geographic area? What are the boundaries?

Q&A WITH A FINE-ART AGENT

If you're interested in photography, there is a good chance that you've been to a photography art opening or have seen a collection of photographs at a gallery or retail space. Have you ever wondered how these photographers placed their imagery on the wall? Or have you dreamed of having your own art show someday? If so, you might find the following information very helpful, or at minimum, very interesting. I recently met a fine-art consultant, Angela Krass, and she has some excellent information regarding submitting your images in the fine-art market.

Angela Krass has enjoyed a diverse 20-year career in film production, promotion, marketing, and visual communications. Her current venture is managing the art of a select group of photographers and painters — marketing and promoting their work, seeking licensing opportunities, and acting as a fine-art agent and intellectual-property producer.

1. What are the basics that a photographer needs to know about submitting work for the fine-art market?

First and foremost, your work must reflect your vision — and that vision must be finely tuned and truly reflect what you as an artist

want to say. I like to see work that pushes the envelope, that provokes, that makes me sit up and take notice. Beyond that, here are a few points to keep in mind:

- **Work in series.** As a reviewer, I like to see a complete body of work with images sequencing to enhance the narrative. To illustrate, I've included images by award-winning fine-art and commercial photographer Natalie Young (see Figures 8.11, 8.12, and 8.13). Have a cohesive presentation. Have a strong starting image, have a strong mid-point image, and end with a truly memorable image. Leave the reviewer with an outstanding image in

the end that has impact. And it's true what they say: You are only as strong as your weakest image. Edit tightly.

- **Be complete.** When preparing your art for review, competition, or gallery representation, it's important to show a complete body of work. You should also include an artist statement and resume or CV (curriculum vitae).

- **Research.** Start with local galleries. Attend openings to learn what the gallery expects of its artists and what type of art they display, and see if your work is applicable to the gallery's theme. Consider attending an art expo such as The Association

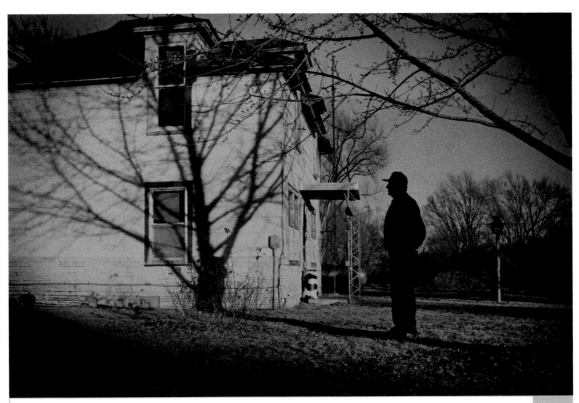

"Roots" © Natalie Young

8.11

"Stasis" © Natalie Young 8.12

of International Photography Art Dealers (AIPAD — www.aipad.com) or Photo LA (www.photola.com) to see what galleries are showing. For a list of art shows, visit www.art-collecting.com/artfairs.htm.

- ■ **Follow the submission guidelines.** When you find a gallery that might be a good fit, ask what the submission policy is. Often, instructions are posted on the gallery Web site. Then follow submission policy instructions carefully and completely. Don't take creative license by sending more images or by sending images in a different format than what is requested.

About Natalie Young's Images

These images are from a larger body of work entitled "Farm." Here is a statement from the artist, Natalie Young, relating the narrative connection between the photographs. "The Farm series was photographed in Kansas over the past decade, on the farm of my husband's grandparents. The land has been in the family for many generations and much of his family's roots, identity, and stories are tied to this particular plot of earth. This project is about place and history, about memory and story. It's about the things that tie us together, and the things that bring us back."

- ■ **Consistency is key.** Your presentation must be cohesive. Whether you show fine-art prints in an archival box, a

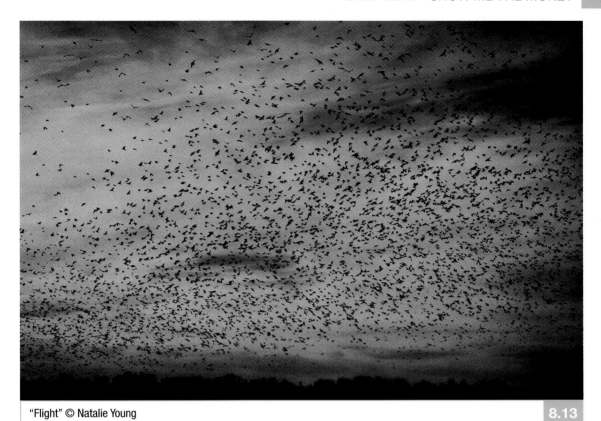

"Flight" © Natalie Young

8.13

portfolio, a book, or an iPad, it should always include a title, project description, and contact information. Make your leave-behinds, business cards, and portfolio work together to present you as a brand.

■ **Follow up.** After a reasonable amount of time — say, two or three weeks after submission — contact the gallery to confirm that your submission was received and ask when you might expect the gallery to make a decision about whether to display your work. Note that date on your calendar; if you don't hear from the gallery by the expected date, give them a call within the next week.

■ **Widen your circle.** Once you've had some success locally, research galleries in bigger cities. Look for cooperative artist-run galleries to build your resume. Artists in many cities are creating pop-up galleries, or phantom galleries, utilizing empty real estate as gallery space.

■ **Get feedback.** One way to get constructive feedback as well as exposure is to submit and attend a portfolio review event. An example of this type of event is Houston FotoFest (www. fotofest.org). There, photographers present their projects to reviewers from the worldwide photographic marketplace. The opportunity for feedback,

beneficial criticism, and networking for your art in this type of venue is invaluable. Attending a portfolio review event is a great way to receive feedback not only from the reviewers but also from fellow attendees. When you attend a review event, take time beforehand to research your reviewers. Learn their backgrounds, and find out what type of work they are willing to see, what they like, and what art applies to them and their business. (This also goes for galleries.)

■ **Prepare an elevator pitch.** Draft an answer to the question "What do you do?" Really challenge yourself with creating the perfect pitch for you and your art.

2. In the corporate-art realm or décor market, what are agents and buyers looking for?

Agents and consultants who specialize in the décor market are looking for imagery that has diverse appeal — art that would be appropriate in hotels, health-care facilities, corporate buildings, restaurants, and on view to the general public. Agents and consultants might be contracted by a company or work directly with architects, builders, or interior designers to bring their ideas to fruition. They are tasked with making the best choices for their client's vision, taste, and budget, and creating a relaxed and welcoming environment.

In the décor market, every project is unique. For each project, the agent or consultant has to learn about the client's culture, values, history, and desires. Often, the imagery has a local theme, depicting neighboring landmarks and landscapes. Agents and consultants like to

showcase emerging talent that creates imagery with a wide perspective — contemporary, traditional, thematic. The talent often works from an inspiration to create an artistic atmosphere to complement the mode and style of the client while giving expression to the corporate identity.

In this market, creating art in a series is essential. Some common themes are botanicals, abstracts, architecture, coastal, animals, figurative, florals, music, seascapes, and landscapes. Keep in mind that the imagery is viewed as an instrument to support a company or organization's brand and to enhance a professional space.

3. What criteria do you use for photography in the corporate-art space?

Research is key. Working with a specialist in corporate art, either an outside corporate art consultant or someone within the company, is the answer to understanding what type of art a corporation collects. Corporations can acquire art as an investment strategy or to inspire customers, clients, and employees.

4. Are online sales outlets such as Etsy.com viable places for selling photography as art?

Online sales outlets such as Etsy are fine for consumer-direct opportunities, but like any venue for art, the artist must have a marketing plan in place in order for this to be a viable outlet. Promotion and networking through friends, organizations, social networking sites, and blogging are key to creating sales, as is establishing the proper price point. Again, review the site to see what others are selling, price points, style, and so on.

Consumer-Direct Sites

Etsy.com is a Web site whose mission is to establish connections between creators (that's you) and buyers (that's people who want to buy your photography). A recent visit to the site found more than 160,000 photo prints for sale ranging in price from 20 cents to thousands of dollars.

Artistrising.com is an online community that allows members to create galleries on the Web for viewing and purchasing by the public.

Zazzle.com enables anyone to set up a store, upload your photographs, and monetize your creations.

Imagekind.com is a Web site that allows you to print and sell your photographs. You can even access your images from your Flickr.com account.

5. Is there an identifiable hierarchy of exposure and commercial viability in the fine-art world?

Absolutely! The more interest and visibility you can bring to your art, the better your chances are for representation. Enter competitions, send out press releases, blog, take on editorial assignments — anything to break yourself out from the pack and put a shine on your brand. Collect testimonials and reviews and put these on your Web site and collateral materials. Donate work to worthy causes, and then blog about it.

6. Is it possible to make a living of fine-art photography?

I believe an artist needs to create multiple streams of revenue. Have a body of work that you present as fine art, have a secondary body of work for the décor market, and if you're so inclined, sell prints through your Web site, other consumer-direct sites, and so on.

7. Who are some of the top-selling fine-art photographers, and in your estimation, why are they successful?

Art is subjective, but I think the common thread is when an artist truly has a sense of vision, a passion that translates through the camera, so the viewer has a reaction deep in his or her soul. I can cite Joel-Peter Witkin as a top seller. He's not for everybody, but he's true to his artistic vision. Cartier-Bresson had the ability to capture everyday life in a way that people can appreciate and relate to. Jock Sturges' art provokes, as does Sally Mann's, Irving Penn's, Julie Blackmon's photographs of the domestic landscape, Peter Beard's, Nick Brandt's — the list goes on. The common thread with these artists — and all of those artists who are at the top of their games — is that they have a unique point of view. Their imagery is bold, distinctive, and captivating.

TIP A simple look at your local Yellow Pages or a quick Google search should help you locate advertising agencies and design firms in your area. Your local chamber of commerce may also be a good resource.

COMMERCIAL ADVERTISING

Many of the opportunities that are available in finding a market for your photographs have been discussed, but I don't want to overlook the commercial advertising field. Commercial advertising photography has historically provided the golden ring many photographers seek — money, prestige, visibility, and if they became popular, free reign with their artistic vision. While it's still possible to sell your work in this area, the field is even more competitive and the game has

changed. To provide you with some current insight, I spoke with Jay Miletsky, a 15-year veteran of the marketing and branding industries and CEO and Executive Creative Director at Mango! Marketing.

His opinion of the state of the market today is that professional photographers have had a tough time since computers have taken over the industry. The problem, Miletsky says, is "Photoshop has made graphic designers think that photography is easy, and that even mediocre pictures can be salvaged by simply adjusting their levels. Inexpensive digital cameras have made it simple for non-pros to take their own pictures and leave it to the graphic designers to improve. Maybe worst of all, royalty-free sites like gettyimages.com, istockphoto.com, and others have made it easy for advertisers to search for photography based on subject, and incredibly cheap and easy to buy. Technology has begun to erode the demand for custom photography. There's simply no longer a huge need for an ad agency to hire a professional photographer for the standard around-the-office or typical lifestyle shots that make up the bulk of the images used in print ads, Web sites, and collateral material. At the same time, more photographers are vying for the few open opportunities that do require specialized talent and custom work, such as photojournalism, product, and event photography."

In responding to the question, what steps can photographers take to land the work that is available? Miletsky offered the following pointers:

- **Listen to your client**. When you're hired by a brand or an agency, the finished product has one purpose: to help sell something, so worry more about getting the shots the client needs, really listen to their concerns, and be open to making changes.

- **Share the creativity.** Be open to brainstorming. Share your thoughts and visions for a shoot. Make suggestions and provide solid advice. But be flexible and willing to work with other people's ideas as well.

- **Provide extra, value-added services.** Most agencies have designers on staff, but they're expensive and their time is valuable. If you can do some of the initial retouching of images yourself, that's a valuable service that would be meaningful to marketers and agencies.

- **Get to know the industry you're approaching**. Be sure to keep your Web site images relevant to the industries you want to attract.

Advertising photographers are still an important sector of the market, and are needed to produce customized, creative, and high-end imagery. There are various levels of commercial advertising photography; for example, you could be hired by a small design firm (as I was years ago) to shoot a local hospital staff because you're good with people. But unless you're very experienced, you're probably not going to be hired by a major ad agency or corporate client to shoot a well-known product any time in the near future. Just like climbing up a mountain, you move one step at a time. Build your portfolio, build your client base, and continue learning.

ENTERING CONTESTS

Especially if your career is just taking flight, entering photography contests can be an

excellent way to boost both your visibility and your credibility. It also enables you to gauge how your work compares to that of other photographers. If you win, you may net a tidy sum — and perhaps more importantly, get your photo published. For example, winners of *National Geographic*'s annual photo contest haul in $10,000, and the winning photos appear in the magazine.

National magazines such as *Communication Arts*, *Photo District News*, and the previously mentioned *National Geographic* run annual photo contests that attract the best images from photographers of all skill levels. You can also check out contests fronted by photography associations such as the

American Photographic Artists, the Lucie Awards, and major publishing houses, as in Figure 8.14.

Before you submit an image to a photo contest, be certain you read the fine print and understand the contest's copyright rules. With some contests, winners forfeit all rights to their images. With others, even people who simply enter the contest forfeit their copyright. Be wary of these types of contests; their intent might be to simply to build a large collection of photos for future advertising or editorial use. Legitimate contests allow you to retain the rights to your photos.

Be sure to read the fine print when entering photography contests. 8.14

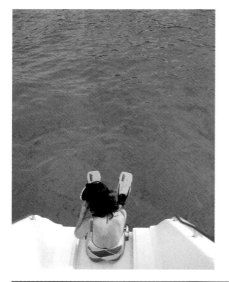

CHAPTER REVIEW

A A good rule of thumb when beginning your photography business is to start where you are, and do what comes easily.

B The recent increase in the popularity of photography as a collectible art form has yielded more opportunities for photographers to generate revenue.

C Stock photography consists of rights-managed, royalty-free, and micro-stock opportunities.

D Entering photography contests can be an excellent way to boost your visibility and your credibility.

marketing

9

At this point you should have a fairly clear idea on the kind of photography you want to do and the equipment you need; the next step is marketing your business. Photography requires creativity and a technical understanding of your equipment. Similarly, marketing requires creative thought and a willingness to embrace the technology essential to reaching your market. Simplified, marketing is the act of buying or selling in a marketplace. What does that mean to you as a photographer? Once you indentify the kind of photography you want to specialize in, you need to determine who your potential customers are, and what they want, and then figure out how to attract them. This chapter guides you through the various marketing modes you need to consider.

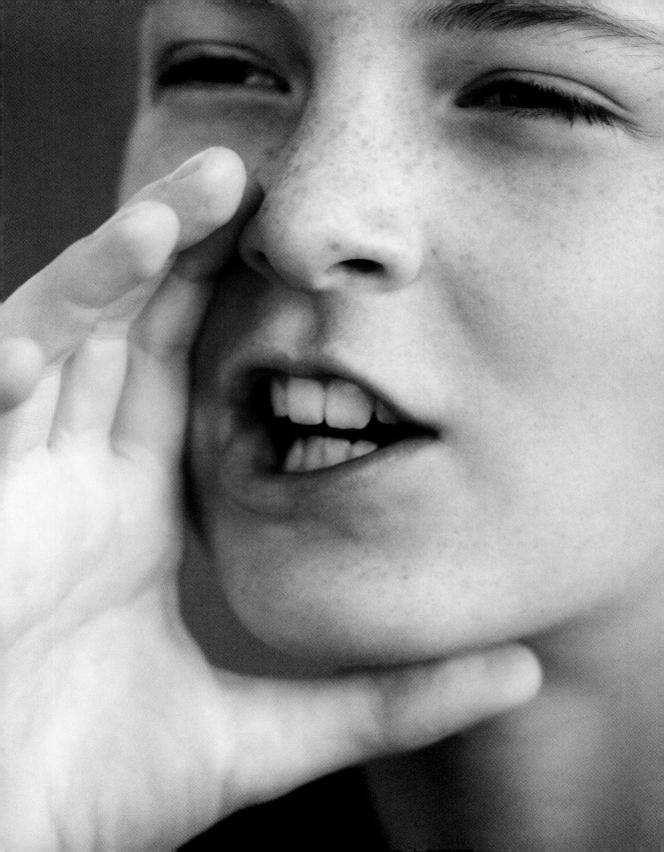

RESEARCH THE MARKET

Before embarking on any marketing effort for your digital-photography business, you must have a clear understanding of what your market is. Who are your potential customers? What do they want? Is your market local or global? You must also be keenly aware of your competition. Who are the other photographers in your area? What do they do well? What do they do poorly? How difficult will it be for you to lure customers away from them?

LOCAL DEMOGRAPHICS

If you live in a small town in Iowa, you probably don't want to launch a photography business that specializes in high-fashion photography. Sure, you might land the occasional high-school senior looking for an eye-popping school portrait, but it's unlikely you'll earn enough to stay afloat. Likewise, if you open a photography studio in midtown Manhattan, you probably won't want to specialize in photographing large farm animals. All this is to say that it's critical that you determine whether your market is likely to want what you're selling.

To get a handle on your local market, you'll want to locate demographic and economic data about your area — age range, income, number of businesses by type, and so on. These services give you a big picture view of what's going on in your area, which can help determine where your market might be and your developing business strategy.

Here are a few places to start:

- **U.S. Census Bureau American FactFinder (http://factfinder.census. gov).** Obtain population, housing, economic, and geographic data at the FactFinder site.

- **U.S. Census Bureau State Data Center (www.census.gov/sdc).** The State Data Center (SDC) is a partnership between the Census Bureau and various agencies in the 50 states, District of Columbia, Puerto Rico, and island territories to disseminate data and make it available to the public.

- **U.S. Census Bureau Economic Census (www.census.gov/econ).** Access the latest economic census, conducted every five years to profile the U.S. national economy and local economies.

- **Chamber of Commerce.** Check your local chamber of commerce for demographic data for your area.

LOCAL COMPETITION

It's not enough to determine whether your market wants what you're selling. You also have to figure out who else is already selling it. Specifically, you want to find out the following:

A simple look at your local Yellow Pages or a quick Google search should help you find photographers who are operating in your area. As for the rest — what they do, what they offer that you don't, how established they are, how strong their reputations are, and how difficult it will be for you to lure customers

away from them — you'll need to check out their Web sites, read their blogs, and be aware of the local photographic industry. Your local chamber of commerce may also be a good resource.

Armed with this information, you can better position yourself in your market. For example, if you specialize in portrait photography and another photographer in your area already has a lock on the local baby-photo market, you might focus your efforts on capturing the teen-photo segment. However, if you feel passionate about taking pictures of babies and feel there is something distinctive and winning about your style and approach, give it a try. You may be able to distinguish yourself in a competitive market by being better than the local competition.

While you may assume it's best to view your competition as the enemy, I don't necessarily share this view. Sometimes, calling up your competition and introducing yourself as a fellow local photographer is a good thing to do. If you're just starting out, you might even offer to assist him in his work. In the end, you could wind up with a powerful professional ally — and possibly a friend.

Researching your competition can also give you a sense of how other photographers in your area are pricing their work, which can help you determine how you should price yours.

Finally, all this legwork will enable you to pinpoint your competitive advantage — what you offer that your competition doesn't. Identifying this competitive advantage is critical to conveying to potential customers why they should hire you and not someone else.

DEVELOP YOUR BRAND

If you're looking to start your own business, whether in photography or any other field, you've probably heard the term *brand* bandied about. Maybe you've even used it yourself. But what *is* a brand, exactly?

One way to think about a brand is as a company or product's reputation, or even its identity. Consider a company like Apple. Apple has developed a brand that is hip, fun, and innovative (see Figure 9.1). In contrast, companies like Brooks Brothers have developed brands that are traditional, serious, and conservative.

The Apple brand is hip, fun, and innovative.
© Erin Manning
9.1

So what does all this mean to you, the aspiring professional photographer? It means that you, like Apple and Brooks Brothers and every other company out there, must develop your brand.

YOUR STYLE

In developing your brand, begin by pinpointing your style and message. Ask yourself, "Who am I as a photographer?" If your photographs are very minimalistic, like the one in Figure 9.2, your brand should reflect that. If you shoot high-impact sports-related images, like the one in Figure 9.3, your brand should

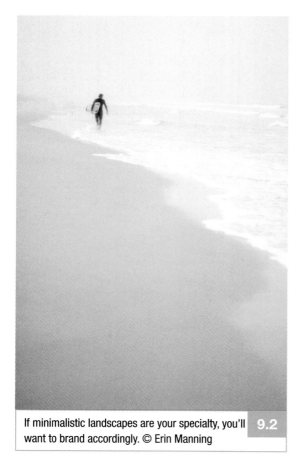

If minimalistic landscapes are your specialty, you'll want to brand accordingly. © Erin Manning 9.2

Pinpointing Your Style

As a photographer, your photographs strongly reflect who you are as an individual. If you're having trouble pinning down your photographic style, think about your own personal style — how you dress, how you decorate your home, the type of car you drive (or *would* drive, given your druthers), and so on. Do you tend to wear simple, streamlined clothes, or are you drawn to garments with more frills? Is your bedroom painted turquoise and stuffed full of flea-market finds or is it minimally furnished in white on white? Most likely, this personal style will show itself in your photographs.

reflect that. And if you're a jack of all trades, handling all different types of photography, your brand should reflect *that*.

YOUR COMPANY NAME

It goes without saying that your company name is an important part of your brand. A great name can make all the difference!

Depending on how you choose to market your business, you may want to use your own name. For me, my photography business strongly incorporated my personality and identity. I built my "brand" upon who I am as a person, everything from the colors, the typography, and the design of my logo. This branding visually represents the simplicity of my photographic style.

While many photographic businesses choose to use a personal name, another option is to use a name that relates to a benefit you offer or that defines what your business provides. For example, if you're a baby and child photographer, the name of your business might be "Kid Pix," or if you're an editorial photographer, the name might be "Media Photos" or something similar.

Once you decide on a selection of names, it's a good idea to check and see if the domain name is available and if it's possible to claim the name locally or nationally via the trademark office. More information about this comes later in this chapter. Keep in mind that you can name your business after yourself and use a different domain name. It all boils down to how you communicate the information via your marketing outreach.

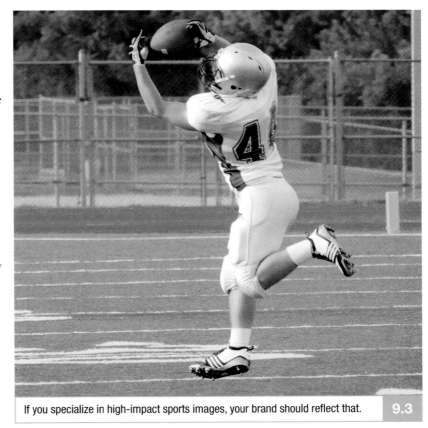

If you specialize in high-impact sports images, your brand should reflect that. **9.3**

If you choose to go a different route, you'll want to keep these points in mind:

- Choose a name that's easy to remember. On a related note, avoid names that involve more than three syllables.

- Pick a name that's easy to pronounce and, even better, fun to say. Try to incorporate syllables that start with a strong consonant.

- Opt for a name that relates to your business, describes the benefit you offer, delineates your business from others, or all of the above.

NOTE

Note that some lawyers advise against naming your business after yourself, citing liability issues. Before going this route, talk to an attorney.

Whatever name you choose, be sure it speaks not just to your market but also to you. It's going to be with you for a long time, so be sure you pick one you like!

TIP

Learn how to register your company's name in Appendix A.

YOUR LOGO AND OTHER DESIGN ELEMENTS

Some people equate brand with a company logo. But the fact is that a logo is simply a visual representation of a brand. That's not to say the logo isn't important; it is. In fact, a successful logo serves as a sort of shorthand for everything your brand stands for. For example, my logo is shown in Figure 9.4. It was designed to convey a fresh, clean, contemporary aesthetic, and to communicate a friendly, simple approach.

Developing a strong logo and other design elements, such as colors and fonts, is critical. After all, you will use them in all your marketing materials — your business cards, letterhead, brochures, Web site, blog, and any advertising you do — and you may even incorporate them into the look of your studio space, if applicable, and even what you wear to photo shoots. You *must* have a consistent brand aesthetic.

A Word on Colors and Fonts

Any colors or fonts you associate with your brand must reflect the brand. For example, if your photography is splashy and fun, you'll want to choose colors and fonts accordingly. If, however, your work tends toward muted and minimalistic, your colors and fonts should, too. Finally, the colors and fonts you choose may depend on your area of specialization. For example, if you're a wedding photographer, you might opt for a pale palette and a fancy font. Alternatively, if you specialize in photographing kids, you might choose a palette of primary colors and a more fun or whimsical font.

You should enlist professional help in developing your logo and other design elements. If hiring a designer just isn't feasible for financial reasons — which may well be the case if you are just starting out — see if you can work out a trade. Alternatively, recruit a design student to design your logo free of charge as a way to build her portfolio. Whatever you do, don't attempt to develop your logo and other design elements on

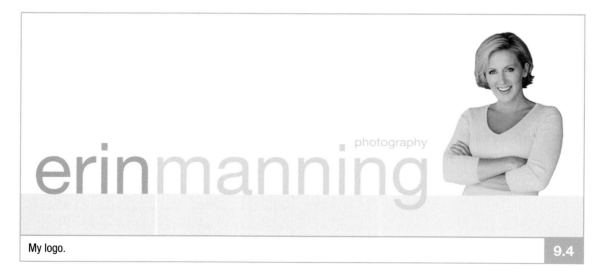

My logo.

9.4

your own. If you are not trained in the art of graphic design, the result will almost certainly be amateurish — which is not what you want your brand to convey!

TIP
Make sure your designer creates your logo in a computer program like Adobe Illustrator, and that he or she gives you all the files you need to use the logo online and in print.

Once you and your designer have a few rough ideas on paper, share them with a few individuals whose opinion you trust, and ask them for their input. Ask them, "Do the logo and other design elements make sense? Do they convey my style? Do they reflect my brand?"

TIP
As you develop your logo and other design elements, keep things simple. Less is more.

MARKETING TOOLS

The best marketing efforts involve a multi-front approach. This ensures maximum visibility. More visibility means more credibility — which translates into more people who trust you enough to hire you.

Fortunately, there are numerous marketing tools at your disposal to implement a multi-front strategy:

- Business cards, letterhead, and other promotional print materials
- A Web site

- A blog
- Social media
- E-mail
- Advertising
- Referrals
- Networking

BUSINESS CARDS, LETTERHEAD, AND OTHER PROMOTIONAL PRINT MATERIAL

Print marketing — although less important than it used to be — remains a critical ingredient in any marketing recipe. This might include business cards (a must), letterhead, and promotional print materials such as 4-× 6-inch cards, brochures, calendars, and so on. Of course, all these print materials should be designed to show off your very best work and to reflect your brand, with the appropriate colors and fonts (see Figure 9.5).

TIP
A great way to get your name across is to print up bookmarks with your company information and a sample of your work, and leave them at bookstores for people to pick up. Each time they use it to mark their place in a book, the name of your business will sink a little deeper into their brain.

With respect to business cards, although you can purchase decent cards at various office-supply outlets for just a few dollars, you might want to spring for a nicer design and higher-quality paper; it makes a better impression. At the very least, your business card should include the following:

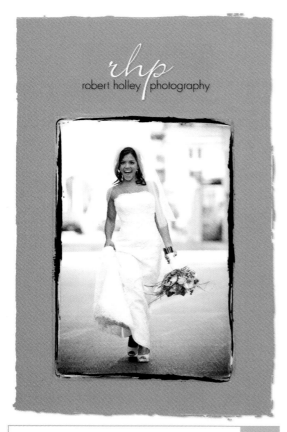

| Your promotional print materials should reflect your brand. | 9.5 |

- Your name
- Your title
- Your logo
- Your mailing address, phone number, and fax number
- Your Web site's URL
- Your e-mail address

Larger promotional print materials should include similar information, along with a sample of your work and, optionally, pricing information. They should also point recipients to your Web site, where they can see more images.

Business cards and other print promotional materials should be distributed in a gratuitous manner. If someone asks for one, give them several! Keep a stash of them in your camera bag whenever you're on a shoot, scatter them around your studio, and ask local businesses like coffee shops and bookstores if you can leave some on display.

WEB SITE

These days, when people want information about a business or product, the first thing they do is search the Web. In fact, according to a report by the Pew Internet and American Life Project, more than 80 percent of all Internet users have used the Web to conduct research on products and services before making a purchase — a staggering statistic! If you hope to convert those Internet users to customers, you need a Web presence — ideally, a Web site. But not just any Web site will do — you need a *good* Web site (see Figure 9.6).

Web Site Design

What constitutes a good Web site? First, a good Web site is one with an attractive design, with visual elements — namely fonts, colors, and images — that speak to the target audience. (Of course, these visual elements should reflect the choices you've made

in developing your brand.) Second, a good Web site is easy to navigate. That is, visitors can swiftly locate the information they need. Third, a good Web site loads quickly; otherwise, visitors will lose interest and go elsewhere.

At the very least, your Web site should contain your logo, your contact information — including your mailing address, e-mail address, phone number, and fax number — and samples of your work.

NOTE

If you plan to post images online — for example, on your own Web site — you might want to add a watermark to them to ensure that no one "borrows" them without your permission. Many image-editing programs enable you to add a watermark to your images.

TIP

Don't let your Web site become outdated! Be sure to keep it fresh with your best and latest work.

In addition, your Web site might feature the following:

- Pricing information
- Testimonials from clients
- Links to press coverage of your work
- A biography
- A blog (more on that in a moment)

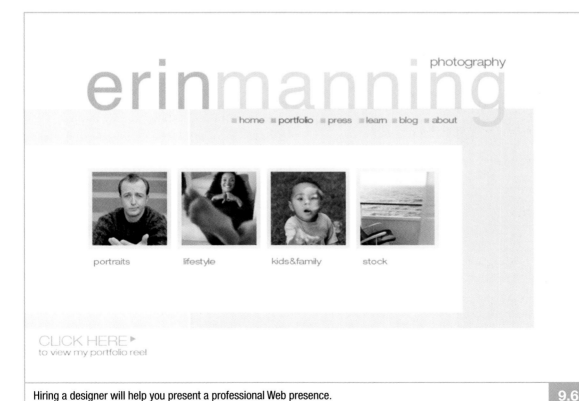

Hiring a designer will help you present a professional Web presence.

9.6

Using Your Web Site for More Than Just Marketing

As a digital photographer, your Web site can be more than just a marketing vehicle; it can be an integral part of the service you offer your clients. For example, you might enable potential customers to check your availability right from your Web site (especially handy if you're a wedding photographer). Or you could set up your site so clients whose shoot is complete can review — and even order — their photos online.

Your Web site will be your business's face to the world — which means you can't just slap it together. A Web site that looks amateurish is worse than no Web site at all. Just as you hired a graphic designer to develop your logo and other design elements, you should employ a Web designer to produce your Web site. As before, if hiring outside help isn't feasible, see if you can work out a trade or recruit a design student to design your site free of charge in order to build their portfolio. Also make sure your Web site is free of spelling and grammatical errors. A Web site that is riddled with mistakes makes you and your business appear unprofessional and incompetent.

TIP

When you receive compliments about your work, ask if you can publish those opinions on your Web site. These types of testimonials can be very persuasive.

Choosing Your Domain Name

A Web site is a must these days. It's no longer a huge investment to get started. You can use a site like www.elance.com and have someone design a simple 3-page website for around $50. Before your Web site can go

live, you have to purchase a domain name — the part of your Web site's uniform resource locator (URL) that goes between the "www." and the ".com." You can purchase domain names from various sites, including Network Solutions (www.networksolutions.com), Go Daddy (www.godaddy.com), and Dotster (www.dotster.com).

If developing a Web site is currently beyond your budget, do at least purchase your domain name. That way, you don't have to worry about anyone taking your name before you're in a position to build your website. While you're at it, go ahead and register your business's name with various social-network sites such as Facebook, Twitter, Flickr, YouTube, and so on.

If you can, use your name or the name of your business as your domain name. If that domain name is not available, choose one that's close. Do try to obtain a URL in the .com domain rather than .net, .org, or .biz domain. The .com domain is the most popular and known for representing anything commercial.

Of course, in order to view your Web site, your potential clients need to be able to find it. That's where search engine optimization — SEO for short — comes in. SEO involves the use of various techniques to ensure that a Web site appears higher in the list of matches — preferably on the first page — when someone conducts a search using certain keywords. When developing your site, be sure your developer implements any necessary SEO measures.

You can also drive traffic to your Web site using services such as Google AdWords. With this service, you can run an ad that

links to your Web page when anyone within a certain geographic area runs a search with specific keywords, such as "photographer" and the name of your town.

BLOG

A great way to keep your Web site fresh — which is key if you want to generate repeat visits among potential clients — is to maintain a blog (see Figure 9.7). A blog — which is simply an easy-to-update online journal of sorts where you can jot down your thoughts on various topics — is a great way to demonstrate your knowledge and experience, and enables potential clients to see what you're all about. For example, you might use your blog to tell stories about events you've photographed and post a few images from the shoot. Or you might use

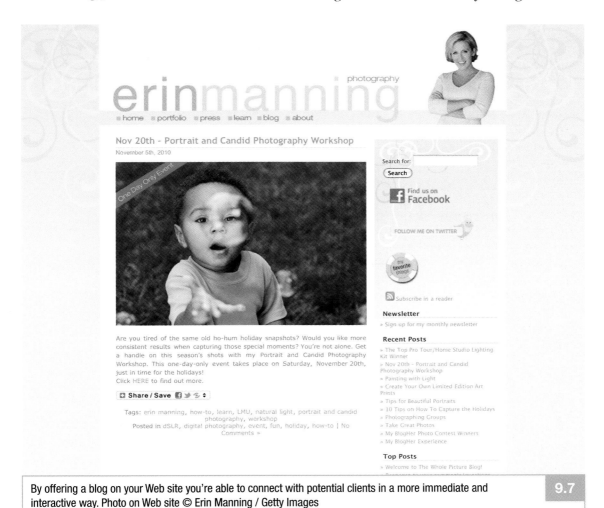

By offering a blog on your Web site you're able to connect with potential clients in a more immediate and interactive way. Photo on Web site © Erin Manning / Getty Images

9.7

your blog to pass on articles you find online about trends in your industry. You could even use your blog to talk about what's going on in your life and share some of your personal images. Just make sure that whatever you post provides value of some kind to the reader.

TIP If creating your own Web site is outside your budget, you can maintain a blog instead. There are many sites that enable you to set up and maintain your own blog free of charge — without knowing the first thing about programming. I recommend WordPress (wordpress.com), which offers loads of great templates, robust statistical tools to determine how many people are visiting your blog, support for SEO tagging, and more.

If you opt to go the blog route, be aware that you'll get more out of it if you maintain a regular blogging schedule. That is, you must generate new content on a regular basis, whether it's once a week, once every other week, or once a month (once a week is best.) Failure to adhere to a regular schedule can lead visitors to believe that there's nothing important happening with your business — which is, of course, *not* what you want to convey. As with your Web site, it's critical that your blog be free of spelling and grammatical errors!

SOCIAL MEDIA

Unless you've been living in a cave for the last few years, you're probably familiar with social media — sites like Facebook, YouTube, LinkedIn, Twitter, and others where users form online communities. Although many people use social media to stay connected with friends and family, social media also represents a great new way to increase exposure for your business, build relationships with your existing customers, and connect with new clients.

Establishing a social-media presence for your business is easy — and free. The catch? It can be time-consuming. You can't just create an account with a social-media site, post the occasional promotional update, and expect an uptick in business. You really need to invest time and energy generating appealing and informative content to share with your audience. The trick is to adopt social media as part of your daily routine; in time, your online community — and your business — will grow.

Facebook

Perhaps the most popular social-media site — for the time being, anyway — is Facebook. Indeed, millions of people use Facebook every day to keep up with friends and family; share photos, links, and videos; and more.

Everyone on the site has their own page, called a *profile*, on which they can post status updates (this might be anything from a brief, pithy statement about what they are doing at the moment to their philosophical views of life and beyond), photos, videos, links to articles, and more. People with whom they have connected on the site — or *friended* — can then view anything they post on their own News Feed screens, and vice versa.

In addition to these personal pages, Facebook also supports the use of fan pages, which are used by businesses and other entities for promotional purposes. Fan pages function similarly to personal pages. The administrator of a fan page (that's you) can post status updates,

photos, videos, and so on, and those posts are distributed to anyone who has opted to become a fan of the page. Your Facebook fan page is the perfect place to announce upcoming specials or promotions, spark conversations, and share your latest work.

TIP

If you post photos of other Facebook members, be sure to tag them; that way, your photo will appear on their Facebook page, for all their friends to see. Hello, exposure! (For assistance with tagging, see Facebook's Help information.)

One caveat: If you're not committed to maintaining your Facebook fan page or hiring someone who will, don't create one. Having a page with outdated information and no fans will actually make your business look worse.

YouTube

YouTube is a worldwide video-sharing community. Their slogan is "Broadcast Yourself," and that's exactly what YouTube allows you to do. If you're unfamiliar with YouTube, it's an online distribution platform for original content creators, advertisers, and even major

Animoto.com

If you're feeling intimidated about creating a video, it's not difficult to do. You can work with still images, video, or both to create professional-looking videos in minutes just by using one of my favorite online video services, Animoto.com. Just upload your photos (you can even pull them directly from Picasa, Smugmug, Facebook, Flickr or Photobucket), choose your music, and click "go." Animoto will automatically analyze your song, choose appropriate motion design and sync your images to the music, and you'll get a custom video back in a matter of minutes. You can even upload it directly to your YouTube account.

networks and politicians. Did I mention that it's free? All you need to do is register an account under your name (or business name) and upload videos of your portfolio, information about your business, and entertaining and valuable content that conveys your message and reaches your target market.

LinkedIn

LinkedIn is a business-oriented social-networking site that enables users to maintain a list of contact details for professionals they know and trust, called *connections*. More than anything, LinkedIn offers a great way to manage the information that's available about you as a professional to the public and to expand your professional sphere. It also provides yet another avenue for others to find you.

When you join LinkedIn, you create a profile summarizing your expertise and achievements; you then connect with others with whom you have worked over the years to form a network consisting of your connections, their connections, and their connections' connections. You can then update your LinkedIn profile much as you would your Facebook page to keep others in your network up-to-date about your professional accomplishments, post photos from your latest shoot, or share other information that might be useful to them.

Twitter

Twitter is designed to enable people and businesses to stay connected, even on the fly via mobile phone, by broadcasting and receiving short (140-character) messages, called *tweets*. People can find your tweets by

conducting searches on Twitter. If they like what they see, they may opt to follow you, meaning they'll receive your tweets automatically. Twitter is great for floating ideas, asking questions, and soliciting feedback.

As a photographer, you might use Twitter to share details about your day on a shoot, announce upcoming specials or package deals, or distribute an article of note to fellow photographers. At the same time, you can keep track of what other Twitter users are saying about your industry and even your business, giving you invaluable insight into the minds of your customers.

You can connect your Twitter feed to your Facebook fan page so that any tweets you send also appear on Facebook.

TIP

Be aware that Twitter has developed a following that borders on cultish with its own unique culture and rules of etiquette. As such, there are a few points you should keep in mind when you use it:

- **Be real.** Use a casual, friendly tone in your messages. Don't try to appear too polished.

- **Be positive.** Don't use your Twitter account to spread negativity. Be cheerful, fun, and useful.

- **Build a community.** Rather than viewing Twitter simply as a place to broadcast information about your business, think of it as a place to build relationships, engaging in dialogues with others who share your interests.

Creative Commons

Creative Commons was invented to create a more flexible copyright model, replacing "all rights reserved" with "some rights reserved." Licensees may copy, distribute, display and perform the work and make derivative works based on it only if they give the author or licensor the credits in the manner specified.

- **Pass it on.** If you like a message, retweet it within your own community. The source of the original tweet will appreciate your efforts to amplify his or her idea, and may just return the favor for you in the future.

Flickr

A great way to boost your exposure on the Web is to post a portfolio of your strongest images — the ones that best reflect what you can do — on Flickr, a photo-sharing Web site with a robust online community. Indeed, you won't find a larger photographic community anywhere on Earth.

Depending on the settings you choose, other Flickr users — including photo researchers who are constantly on the hunt for new talent — can view and comment on your photos. If you want, you can apply a Creative Commons license to your Flickr images to enable others to use them. Alternatively, you can use Flickr to submit pictures to stock-photography giant Getty Images for their consideration.

With so many members — professional as well as amateur photographers — Flickr can be an excellent source of inspiration. Sometimes, seeing what others are doing is the best way to breathe new life into your own work.

TIP

E-MAIL MARKETING

A great way to keep your photography business in the forefront of people's minds is to send a regular e-mail newsletter. You don't need to do this too often — once a month is fine. The newsletter might include a rundown of recent shoots, any specials you're running, any classes you're teaching, or even handy photo tips for your clients' personal use (see Figure 9.8). Be sure to include links to your Web site, blog, Facebook page, Twitter account, and so on.

newsletter

MAY 2008

erin

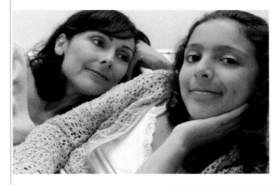

inspire

"It's not what you look at that matters, it's what you see." -- Henry David Thoreau

inform

Great photography is all about the light and this tutorial makes it simple to take a professional looking portrait. Capture a beautiful picture of Mom on Mother's Day, the low-tech way -- it's easy!

Click here

invite

You're invited! Exclusive for my newsletter subscribers - take advantage of a special, limited time offer from Shutterfly (good until May 31st). Get 20% off your Shutterfly order when you spend $30. Enter Special Offer Code: EMNL - SFLY (case sensitive)
Click here

Erin Manning Photography | http://www.erinmanning.com

You are receiving this email from Erin Manning because you subscribed on the website. Thank you! To ensure that you continue to receive emails from Erin, add info@erinmanning.com to your address book today. To add or subtract a subscription, or change your e-mail with us, click on the "update profile" link at the bottom of this newsletter.

Send out a regular e-mail newsletter. 9.8

To build your list of recipients, include a "Sign Up for My Newsletter!" link on your Web page that leads to a page where visitors can enter their contact information. Also make it a habit to ask your existing clients if they'd like to be added to the list.

Whatever you send, make sure it will be of use to the recipient, lest your missive be perceived as spam!

TIP

ADVERTISING

Although you will most likely focus your efforts on other marketing tools, such as your Web site, social-media pages, blog, and promotional print materials, there may be room in your marketing strategy for advertising, at least in the print and online realms.

One obvious platform is your local *Yellow Pages* — assuming your prospective clients live in your community. There, you can list your business free of charge, or upgrade to a small ad for a fee. If you're not sure whether to run an ad, consider your target audience. If it consists of a younger demographic, you might reasonably assume most of them will find you online. If your target group is older, they might be more likely to turn to the Yellow Pages, in which case placing an ad there might make more sense.

Your hometown newspaper and other community-centric publications — both print and online — are other obvious venues for advertising, again assuming your market is local. If you go this route, don't run one large, splashy, expensive ad; rather, commit to running a smaller ad on a regular basis

If you advertise with a publication, see if you can persuade them to run a story about you. Try to feed them an interesting angle. This can do wonders to build your credibility in the marketplace.

TIP

over a period of time. If you specialize in a certain type of photography — for example, weddings or kids — you might also opt to advertise in regional print and online publications devoted to that market.

REFERRALS

By far, referrals are your most valuable marketing tool. In fact, a good referral from a trusted source is far more likely to motivate a prospective client to call you than even the most professional Web site or beautiful business card.

Obviously, to generate referrals, you must make every effort to please your customers — before, during, and after the shoot. Conducting yourself professionally and putting your clients at ease are musts. Beyond that, it's a simple matter of staying in touch. That way, when their friends need a photographer, you'll be in the forefront of their minds. One obvious way to stay in touch is to send your e-mail newsletter to your existing clients (unless they prefer to opt out, of course). Another is to connect with them via Facebook and other social-media sites.

Consider offering existing customers a discount on future services if they refer a new customer to you.

TIP

Referrals can also come from your fellow photographers or other vendors. For example, if you specialize in photographing weddings, you may find that other wedding vendors, such as wedding planners, DJs, caterers, wedding videographers, and even other wedding photographers, are more than happy to send clients your way — especially if you return the favor.

NETWORKING

Networking is essential to the success of your business. Not only should you seek to connect with other photography professionals, but you should also make it a point to expand your sphere in general.

Contrary to popular belief, networking need not involve attending formal meet-and-greet events or making cold-calls — although it certainly can. Networking can be as simple as visiting with other parents during your child's soccer game, chatting with fellow members of your church congregation, or striking up a conversation with a fellow regular at your favorite coffee shop. The idea is to build relationships with people in your community who might be able to help you land clients — and for whom you can return the favor.

That's not to say you can't employ more strategic networking. For example, you can make it a point to attend networking events in your area. Often, these involve gathering for lunch, meeting for coffee, or

Expanding Your Reach: Joining Professional Associations

Joining professional associations is a great way to network with other photographers — which is an excellent means to form alliances and stay inspired. But depending on the association, there may be other perks as well. For example, some associations offer training seminars and expos as well as certification programs. Others might have relationships with vendors that enable you to receive discounts on such necessities as business insurance and photographic equipment. Joining a professional association can also lend credibility to you and your business, especially if there is some accreditation involved.

Here are a few photography associations that may be worth a look (you can conduct a quick Google search to find others):

- Professional Photographers of America (www.ppa.com)
- American Society of Picture Professionals (www.aspp.com)
- American Photographic Artists (www.apanational.com)
- Photographic Society of America (www.psa-photo.org)
- PMA (www.pmai.org)
- American Society of Media Photographers (http://asmp.org)
- The Association of Photographers (http://home.the-aop.org)

mingling at a local tavern. Trade shows are another excellent venue for connecting with other photographers and potential clients.

215

CHAPTER REVIEW

A Research other photographers in your area.

B Develop your own style of identity and branding.

C Be diligent and creative with your marketing.

D Use social media to build your community and communicate.

digital darkroom

Photography has come a long way since 1839. Film cameras have been replaced by digital cameras, and the traditional darkroom, with chemicals and paper, has been transformed into a digital darkroom with computers, scanners, and printers. Instant feedback and creative flexibility are just a few of the perks of going digital.

In addition to these new possibilities, digital photography presents a new assortment of challenges. Once you begin to collect and store your vast array of images, you also need an easy way to sort, store, and locate all this data. And unlike film, thousands of digital images can be lost in a fraction of a second.

So how do you handle all these images? How do you organize your images so you can find what you want, when you want it? How do you avoid losing your images? This chapter helps answer those questions by providing the basic principles of organization and file storage and presenting the use of digital asset management (DAM) techniques.

ORGANIZE YOUR IMAGES

As you transfer more digital image files from your camera to your computer, it will become harder to keep track of them all — *unless* you develop a system for organizing them right from the start. Doing so helps you to ensure that you can quickly and easily find any image you seek — which is vital when you are in the business of selling your photographs. Regardless of the software you choose to accomplish this task, the following steps and information are universal to keeping your images organized and intact.

SELECTING AND EDITING

In the scope of digital photography, the term *edit* is often used to define the process of adjusting your images in an image-editing software program to produce the most visually pleasing image. But first you need to edit your images by going through them, getting rid of the problem images, and finding your favorites.

While you may be tempted to begin working on one of your images immediately, it's best to get an overview and sort through the entire batch; determine how many images there are, how much redundancy there is, and get a basic idea of which images are your favorites. Once you have an idea of what you're dealing with, it's time to delete the outtakes. Start with the most obvious, the bad exposures, and out-of-focus images, and any exact duplicates. The process of deleting images can be very subjective. In the beginning it may be obvious which images aren't worthy of saving, but after this initial round of editing, it can become more challenging as to which images to keep or throw away.

The goal is to edit your images down to a manageable quantity, saving only your best images and avoiding using up valuable hard drive space with images you'll never use. However, because you're no longer limited by the number of frames on a roll of film, and digital offers an opportunity for much more creative experimentation and freedom, the tendency is to shoot as many photos as a memory card holds, and then some. Due to this situation, it's easy to suddenly be overwhelmed with an immense number of digital files to assess, which can result in frustration and a tendency to "over-delete." Remember this as you're reviewing your images and think about saving an image that evokes emotion, regardless of its aesthetic qualities.

NAMING FILES

Many software programs exist to help you manage your large library of digital images. When considering software and your nomenclature, think about how you would organize your images in your own mind, and what image characteristics you use to identify the right image for a particular need. For example, a portrait photographer needs to be able to search by name and date, a product photographer might search by job number, and a landscape photographer might search by location or time of year. There is not one way to orchestrate a workflow; instead you need to develop your own method that works best for the type of photography you work in and the style of photographer you become.

Regardless of what type of photo-editing software you use, one excellent way to keep track of your image files is to store files from each shoot in their own folders on your computer's hard drive, and devise a system for naming each file. For example, suppose you conducted a photo shoot on September 19, 2010, with a client whose last name is Smith. In that case, you might create a folder with the title, 2010.09.19.Smith. Then, you would place images from that shoot in the folder, assigning names (such as 2010.09.19_ Smith.0001 or 2010.09.19.Smith_0002) to the images. If you have a large quantity of photos located in one folder, take some time to create subfolders and sort them into the appropriate category.

METADATA

Think about all the images you've captured so far with your digital camera. Now pick a random image and try to recall exactly where it was captured, the camera and lens you used, and what the aperture and shutter speed were set to. Too difficult? Fortunately, with digital photography you don't have to remember these details because digital cameras store additional information, called metadata, with the image file every time you capture an image, as shown in Figure 10.1. Metadata is information about the image that is recorded into the digital camera file; it includes the time, date, camera and lens used, f-stop, shutter speed, flash information, and even GPS information. You can use metadata to analyze your images, and edit, sort, track, organize, and retrieve them. This metadata is saved in a standard format called Exchangeable Image File (EXIF). You can search for your images using this metadata as your criteria.

For example, if you photographed a child running across the yard with different shutter speeds and then reviewed the images to see which image achieved the effect you wanted, the metadata could tell you what camera settings you used. The goal is to reproduce the same effect based on that knowledge rather than having to guess which settings might be best. Or perhaps you noticed that several images from a photo session are slightly out of focus while other images are sharp. A check into the EXIF data in the soft images might reveal that the digital camera used a slower shutter speed.

NOTE Metadata is saved using a standard format called Exchangeable Image File (EXIF). This EXIF was created by the Japan Electronic Industry Development Association (JEIDA) in 1995.

You can also use the metadata to look for a particular photo based on capture settings. If your favorite images of the child running used slow shutter speeds in the range of 1/4 to 1/8 second, you could search for all images that were captured at those shutter speeds to find similar photos.

TAGGING

In the context of digital photography, the term *tagging* refers to applying descriptive keywords to your images in the form of tags. For example, if an image portrays an individual, you might tag the image with his or her name. Or if the image was taken in a particular city, you might tag it with the name of that city. As a third example, you might tag all images that contain a dog with the tag "dog." Then you can sort your

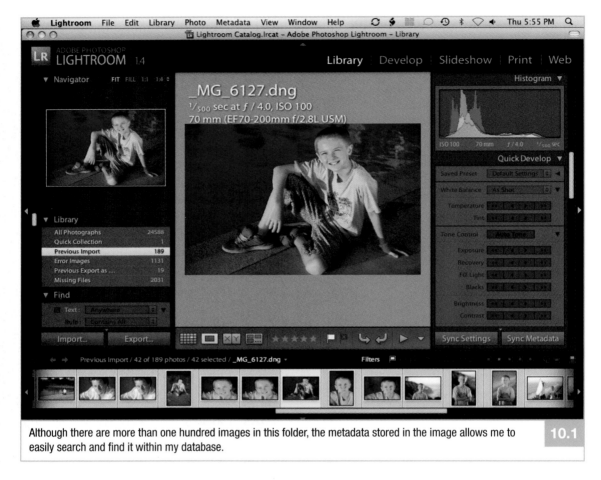

Although there are more than one hundred images in this folder, the metadata stored in the image allows me to easily search and find it within my database.

10.1

images by tag, displaying all images with the same tag together. If you're looking for an image with a particular tag, this can make it much easier to find. Once you've tagged all your photos, it doesn't matter where they reside in the computer's hard drive; you simply search for the image using a keyword.

KEYWORDS

Keywords are words or phrases that you associate with an image to describe the subject matter, style, concepts, usage, or other attributions of the image. These descriptions can be of great use when organizing and searching your image collection, as shown in Figure 10.2.

Keywords can be abstract terms (like "peace") or subject-oriented terms (like "Mom" or "cat"). Subject–oriented terms are generally easier to apply because they require less careful consideration. Abstract terms may require more time and thought and are useful to apply to images that might be searched for in a stock photography database.

Using keywords enables me to quickly sort images, such as these which have the keywords "blue," "abstract," "swimming pool," "cool," and "water."

10.2

The best way to make sure the information that is important to you is associated with the file is to embed the metadata right into the file. You may have a meticulously labeled set of images in your software program, but if that information doesn't travel with the files, it is of no use to any other program, and to no other user but you.

To summarize, metadata is information about your digital image that is instantly and automatically stored in your digital image by your camera; tagging is an additional step you should take to add in personal and descriptive search information; and keywords are the descriptive words you use when tagging your images.

TIP

Shooting in RAW format stores the data from the camera sensor in an unprocessed state and offers a great deal of flexibility. If you want to change the exposure, color balance, or greatly enlarge the image, you'll get better results by working with a RAW image file.

CHOOSE SOFTWARE

In Chapter 2, you discovered what computer hardware you need — namely, a computer (either a Mac or a Windows PC) and a printer. In addition to that, you need some special computer software to work with your digital photographs, software that allows you to transfer images from your camera or memory card to your computer, view them on your computer, keep them organized, enhance them (for example, by cropping, adjusting the color, removing red-eye, and so on), and preserve and protect them.

There are quite a few programs available that enable you to perform some or all of these tasks. Here's a list of a few photo programs for photo enthusiasts:

- **iPhoto.** Apple includes this software with every new Mac computer. iPhoto provides a very user-friendly, intuitive

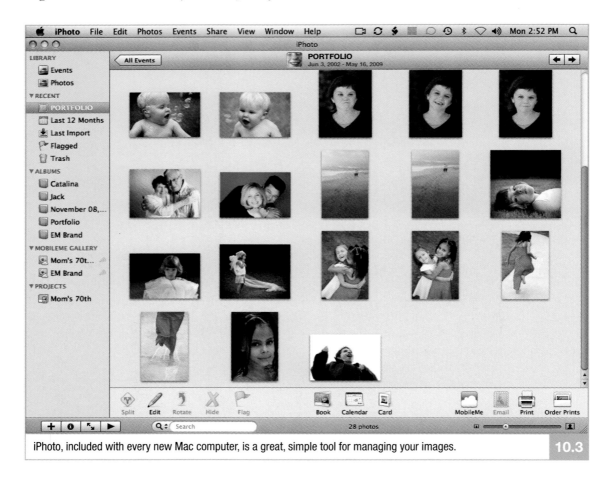

iPhoto, included with every new Mac computer, is a great, simple tool for managing your images. 10.3

interface where you can organize, view, edit, and print your photos (see Figure 10.3).

■ **Windows Live Photo Gallery.** This program, for managing, fixing, printing, and sharing photos on a Windows PC, is available free of charge with the Microsoft Windows Live suite (see Figure 10.4). To download Windows Live Photo Gallery, you must create a Windows Live ID (this is free); visit live.com to get started.

■ **Adobe Photoshop Elements.** This program is a consumer version of the professional-level Adobe Photoshop (discussed shortly), offering many of the same tools and features photographers need at a fraction of the price. In its current incarnation, version 9.0, Photoshop Elements is composed of two separate utilities: Photoshop Elements Organizer and Photoshop Elements Editor. If you're looking for more functionality than is offered with the various free programs,

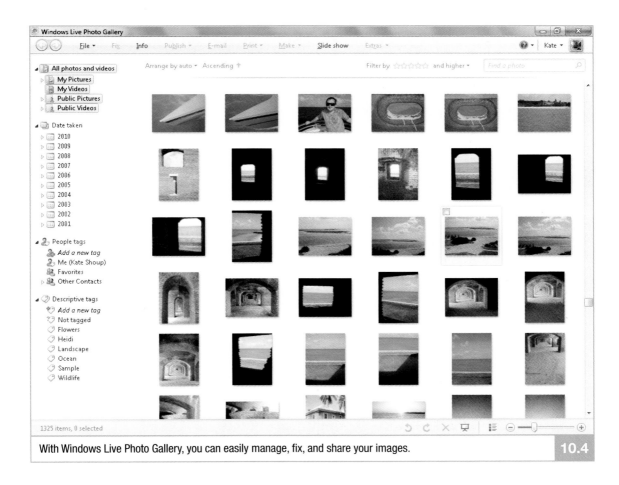

With Windows Live Photo Gallery, you can easily manage, fix, and share your images. **10.4**

but aren't ready to invest hundreds of dollars in a professional-level program such as Photoshop, then Photoshop Elements is a great option (see Figure 10.5).

Other photo-related software programs are designed with photo professionals in mind (and are priced accordingly), offering more robust features for organizing, enhancing, and sharing your images. Here are just a couple of examples of professional-level photo programs:

■ **Adobe Photoshop Lightroom.** This program is designed to assist you in managing large image quantity and post-production work (see Figure 10.6). Unlike Adobe Bridge, it is not a file browser, but is an image management application database. Use it to view, edit, and manage your digital images.

■ **Adobe Photoshop.** Generally considered *the* industry standard for image-editing programs, Photoshop offers countless tools for organizing and

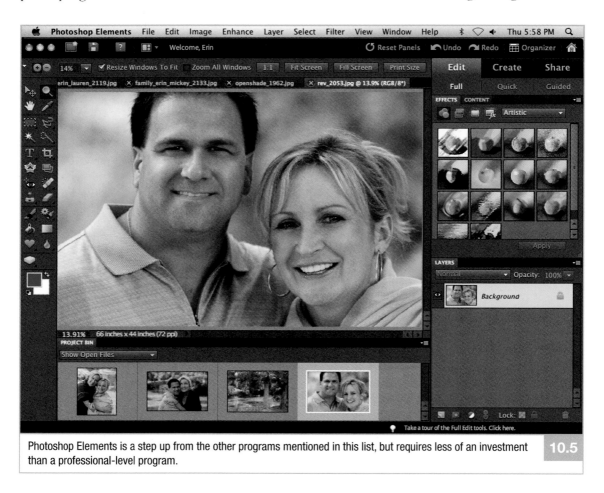

Photoshop Elements is a step up from the other programs mentioned in this list, but requires less of an investment than a professional-level program.

10.5

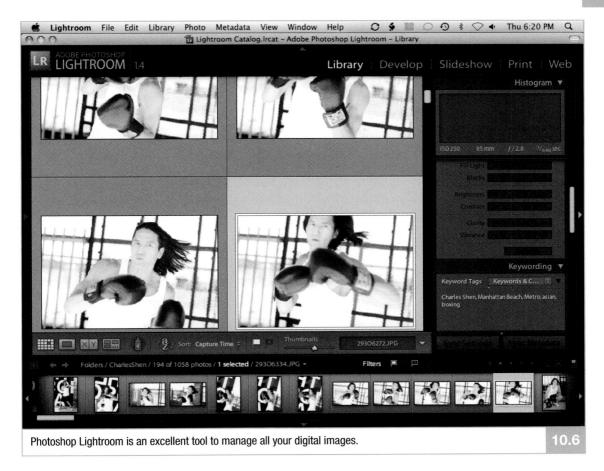

Photoshop Lightroom is an excellent tool to manage all your digital images. **10.6**

enhancing images (see Figure 10.7). Among the more impressive of these features is Puppet Warp, which enables you to precisely reposition image elements — for example, an awkwardly bent arm — to improve your composition. Another great feature is Automatic Lens Correction, which automatically fixes lens distortions, vignetting, and more.

File Browsers versus Cataloging Software

Both file browsers (iPhoto, Windows Live Photo Gallery, Adobe Bridge) and cataloging software (Lightroom) help you display, review, and sort images, but cataloging software also helps you manage your files, keeping the metadata in a database that is easily searchable, faster, and allows you to work offline.

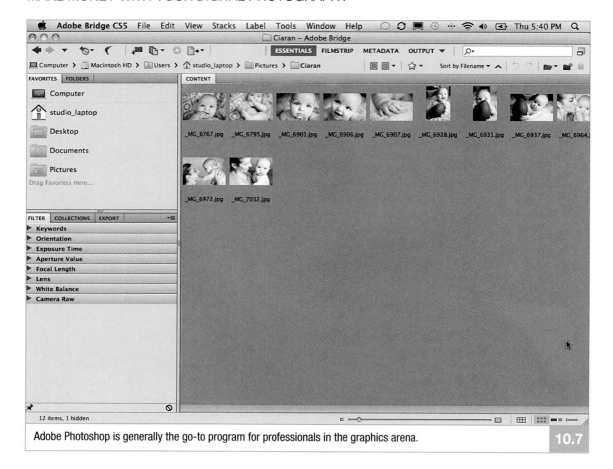

Adobe Photoshop is generally the go-to program for professionals in the graphics arena.　　10.7

■ **Adobe Bridge.** Adobe Bridge is an organizational (file browser) software application included as part of the Adobe Creative Suite beginning with CS2 and is also included with the stand-alone version of Photoshop. Bridge is a powerful tool for rating images, bulk media entry, and image correction with RAW files. Bridge is also helpful for finding images if your search is confined to a small and known directory subset.

ENHANCE YOUR IMAGES

Digital images are almost always in need of a little enhancement. For example, you might crop an image to alter its composition. Or perhaps you simply need to tweak white balance, or the contrast of an image. Or maybe a bit of digital dermatology is in order to play up your subject's best features or remove distracting imperfections.

The focus here is not to cover all the various things you can do to enhance an image, but to concentrate on a few core techniques to improve your digital photographs. First, you need to create an editing plan, a workflow that determines what step comes next. Regardless of what you intend to do to your photographs, there are a few basic steps that are typically applied to all digital images. They include setting a black-and-white point, neutralizing highlights and mid-tones, adjusting brightness and contrast, sharpening, and preparing for output.

The following are some things to consider when reviewing your images for possible enhancement:

■ **Exposure.** Are there issues with under- or overexposure? Check out your histogram. If the image is overexposed, you need to make sure the highlight values still retain detail. If your image is underexposed, you may have a hard time lightening up the dark shadows without revealing noise.

■ **Color Balance.** How does the color balance in the image look? Is it warm or cool? Was the image taken indoors with tungsten lights? Sometimes the digital camera's white balance needs a little help; this is where your software program steps in.

■ **Focus.** Zoom in on your image to check its sharpness. Remember that images not sharpened in your camera (especially RAW images) need a little

sharpening. Not every image needs to be tack sharp; however, sometimes, a blurred image might be the effect you intended.

IMAGE HANDLING TIPS

Before you get started, take a look at your image and think about what steps are involved, what your general skill level is, and how much time it will take to achieve the look you want. Some tasks can take a long time, especially if you're somewhat new to image enhancement. For example, if you need to remove an element from an image, and perform major tonal surgery to bring an underexposed image back to life, the end result may not be worth it. You may want to consider working on a similar image in your batch, or simply reshooting the image under better circumstances and lighting conditions. You need to gauge the importance — not every image is going to qualify for your special enhancement techniques.

Here are some best practices for working with your images:

■ **Work on a backup copy.** This allows you to rename your image, creating a copy that remains open so you can work on it. Now the original image is not modified and can be saved as your digital negative.

■ **Use TIFF or PSD as a working format.** If you're shooting in JPEG format in-camera, you should never us it as your working file. The JPEG

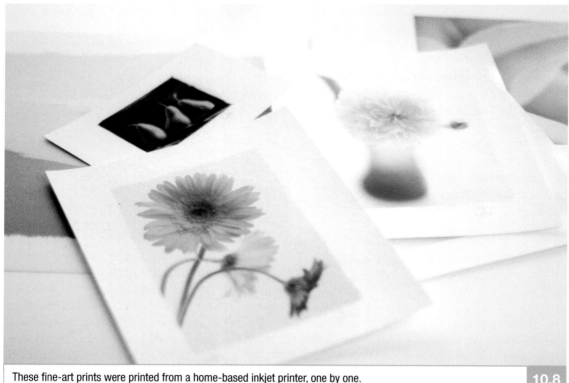

These fine-art prints were printed from a home-based inkjet printer, one by one. **10.8**

method of compression is *lossy*, which means that information is eliminated to make the file smaller. This loss of data increases each time you open and close the file in an image-editing software application.

■ **Work with layers.** Create a duplicate copy of your background layer and work in this layer. This is a nondestructive way to make enhancements to your image, and it also provides greater creative flexibility.

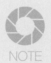
NOTE

The information covered here offers only a brief glimpse at what you can do with image-editing programs. Indeed, entire books are devoted to the topic. I strongly advise you to explore this area further as your photography business grows!

PRESERVE YOUR IMAGES

Don't make the mistake of transferring your images to your computer hard drive and then walking away. Computers can

crash, hard drives can freeze up, and your precious images can disappear if you don't take the time to protect them — namely, by archiving them, or backing them up. In fact, you should make it a habit to back up your images every time you transfer them to your computer. Save your images at least two times in two different ways, in two different places. For maximum coverage, I recommend that you copy them onto an external hard drive, *and* upload them to an online image-sharing Web site or server.

If you prefer, you can use various tools to set up your computer to back up your images on a schedule that you set. For example, PCs running recent versions of the Windows operating system include a tool called Windows Backup, which you can use for just this purpose. Likewise, Macs include a tool named Time Machine, which automatically backs up your data to an external hard drive. Mac also has an application called iDisc for automatically backing up your data to a remote server. (Think of it as your hard drive on the Web.)

For more information about using these tools to back up your images, see your system's help information. In addition to these applications, various third-party tools, such as SuperDuper for Macs and Mozy for both Windows PCs and Macs, are available for archiving files, including photos.

NOTE Depending on where you store your images, they might be difficult to retrieve in the future due to the constant changes in technology. For example, DVDs are known to degrade over a period of time. And as one generation of digital magic replaces the next, archived materials must be repeatedly migrated to the new format or risk becoming unreadable. It's a good idea to update your digital images every few years.

PRINT YOUR IMAGES

Perhaps you plan to sell prints of your images. Or maybe you simply want to print them out for archiving purposes. Printing on an inkjet dye-based or pigment-based printer from home is always an option; however, if you plan to produce quality prints for fine-art or other high-end purposes, you must have a high-quality printer, understand color calibration with your computer monitor and printer, and intend to produce prints in small quantities (see Figure 10.8). Due to these requirements, many professional photographers are now outsourcing their printing to online photo services such as White House Custom Color (www.whcc.com) or Pictage. com. Check with these services for the most accurate settings to ensure the best results. For example, some printers require using the Adobe RGB 1998 color space when capturing images, while other printers work best with sRGB. The typical resolution setting is 300ppi, and some services request that you send JPEG files instead of a TIFF file.

CHAPTER REVIEW

A
Digital cameras store additional information, called metadata, with the image file every time you capture an image.

B
Developing a system for organizing your digital images helps you to ensure that you can quickly and easily find any image you seek. Remember to tag your images with additional keywords to help sort and find your images.

C
Printing from home-based inkjet printers can be expensive. Explore the options that online printing services provide.

D
Save your images at least two times in two different ways, in two different places.

Epilogue

E

Reading the closing pages of this book marks the end of a journey of sorts and the beginning of another: your journey as a professional photographer. It's time to pack what you learned in this book — what equipment to use, which genre suits you, who your customers are, how to market your work, how best to present your digital images, and the ins and outs of running a photography business — and begin your journey.

Of course, no entrepreneurial adventure — especially one in the direction of your dreams — is easy. Fortunately, you have this book as your map. Even so, you will meet challenges and experience frustrations. Don't become discouraged! They are a necessary part of any endeavor. In the words of the nineteenth-century American author Henry David Thoreau, "Go confidently in the direction of your dreams. Live the life you have imagined."

Onward and upward!

Erin Manning

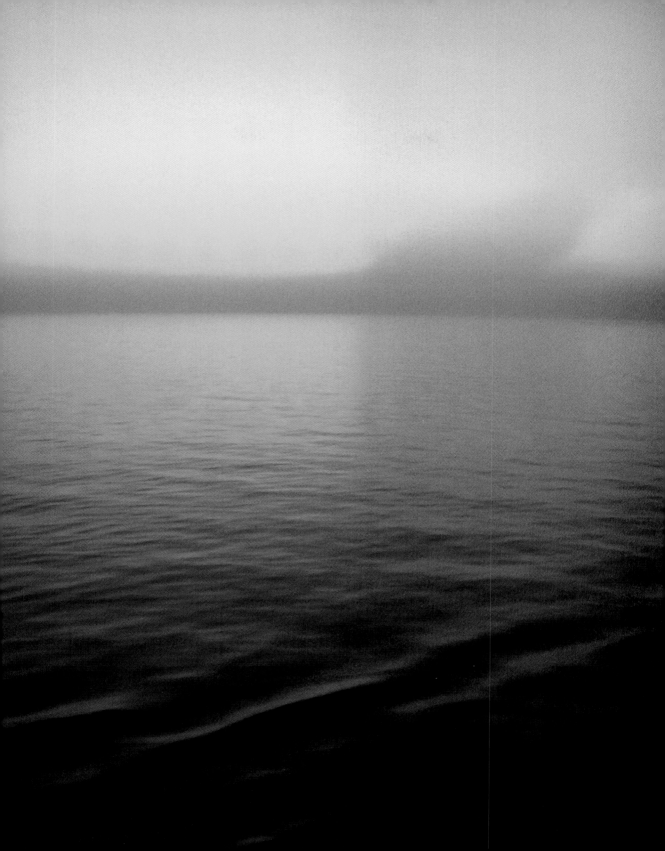

A
taking care of business

No doubt, you have an eye for captivating images. And naturally, your technical skills are second to none. You may even have the best equipment money can buy. But you need more than that to become a successful professional photographer: You need business savvy. In this chapter, you'll explore the steps you need to take to get your photography business off the ground — and keep it there.

DEVELOP A BUSINESS PLAN

If you're like most entrepreneurs, about the last thing you want to do is create a business plan — that is, a formal statement outlining your business goals, why you believe those goals are attainable, and your plan for reaching those goals. No doubt, you just want to get started!

But the fact is that, especially if you will be seeking outside financing to get your business underway, you need a business plan. Not having a business plan is a little like casting off on a trip around the world without a map. Sure, you might have fun for a while — but eventually, you'll get lost and run out of gas. Indeed, your failure to create a business plan may well result in the ultimate failure of your business.

Still not convinced? Think about it this way: Forming a business plan is an excellent way to test the viability of your business idea, not to mention gain an understanding of your customers, competition, and industry. It enables you to identify the following key pieces of information:

- Who you will serve
- How you will serve them better than anyone else
- How you will reach as many of them as possible
- The value of what you will offer

You don't have to get too caught up in the details of the plan; just lay down some basics, with the understanding that things might change over time. This knowledge will be critical when the time comes to decide how you will price and promote your business. A good place to begin is by visiting the U.S. Small Business Administration Web site www.sba.gov. The site offers links to information, services, and tools for entrepreneurs.

Now that you're thinking along the lines of identifying your key objectives in a formalized plan, even if it's simply an outline, it's time to develop your elevator pitch. This is the very brief verbal version of who you are, what you do, and why you are special. It's designed to convince potential customers to remember who you are and to take action. The reason it's called an elevator pitch is because it's to be delivered within the amount of time it would take to ride an elevator a few floors. In other words, it's a focused message delivered in a very short period of time, not a rambling monologue. Whether you're communicating via phone, in person, or even online or in print, you need to be prepared to articulate what you do in short bursts. You may be thinking, "but I'm a photographer, my images speak for themselves." In many instances your images may not be available for viewing, so you need to take charge and speak the words that tell your story.

- **Take some time to write down who you are as a person.** Think about some adjectives that describe who you are, not what you do. For example, caring, personable, creative, giving, happy, and proactive might be a few. This exercise helps you articulate who you are and is not necessarily going to be used in its entirety as your elevator pitch.

- **Describe what you do.** Simply stating that you're a photographer is not enough information. Adding what type of photography you do helps focus your message. Next, add some context to the message. For example, being a portrait photographer means different things to different people, so you might say "I shoot contemporary lifestyle images in natural light." You can also mention a specific style or piece of equipment you use that sets you apart.

- **Finish up your elevator pitch with a call to action.** This is not the "Call now" sales pitch you hear on infomercials, rather a subtle offer to make it easier for them to reach you. "Here's my card, check out my Web site and let me know if I can be of service."

- **Work on your pitch until you reduce it down to a short, succinct message.** Then practice it constantly until it sounds natural and becomes second nature to say.

The one thing you should not mention in your pitch is your price. This is not the time to talk about money. If you're still grappling with figuring out your message, remember that when someone asks you what you do, they're really asking "what can you do for me?"

CHOOSE A COMPANY CLASSIFICATION: AN OVERVIEW

Often, people launching a photography business set it up as a sole proprietorship because it's the easiest type of business to start and is subject to fewer regulations than other types of businesses. With a sole proprietorship, you — and only you — own the company outright. Income from the business is treated as personal income. You do business as yourself; legally and for tax purposes, you and your business are one entity. As the owner of a sole proprietorship, you are solely responsible for all decisions — and all debts. You are personally accountable for all liabilities associated with the business — meaning that if, for example, your company is sued, your personal assets, such as your home, your car, or your collection of vintage PEZ dispensers are at risk. As your business grows and your liability increases, you might consider changing your company's classification to a limited liability company, or LLC. An LLC is a sort of hybrid, incorporating the flexibility of a sole proprietorship with the protection offered by a corporation (discussed next). That is, with an LLC, profits from the business flow directly to you and are taxed at your personal rate rather than at a corporate tax rate; at the same time, you are legally distinct from your company, meaning that if you are sued, only the assets of the business are at risk.

Of course, a third option is to form a corporation. The most common type of business, a corporation, like an LLC, is its own legal entity and shelters its owners from liability. In addition, corporations allow for the issuance of shares. With respect to taxation, corporations have different obligations than do sole proprietorships and LLCs — some advantageous and some not. If your company grows to support numerous employees, upgrading its status to a corporation might be a wise move. There are two main types of corporations: S corporations and C corporations. An S corporation is typically owned by only a few individuals (to a maximum of 100), whereas a C corporation may have an unlimited number of owners. There are different tax implications, depending on which type of corporation you choose.

If you decide to take your "making money with digital photography" further than "a little extra money on the side," you should begin to think about these options. Keep in mind that this is merely a brief overview. Seek the advice of a good accountant and a competent attorney to determine what classification is right for you and to help you file the appropriate paperwork.

REGISTER YOUR COMPANY NAME

If you choose a business name that is different from your legal name, you may be required by your county, city, or state to apply for a DBA (Doing Business As) certificate in the county in which your business is located. Even if you are not required to obtain a DBA certificate, doing so is a good idea because it enables you to ensure that no other business in your state can operate under the same name. In addition, you may be required to obtain a DBA certificate in order to open a business account at your bank. For more information, contact your local county clerk's office.

In most states, if you have set up your company as a corporation rather than as a sole proprietorship or LLC, you are generally not required to obtain a DBA certificate.

NOTE

In addition to obtaining a DBA certificate, you also have the option of filing for a federal trademark. That way, if you expand your business into other states, you can rest assured that your business name is available for use. For help, seek out a qualified trademark attorney.

TIP

OBTAIN INSURANCE

Like it or not, we live in litigious times. Some people won't think twice about suing you, even for the smallest mistake. You must obtain general liability insurance so that you are covered if this happens. General liability insurance protects your company's assets if it is sued. You also need to insure your place of business and your equipment. This insurance should also cover you while you're on location to protect you if your equipment is damaged, lost, or stolen. To find out what other policies you should carry, consult with a risk manager or insurance broker. Don't just buy the cheapest policy you can find. One inadequately covered catastrophe could result in the end of your photography business!

PRICE YOUR WORK

An important part of running your photography business is pricing your work. How you decide what your work should cost depends on a few different factors. For example, pricing for custom images that you shoot for clients will be different from pricing for prints that you sell in galleries or other

outlets, which will be different from pricing for images destined for publications such as newspapers or magazines. If you're shooting custom photographs for clients — for example, you're conducting a portrait session, photographing food or other products for advertising purposes, or covering an event such as a wedding — you must be compensated not only for the cost of the images that result from the session but also for the time you spend preparing for and conducting the shoot. Let's look at a few basic ideas for establishing prices for your work.

Potential clients may be price shopping with your competition (other photographers) and comparing prices, so you should probably undercut the competition, or charge the same price, right? No. If you undercut the competition, you may be a favorite "low-price" option for clients for a short while, but it's also possible that your perceived value will diminish. It's human instinct; if you are the least expensive option available, people will associate your products and services with being "less than." More importantly, you may not turn a profit and you'll be doing business for free. This is not a sustainable option for very long, unless you have a lot of money, in which case, I'm not sure this is the book you should be reading! While it's important to know what the competition is charging, it isn't the only thing to consider when determining how to price your work. In order to generate a profit, you need to calculate what the costs are to produce your products and services.

Once you decide what services and products you want to offer, you calculate the costs associated in delivering those to your clients. For example, if you're shooting on location,

factor in the cost of gas, an assistant (if you hire one), cost for props, and any post-production time or outsourcing you invest in regarding editing, enhancing, posting, and proofing online. Even if you're just starting out and not sure how serious you intend to be about starting an actual business, it's a good idea to calculate the minimum costs associated with conducting a photography session, factor in the local competition's rates, and charge accordingly. The goal: adjusting your profit to be competitive while ensuring you don't fall beneath the break-even point. If you decide to become more serious about running a part-time or full-time business, it's also important to factor overhead expenses into the equation, such as utility costs, Internet, phone, marketing, professional memberships, insurance fees, office help, and so on. Cutting your profits initially may be a good way to get your feet wet and build a portfolio, but don't rely on this for too long, and you certainly should not work for free.

Many clients who are using a photographer for the first time may think your pricing is too high. When you are beginning your business, you may be tempted to ask your potential clients what price they would be willing to pay. Don't succumb to this approach. Most people do not have an understanding of the rates of professional photographers or what your unique services would cost — and why wouldn't they want to pay the lowest price possible? If you do try this approach, be prepared not to make a profit. When I first started out as a photographer, I captured hundreds of beautiful portrait images of family members for high-school graduation. My family loved the pictures and appreciated them, but it was

only some time later, after hiring professional photographers to perform other work for them, that they realized how expensive photographic portraits actually were. So be realistic about your expenses, the going market price, and the worth of what you have to offer — otherwise, you'll never make a profit.

It's reasonable to ask clients to advance 50 percent of the total estimate for the shoot to cover direct expenses. The balance can be due on delivery of the final images.

If, on the other hand, you want to sell prints of your images — for example, in a gallery or even a boutique-type shop — rather than creating custom images for clients, here is a pricing approach to consider:

1. Add up the cost of all the materials you used to create your photograph — the paper, the ink, any mounting or framing materials, and so on.

2. Estimate how long it took you to create the photograph, and multiply that number by your desired hourly rate.

3. Add the sum from step 1 to the product from step 2, and then multiply the total by at least 2 to set your wholesale price.

4. To set the retail price, multiply the wholesale price by 2.

5. Compare your retail price with prices charged by other photographers in your area for work of similar size and quality. If your prices are significantly higher, look into reducing your costs. If they are significantly lower, consider raising prices to be more in line with your competition.

TIP If your images are destined for publication in a newspaper or magazine, the price of your work may simply be what the publisher is willing to pay. That is, you may not have a lot of control over how much you can command for each image.

KEEP TRACK OF YOUR MONEY

If your skills and experience include organizational and financial planning, this may be a no-brainer area for you, but if you're like many creative people in the world, keeping track of your money can be a challenge. Wherever you stand, as an entrepreneur, you must keep track of your money, including banking transactions as well as payables and receivables. Why? First, so you don't go broke. And second, so that if you need to secure a bank loan — for example, to purchase equipment — you have all your paperwork in order. As your business grows, you might consider hiring an accountant to handle your bookkeeping, freeing you up to focus on your photography. But in the beginning, when money is likely to be tight, you may have to manage it yourself.

To make it a bit easier to track your finances, use bookkeeping software, such as QuickBooks. With QuickBooks, you can track sales and expenses, access easy-to-understand graphs that depict your company's finances, view customer data, create and manage invoices, create and send purchase orders, track industry trends, and more — all free of charge with the online version. For even more features, you can upgrade to QuickBooks Pro.

Speaking of Bank Loans…

Often, obtaining a bank loan for your small business — especially if you are just starting out — can be tricky. Enter the Small Business Administration (SBA), a U.S. government agency charged with helping small-business owners. The SBA does not offer loans; rather, it *guarantees* loans obtained by small-business owners from banks, thereby reducing their risk. Although there are some drawbacks to working with the SBA — for one, they require a lot of collateral on your part; for another, the amount of paperwork can be a bit daunting — they often give you more time to repay loans and can arrange for better interest rates than you might obtain on your own.

MAKING TAX TIME EASIER

You will be accountable for some basics like taxes, based upon income and deductions, so you need to keep receipts. That way, you can recoup some of your expenses at tax time. Although the IRS does not require receipts for expenses under $75, you should still make a habit of keeping them so you can accurately account for your expenses — which is especially important if you are audited. The same goes for other paperwork: Legally, your business must keep accounts payable, accounts receivable, banking, and budget information on file for at least seven years.

Keep your personal and business expenses separate.

HANDLE MODEL AND PROPERTY RELEASES

In today's litigious environment, you must secure model and property releases — no matter what. A model release is a legal document signed by the subject of a photograph

that grants permission to publish the image — for example, in a book, in an advertisement, as a stock photo, on your Web site, and so on. Failure to obtain a model release before publishing an identifiable photo of a person can result in civil liability on your part — read: a lawsuit.

TIP Some forms of publication — for example, news articles — do not require a model release. If you work as a photojournalist, you are not required to obtain model releases for images shot for or sold to news or qualified editorial publications.

In addition to securing model releases, you should secure property releases. A property release confirms that the owner of a property — be it a building, land, a pet, or what have you — has consented for you to photograph and publish images of that property. Note that you need not obtain property releases when photographing on public property.

NOTE When in doubt, get a release! Better safe than sorry.

There are many sample model and property releases available for download on the Internet — some free of charge, and some for a fee. A great source for releases is http://asmp.org/tutorials/property-and-model-releases.html.

It's also possible to attain model and property releases digitally. Mobile applications now create professionally worded releases right on your mobile phone. Just fill out

the release, snap a photo to attach, have your subject sign directly on the screen, and e-mail yourself a copy to print and file on your home or office computer. I use the *EasyRelease* mobile application, which uses the same release language as the major stock photography agencies.

NOTE The legal issues resolved by model and property release forms relate to privacy, not copyright. You learn more about copyright in the next section.

COPYRIGHT AND REGISTER YOUR IMAGES

The moment you capture an image, you own it — period. But to ensure that others are aware that you own a particular image, you should add a copyright notice to it. A copyright image looks like this: © 2010 Erin Manning. In addition, you should register your work with the U.S. Copyright Office. This can make a big difference in terms of legal recourse in the event someone uses your image without your permission. Registering an image with the U.S. Copyright Office is neither difficult nor expensive; you should get into the habit of doing so as a matter of course, the same way you edit, retouch, and archive your photos.

You can easily register your images separately or in bulk. If you register your images together on one CD or DVD, the charge is the same as for one image. The online registration Web site is www.copyright.gov/eco or for an offline form, go to www.copyright.cgov/forms/formco2d.pdf.

Q&A WITH A COPYRIGHT ATTORNEY

To help you navigate copyrights, I interviewed Carolyn E. Wright, a copyright attorney. For even more helpful information, check out Carolyn's book, *Photographer's Legal Guide*, available on her Web site, www.photoattorney.com. The information that follows is copyright Carolyn E. Wright, Esq., all rights reserved.

What is the best way to copyright your images?

Copyrights for photographers are created at the click of the shutter — it does not matter whether an image was recorded on film or by digital methods. Once the image is created, the laws that relate to the copyright of that image are effective immediately. Even if the photograph is never registered, the copyright exists and is protected by copyright law.

If the copyright to your photo is later registered with the U.S. Copyright Office, additional benefits arise, such as the option to recover statutory damages for infringements and the inference that the person who registered the copyright is the owner.

If photographers tell others that they are "copyrighting" their photos when they actually are registering them, people may believe that the photos are not protected until that time. Some may feel free to use the photos without permission or may not give photographers their due credit. To best protect your work, "register" your copyrights as soon as you can (and refer to them that way). You can register your copyrights online using the Electronic Copyright Office Web site, run by the U.S. Copyright Office. You can find this Web site at www.copyright.gov/eco.

What is the advantage to registering your images with the U.S. Copyright Office?

When a photo is not registered with the U.S. Copyright Office prior to the infringement or within three months of the first publication of the photo, the copyright owner may recover only "actual damages" for the infringement (pursuant to 17 USC §504 [b]) instead of statutory damages. Courts usually calculate actual damages based on your normal license fees and/or industry-standard licensing fees. You also may recover the profits the infringer made from the infringement if they aren't too speculative. Unfortunately,

Creative Commons License

A Creative Commons license lets you dictate how others may use your work. The Creative Commons license allows you to keep your copyright but allows others to copy and distribute your work provided they give you credit and only on the conditions you specify. For online work you can select a license that generates "Some Rights Reserved" or a "No Rights Reserved" button and statement for your published work.

actual damages usually don't amount to much, so attorneys will not take your infringement case on a contingency basis.

If your photo is registered when an infringement occurs, you will be eligible for statutory damages of up to $150,000 for a willful infringing use. (See 17 USC §504 [b] and [c].) Legal fees and costs also may be recovered from the infringer. (See 17 USC §505.) However, you need to have received your registration certificate to file a complaint for a copyright infringement lawsuit in most jurisdictions.

It's also a good idea to put your copyright notice on or adjacent to each of your images. The official copyright notice requires three parts. The first part is the © (the letter *c* in a circle), the word *Copyright*, or its abbreviation, *Copr.* The second part notes the year when the work was first published. The third part is the name of the copyright owner. The final form looks like this: © 2010 Carolyn E. Wright. You may use the copyright notice without registering your images with the U.S. Copyright Office. Including a copyright notice is no longer required for copyright protection, but it is a good idea to use it.

When you use the copyright notice, it may stop someone from stealing your photographs either because it serves as a reminder that the work is protected or because the notice interferes with the use of the work when it is part of the photo. When you post a copyright notice along with your registered images, the infringer cannot claim that the infringement was innocent (reducing the damages to as low as $200 per work) and the court is more likely to find that the infringement was willful, supporting the maximum in infringement damages.

Also, when possible, put your copyright management information (CMI) in, on, and/or adjacent to each of your images. Copyright management information "means any of the following information conveyed in connection with copies of a work or displays of a work, including in digital form (such as in the metadata of your photo file):

"(1) The title and other information identifying the work, including the information set forth on a notice of copyright.

"(2) The name of, and other identifying information about, the author of a work or

"(3) The name of, and other identifying information about, the copyright owner of the work, including the information set forth in a notice of copyright."

Section 1202 of the U.S. Copyright Act makes it illegal for someone to remove your CMI from your photo to hide the infringement. The fines start at $2,500 and go to $25,000 *in addition to* attorneys' fees and any damages for the infringement. You don't have to register your photo in advance to recover under this statute. So, if possible, put your CMI as a watermark on your photo and in the metadata of your digital file. (Be careful that your CMI is not removed when using your image-editing software's "Save for Web" function.)

Watermarking

Digital watermarking is the process of embedding information into the metadata of a digital image. A visible watermark is difficult to remove and meant to identify the owner of the image, preventing possible theft or misuse.

What are good online resources for copyright law?

The law related to copyright can be confusing. Unfortunately, photographers often rely on fellow photographers or random Internet postings for their information, which may be incorrect. But a free and great resource is the U.S. Copyright Office's Web site at www.copyright.gov. Answers to frequently asked questions are available at www.copyright.gov/help/faq/. You also may request individual assistance from the U.S. Copyright Office by e-mail at www.copyright.gov/help/general-form.html or by phone at (202) 707-5959.

Here are some other good online resources on copyright law for photographers:

- Attorney Bert Krages (www.krages.com)

- Attorney Carolyn E. Wright (www.photoattorney.com)

- American Photographic Artists (APA) (www.apanational.com)

- American Society of Media Photographers (ASMP) (www.asmp.org)

- Editorial Photographers (EP) (www.editorialphoto.com)

- National Press Photographers Association (NPPA) (www.nppa.org and blogs.nppa.org/advocacy)

- Picture Licensing Universal System (PLUS) (www.useplus.com)

B

resources

PERIODICALS

There are many magazines and other publications to choose from. Here are a few of my favorites that I hope you find useful.

DIGITAL PHOTO PRO

www.digitalphotopro.com
Although this publication is designed largely for working digital photo professionals, its in-depth reviews, how-to articles, and detailed explanations are useful to any photographer interested in expanding and improving his or her skills.

MAC LIFE

www.maclife.com
Written for both new and veteran users, Mac Life provides exclusive, authoritative information and advice for readers who want to get the most out of their Macs, iPods, and third-party hardware, software, and services. The magazine also delivers informative feature articles showcasing the latest hardware and software, an expanded how-to section, and candid reviews of the latest gear.

DIGITAL PHOTO

www.dpmag.com
This magazine is devoted to digital photography and related techniques.

PHOTO DISTRICT NEWS

www.pdnonline.com
Photo District News (PDN) provides useful photography news ranging from marketing and business advice to legal issues, photographic techniques, new technologies, and more.

POPULAR PHOTOGRAPHY

www.popphoto.com
For both amateurs and professionals, this magazine offers illustrated, instructional articles and covers all facets of photography, offering artistic inspiration as well as hands-on techniques. You can also find helpful reviews of cameras and accessories.

ORGANIZATIONS

While you may not be ready to dive into joining a professional organization just yet, there may come a time when you will benefit from what these organizations have to offer. This listing contains just a few of the more well-known groups — there are many others.

AMERICAN PHOTOGRAPHIC ARTISTS

www.apanational.com
American Photographic Artists (APA) establishes, endorses, and promotes professional practices, standards, and ethics in the photographic and advertising community.

AMERICAN SOCIETY OF MEDIA PHOTOGRAPHERS

www.asmp.org
The American Society of Media Photographers (ASMP) promotes photographers' rights, educates photographers in better business practices, produces business publications for photographers, and helps buyers find professional photographers.

NATIONAL ASSOCIATION OF PHOTOSHOP PROFESSIONALS

www.photoshopuser.com
The National Association of Photoshop Professionals (NAPP) is a trade association and a resource for Adobe Photoshop education, training, and news. It is led by a world-class team of Photoshop experts, authors, consultants, trainers, and educators whose focus is to ensure that NAPP members stay on the cutting edge of Photoshop techniques and ahead of their competition.

NATIONAL PRESS PHOTOGRAPHERS ASSOCIATION

www.nppa.org
This is a national organization for photo-journalism, including sports photographers.

PHOTOGRAPHIC SOCIETY OF AMERICA

www.psa-photo.org
This is a worldwide, interactive photography organization for all types of photographers.

PROFESSIONAL PHOTOGRAPHERS OF AMERICA

www.ppa.com

Professional Photographers of America (PPA) seeks to increase its members' business savvy as well as broaden their creative scope. It aims to advance their careers by providing them with all the tools for success.

STOCK ARTISTS ALLIANCE

www.stockartistsalliance.com

This is a trade organization that protects the rights of independent stock photographers.

THE PICTURE ARCHIVE COUNCIL OF AMERICA

www.pacaoffice.org

If you're researching stock photography agencies in North America, check to see if the agency is a member of this trade organization. Members are required to uphold certain standards of professionalism.

WOMEN IN PHOTOGRAPHY INTERNATIONAL

www.wipi.org

Women in Photography International (WIPI) promotes the visibility of women photographers and their work through a variety of programs, exhibitions, juried competitions, and publications. The group's aim is to serve the needs of photographers, photo educators, photography students, gallery owners, and photographic organizations around the world.

PHOTOGRAPHY WORKSHOPS

These workshops are a year-round source of experiential learning and creativity for image makers of all skill levels. I've only listed a couple here, but there are many more around the country. Search the Web to find one that fits your interests and skill level.

MAINE MEDIA WORKSHOPS

www.mainemedia.edu

Maine Media Workshops is a year-round educational center that offers many inspiring and informative classes, from photography to film making and multimedia. Classes are taught by instructors prominent in their field.

SANTA FE PHOTOGRAPHIC WORKSHOPS

www.santafeworkshops.com

This is a year-round educational center with inspiring, informative, hands-on photography and media workshops. Taught by world-renowned instructors, the workshops cover both the technical and creative aspects of photography.

ONLINE PHOTOGRAPHY AND SOFTWARE CLASSES

There are some great tutorials on the Web on a variety of photography subjects, and there are also many sites that offer useful educational materials. Below are two of my favorites.

RENEEPEARSON.COM

www.ReneePearson.com
This is an online educational Web site for photography, scrapbooking, design, and artistry.

LYNDA.COM

www.lynda.com
This Web site provides educational materials and video training for creative designers, instructors, students, and hobbyists. You'll find digital photography, design and development, and motion tutorials.

PHOTOGRAPHIC EQUIPMENT AND REVIEW SITES

Even if you do not choose to purchase photographic equipment online, the Internet is a great source of information, including competitive pricing and equipment reviews. The sites listed here are just a smattering of what's out there, but I have found them to be very useful.

ADORAMA

www.adorama.com
This is a major photography retailer that provides high-end cameras, lighting and grip equipment, accessories, online learning, and rentals.

B&H PHOTO

www.bhphotovideo.com
This is a very good place to purchase cameras, equipment, and accessories. They stand behind their products, and many professional photographers purchase their cameras and equipment there.

CNET.COM

reviews.cnet.com
This Web site offers information and product comparisons, and allows you to shop for digital cameras, all in one place.

DIGITAL PHOTOGRAPHY REVIEW

www.dpreview.com
This Web site offers information on new products from a variety of major camera manufacturers, as well as thorough reviews on a variety of cameras and equipment.

EPINIONS.COM

www.epinions.com/digital_cameras
This Web site covers many different products, including reviews of digital cameras from other consumers.

PHOTO- AND VIDEO-SHARING WEB SITES

Whether you just want to post a few pictures for your family members on the other side of the country, or you want to have a gallery to showcase your photography, there is a site for you on the Web.

These Web sites allow a secure and easy way to view, store, and share your photos with friends and family. Most also provide free and premium services for editing with creative tools, and specialty photo products.

The subscription-based Web site charges a monthly or annual fee and allows you to upload, store, share, and order prints and other specialty photo products. Some sites are now offering video, music, and long-term image storage with no advertising.

A few are more community-based, meaning they enable others to look at your posted photos and comment on them. These sites make it easy to link your images to Web sites and blogs for online photo sharing.

ANIMOTO

www.animoto.com

KODAK GALLERY

www.kodakgallery.com

SHUTTERFLY

www.shutterfly.com

SNAPFISH

www.snapfish.com

PHANFARE

www.phanfare.com

PHOTOWORKSHOP

www.photoworkshop.com

SMILEBOX

www.smilebox.com

SMUGMUG

www.smugmug.com

PHOTOSHELTER

www.photoshelter.com

PICTAGE

www.pictage.com

FLICKR

www.flickr.com

FOTKI

www.fotki.com

PICTURETRAIL

www.picturetrail.com

IMAGE ORGANIZING, ARCHIVING AND SLIDE-SHOW SOFTWARE

There are many ways to organize photos and many software products to choose from for organizing and creating slide shows. This list offers just a quick look at some of the more widely used solutions.

ADOBE PHOTOSHOP LIGHTROOM

www.adobe.com/ap/products/photoshoplightroom
You can organize thousands of images in Lightroom. You can also use this software to develop, protect, and showcase large volumes of your digital pictures while saving valuable time in your workflow.

This workflow tool is designed specifically for digital photographers, and makes organizing, enhancing, and sharing digital images quick and easy.

APERTURE

www.apple.com/aperture

Aperture is an all-in-one, post-production tool for serious photographers. Aperture makes it easy to import, manage, edit, catalog, organize, adjust, publish, export, and archive your images more effectively and efficiently.

BOINX FOTOMAGICO

http://www.boinx.com/fotomagico

Boinx FotoMagico allows you to easily add your photos to a dynamic, moving slideshow presentation with music and transition effects that rival professionally created slide shows. It's a universal application that works on both Windows PCs and Intel-based Macs. It also has the capability to export to iPod, DVD, and HDTV formats.

IPHOTO

www.apple.com/ilife/iphoto

iPhoto (for Macs) includes a photo-organizing and -viewing software program. It comes bundled with every Apple computer. iPhoto allows you to import, organize, edit, and retouch your images with a user-friendly, intuitive interface.

MOZY.COM

www.mozy.com

Mozy is an online backup service. You can set up Mozy to back up your system automatically, on a schedule you specify. Backed-up files are encrypted and stored in a secure location; you can access them anywhere, at anytime.

TREND MICRO SAFESYNC

www.safesync.com

Store photos, videos, documents, and passwords online to the SafeSync servers, and access them from anywhere in the world through web, computer, or a mobile device. This service provides unlimited online backup and automatic synchronization at an affordable price.

PICASA

picasa.google.com

A free software download from Google for Windows users, Picasa helps you locate and organize all the photos on your computer. This software collects and organizes all the images on your computer, scanning the images and automatically sorting them by date, while you watch. You can also edit and add effects to your photos with a few simple clicks and then share your photos with others through e-mail, prints, and online — and it's free.

SMALL-BUSINESS RESOURCES

Small-business owners can find myriad resources on the Web. Following is a small sampling.

STARTUP NATION

www.startupnation.com

This Web site is a comprehensive resource for starting a business.

BLU DOMAIN

www.bludomain.com

Blu Domain is devoted to hosting Web pages, as well as offering site-creation services to creative professionals like you.

ENTREPRENEUR.COM

www.entrepreneur.com

The online home of *Entrepreneur* magazine, Entrepreneur.com houses countless articles that are relevant to the small-business owner.

U.S. SMALL BUSINESS ADMINSTRATION

www.sba.gov

The objective of the U.S. Small Business Administration (SBA) is to help Americans start, build, and grow businesses. This Web site offers links to information, services, and tools for small-business owners.

SMALLBUSINESS.COM

www.smallbusiness.com

This wiki site features user-generated content on all manner of topics related to small business. This open-source collection of shared knowledge is a great resource for anyone with a small business.

glossary

ambient light The natural light in a scene.

angle of view The amount of a scene that a lens can capture.

aperture An opening inside the lens that can be adjusted to control the amount of light reaching a camera's sensor prior to the image being taken. The aperture diameter is expressed in f-stops; the lower the number, the wider the aperture. The aperture and shutter speed work together to control the total amount of light reaching the sensor. See also *f-stop* and *shutter speed*.

backlight The light coming from behind the subject in a photograph.

ballhead A type of tripod head. This spherical ball is mounted on the platform of a tripod, and when you attach it to your camera, it allows you to smoothly move the camera in different directions, until you lock it in place to keep it from moving. Protruding from the top part of the ball is a shaft that holds the quick release clamp or platform.

barrel distortion A lens aberration that causes straight lines near the borders of an image to appear to bend outward.

big glass lens A very large lens — usually 400mm or 600mm — that has near-perfect optics.

bounce light The light bounced into a reflective surface (such as a wall, ceiling, or reflector card) to illuminate a subject with softer light, thus reducing harsh shadows. The color of the reflective surface determines the color of the light bounced into the subject.

brightness The amount of lightness or darkness in an image; the intensity of a light source or color luminance.

card reader A device that allows you to transfer images from a memory card to your computer. Instead of connecting your camera to the computer to download your images, you simply plug a card reader into your computer's USB or FireWire port.

catch-light A light reflection represented by a twinkle in the eye, or a small, intense reflection of light from any surface.

continuous light A light source that is on all the time, allowing you to see how the light falls upon your subject in the scene.

continuous mode A camera mode that allows continuous shooting of images in quick succession. This mode works well when shooting sports and active children.

contrast The difference between the darkest and lightest areas in a photograph — the greater the difference, the higher the contrast. Photos with low contrast can appear muddy or blurred, lacking clear distinctions between image details.

corporation An organization that is its own legal entity, thus sheltering its owners from liability. Corporations also allow for the issuance of shares. If your company grows large enough to support numerous employees, it may be wise to upgrade it to a corporation.

diffuser A translucent material placed between the light source and your subject to soften the harsh light in your scene. See also *flash diffuser* and *soft box*.

dSLR Short for digital single lens reflex, a type of camera that possesses a higher-quality sensor than a standard point-and-shoot model. dSLRs allow for faster image capture and better-quality images, and they also enable you to use different lenses. See also *SLR*.

elevator pitch A 30-second overview of your business that is designed to inspire potential clients to sign on with you.

external flash A flash unit that connects to the camera with a cable, or is triggered by the light from the camera's internal flash.

filter A piece of glass or optical resin that you place in front of the lens to affect the appearance of your final image.

fixed-aperture lens A lens whose maximum aperture remains constant as you zoom closer in or farther away from your subject.

fixed lens Also known as a prime lens, it is a lens whose focal length does not change. This is in contrast to a zoom lens.

flash An on-camera or off-camera device that emits a burst of light, artificially illuminating your scene.

flash diffuser A flash accessory that consists of a white, translucent plastic or fabric cover that slips over the head of your flash unit. The flashed light passes through the translucent cover, and so is diffused and softened when it reaches your subject.

fluorescent light A type of photo light that operates at cooler temperatures than photo floods/hotlights, is energy efficient, and is easy to use.

focal length The distance from the surface of a lens or mirror to its focal point. Think of focal length as the amount of magnification a lens has — the longer the focal length, the more the lens magnifies the scene.

format To prepare and optimize a memory card for use with your specific camera. Formatting is also the best way to clear the images from your memory card after you transfer them off the card for safekeeping.

f-stop An f-stop is a fraction that indicates the diameter of the aperture. The f stands for the focal length on the lens, the slash (/) means divided by, and the number represents the stop in use. The smaller the f-stop or f-number, the larger the actual opening of the aperture; higher-numbered f-stops designate smaller apertures, letting in less light. See also *aperture* and *shutter speed.*

golden hour A time that occurs near sunrise or sunset when the angle of the sun is low in the sky and just above the horizon. Golden hour light is considered to be very beautiful, soft light.

head shot A portrait type that emphasizes the subject's head and shoulders. Head shots are generally used for marketing purposes in various industries. For example, actors and models need head shots to market themselves in the entertainment and advertising fields, and other professionals, such as real-estate agents, often incorporate head shots into their promotional materials.

hot-shoe A mounting bracket located on the top of your camera with a connector for a flash unit.

image sensor A computer chip that electronically captures the light rays coming through the lens of a digital camera in order to create a digital image.

incandescent light Light from a tungsten light bulb; this is the most common source of light in most homes. Although incandescent lights emit very warm light and can be used in a lot of photographic situations, they are limiting because of their relatively low light output.

ISO speed A rating of a digital camera sensor's sensitivity to light. Digital cameras use the same rating system for describing the sensitivity of the camera's imaging sensor as film manufacturers do for film. Your digital camera has a manual control for adjusting the ISO speed, or it can adjust the ISO speed automatically depending on the lighting conditions. Generally, as the ISO speed increases, the image quality suffers.

JPEG A standard for compressing image data. The JPEG standard was developed by the Joint Photographic Experts Group. Compression is applied to a JPEG image when it is captured and stored on a memory card. Due to this compression, the JPEG format does not give you the same range of editing capabilities as the RAW format does. See also *lossy compression.*

LCD Short for liquid crystal display, a low-power monitor, often found on the back of a digital camera, that is used to display settings and view images.

lens speed The maximum aperture diameter of a photographic lens. A lens with a wide maximum aperture (for example, f/2.8) is considered a "fast" lens because more light passes through the lens, enabling you to use a faster shutter speed. A lens with a smaller maximum aperture (for example, f/5.6) is "slow" because less light passes through the lens and therefore a slower shutter speed is required for a proper exposure.

light blocker Any dark or black object or surface that obstructs light and/or subtracts it from your scene. This is helpful when you want to create shadows or block light in a certain area of your image. Light blockers

are also known as *flags* or *gobos* because they flag off the light or "go between" the light source and your subject.

light quality A term used to describe how hard or soft the light is. Bright sunlight is hard light, but an overcast day typically produces soft light.

LLC Short for limited liability company, a sort of hybrid that incorporates the flexibility of a sole proprietorship with the protection offered by a corporation. With an LLC, profits from the business flow directly to you and are taxed at your personal rate rather than at a corporate tax rate; at the same time, you are legally distinct from your company, meaning that if you are sued, only the assets of the business are at risk.

lossy compression A compression format where portions of the image are discarded in order to make the output as small as possible.The more compression, the smaller the file, but the less precision of detail.

macro lens A lens that allows you to photograph your subject from a very close distance without distortion. Macro lenses are available in various focal lengths.

macro photography Photography where the image on the sensor is equal to or bigger than the subject that is being photographed. For example, the ratio of 1:1 means the image size on the sensor is equal to the subject size. Getting closer increases the ratio of the image to the subject, so a ratio of 2:1 means that the image is twice as big as the subject.

megabyte Abbreviated as MB, a measurement of data storage equal to 1024 kilobytes (KB).

megapixel Abbreviated as MP, a measure of a digital camera's resolution. One megapixel is equal to one million pixels.

memory card A small, thin, device that is inserted into a slot in a digital camera to electronically record and store digital images. Memory cards are available in various capacities and qualities.

metadata Data stored within a digital image. Images typically contain several forms of metadata, including a record of the camera settings that were used when the digital image was created — pixel resolution, shutter speed, aperture, focal length, ISO, white balance, metering pattern, whether a flash was used, and so on. Images typically also contain metadata noting the date and time the image was captured. This metadata is saved in a standard format called Exchangeable Image File (EXIF). Often, you can search for your images using metadata as your criteria.

model release A legal document signed by the subject of a photograph that grants permission to publish the image — for example, in a book, in an advertisement, as a stock photo, on your Web site, and so on.

noise The degradation of a digital image, usually indicated by random discolored pixels. Most noticeable in the even areas of color in an image, such as shadows and sky, noise results from shooting in low light using a high ISO.

normal lens Also known as a standard lens, the focal length representing the field of view of human sight.

photo floods Lights that emit a golden color cast and are often used as construction or utility work lights. They produce a generous amount of light, but the bulbs have a fairly short lifespan and emit a lot of heat.

pixel Short for picture element, the smallest part of a digital image. Digital images are comprised of millions of these tiny, tile-like, colored squares. One million pixels are the equivalent of one megapixel.

polarizing filter A filter that modifies light as it enters the lens, removing the glare and reflections from the surface of glass and water. It can also darken the sky and increase color saturation.

property release A release that confirms that the owner of a property — be it a building, land, a pet, etc. — has consented to that property being photographed and published. A release is typically not required when photographing on public property.

RAW capture An image format that contains *all* of the uncompressed data of a photographed image. RAW files are not standard image file formats, and the file extensions for RAW files vary by camera manufacturer. To edit RAW image files, you must first convert the files in your computer. RAW files work well for difficult exposures or when you want to maximize the information captured for the best possible image.

red-eye The red glow from a subject's eyes caused by an on-camera flash reflecting off the blood vessels behind the retina. Red-eye occurs in low-light situations due to the enlargement of the pupil.

red-eye reduction A camera feature that can reduce red-eye in low-light situations. Some cameras emit one to two pre-flashes before the picture is taken using the actual flash; others have a steady red-eye reduction light. This constricts your subject's pupils and can help reduce the amount of red-eye in your images.

reflector A tool for redirecting light; this is usually a white or metallic cloth, a reflective umbrella, or a light-reflecting board.

remote shutter release A mechanism that enables you to engage the shutter without having to press the shutter release button on the camera — useful for minimizing vibrations that could cause image blur. This is a necessity when photographing in low light or at night.

resolution The amount of digital information in an image, usually measured in pixels per inch. The more pixels in your digital image, the higher your image resolution. Image resolution determines how much detail you see in your images and how large an image you can successfully print.

setups Setting up the scene considering the light, location, and composition of the image.

shutter lag The delay that occurs between when you press the shutter release button on a digital camera and when the shutter actually engages.

shutter speed A measurement of how long the shutter remains open when a picture is taken. The slower the shutter speed, the more light hits the sensor. You can specifiy different shutter speeds on your camera. For example, when you set the shutter speed to 250, this means the shutter is open for 1/250 second. The shutter speed and aperture work together to control the total amount of light reaching the sensor.

slave A light-sensitive triggering device that can be triggered via cord, via light, or via radio signals. It's used to synch strobes and flashes.

SLR An acronym for single lens reflex; in an SLR camera, the light from the image comes through the lens, and bounces off a mirror in front of the shutter into the viewfinder until the shutter release is pressed. At that time, the mirror flips up; the shutter opens, exposing the digital sensor, and then closes; and the mirror flips back down.

soft box An enclosure around a light source (typically box-like) that includes a reflective interior and a diffusion panel in the front to soften the light falling upon your subject.

sole proprietorship A type of business where you — and only you — own the company outright. Income from the business is treated as personal income. You do business as yourself; legally and for tax purposes, you and your business are one entity. As the owner of a sole proprietorship, you are solely responsible for all decisions — and all debts. A sole proprietorship is the easiest type of business to start and is subject to fewer regulations than other types of businesses.

spot meter A light meter that allows you to select a very small part of the scene and find the exposure for just that area. This is particularly useful when you need to find the exposure of your subject when he is surrounded by large amounts of light or dark.

strobe Also known as a *stroboscopic lamp*, a repeating flash that can be set to flash at a selected rate.

tag A descriptive keyword that is attached to an image, such as the name of the subject of a photo or the name of the city where it was captured. You can sort your images by tag, displaying all images with the same tag together. If you're looking for an image with a particular tag, this can make it much easier to find.

telephoto lens A lens designed for photographing distant objects. Similar to a telescope, it magnifies your subject and narrows your field of view.

transmitter A mechanism that attaches to your camera's hot-shoe and sends a signal to dedicated flash units within a specified distance, causing them to flash. An infrared transmitter requires a line-of-sight to a flash unit, while a radio transmitter does not require a line-of-site to a flash unit and can be easier to use.

tungsten/incandescent light A metal filament used in most light bulbs that emits a reddish/yellow-colored light, creating a color cast in a photograph.

UV filter A filter used to reduce the amount of ultraviolet light entering your lens so that the image appears less hazy. UV filters are also used to protect the surface of a camera lens.

variable-aperture lens A lens in which the aperture changes as you focus closer in or farther away from your subject. Although variable-aperture lenses, which are less expensive than their fixed-aperture counterparts, are capable of producing excellent images, they do have limitations. For example, you won't be able to shoot hand-held with a variable-aperture lens in most low-light situations; you can only capture action in bright light or by using a flash. Also, variable-aperture lenses cannot render a very shallow depth of field.

vignetting A reduction of the image's brightness in the periphery, causing the edges to appear soft and fade to the background color.

white balance A camera function that compensates for different colors of light being emitted by different light sources. Auto white balance (AWB) works well in most lighting situations, although it can vary depending on the camera and type of light in your scene. White balance presets offer a choice of white balance options designed for specific lighting conditions. Custom white balance is useful when your scene is illuminated by mixed light sources, such as daylight coming in through a window blended with fluorescent or tungsten lights.

wide-angle lens A camera lens that has a shorter focal length than a normal or standard lens, and covers a wider angle of view. A wide-angle lens is useful when you can't move far enough away from a subject to get everything in the picture, as well as for grand, scenic vistas. Wide-angle lenses also provide a greater depth of field, so that all the elements seen through the lens appear in sharp focus. When close to a subject with a wide-angle lens, the subject appears huge in comparison to the background. However, these lenses may distort subjects at the far edges of the image by making them appear wider than they actually are, and when used at their widest setting, these lenses may create dark edges in the corners of your images.

zoom lens A lens that offers a range of focal lengths — for example, 24–70mm. With zoom lenses, you can switch from one focal length to another, including more or less of your scene in your shot, simply by moving the lens barrel. While using a zoom lens enables you to carry fewer lenses around, zoom lenses do have their disadvantages. For one, they tend to be more expensive. For another, they are less sharp than lenses with a fixed focal length, which can be a problem if the image will be printed in a larger format.

index

INDEX

INDEX

INDEX

INDEX